Brilliant Women
18th-Century Bluestockings

Published in North America by Yale University Press, P.O. Box 209040,
302 Temple Street, New Haven, CT 06520-9040, www.yalebooks.com

Published in Great Britain by National Portrait Gallery Publications,
National Portrait Gallery, St Martin's Place, London WC2H 0HE

Published to accompany the exhibition *Brilliant Women: 18th-Century Bluestockings*
held at the National Portrait Gallery, London, from 13 March to 15 June 2008.

Brilliant Women: 18th-Century Bluestockings has been supported by

 Arts & Humanities
Research Council

ISBN: 978-0-300-14103-0

Library of Congress Control Number: 2007941632

Publishing Manager: Celia Joicey
Editor: Susie Foster
Production: Ruth Müller-Wirth
Design: Zach John Design
Printed and bound in Hong Kong

Front cover and p.13 (details): Hannah More, Augustin Edouart, 1827.
National Portrait Gallery, London (NPG 4501)

Back cover and frontispiece (detail): *Portraits in the Characters of the Muses in the
Temple of Apollo (The Nine Living Muses of Great Britain)*, Richard Samuel, 1778.
National Portrait Gallery, London (NPG 4905)

Brilliant Women
18th-Century Bluestockings

ELIZABETH EGER and LUCY PELTZ

Yale University Press

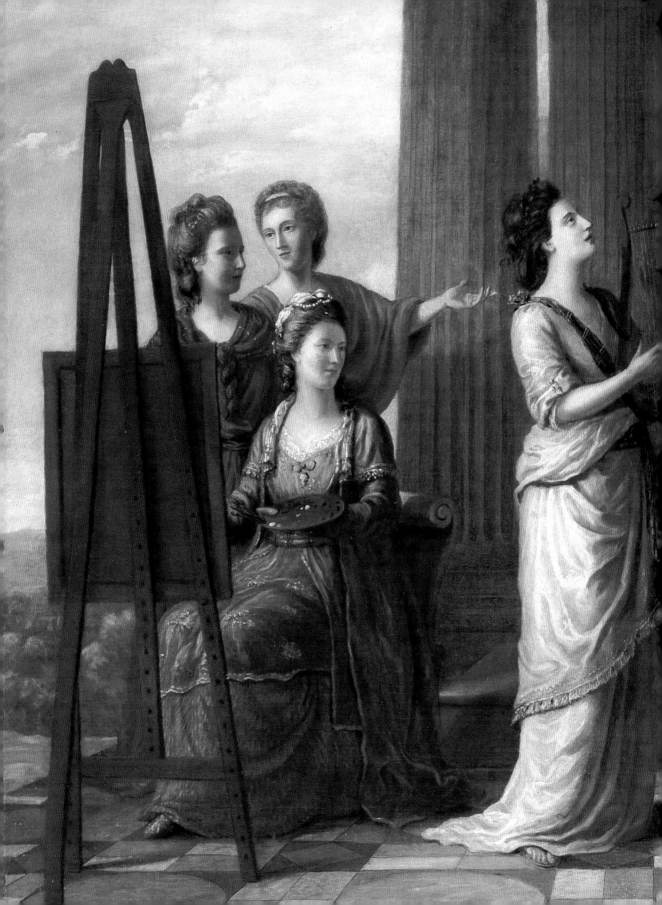

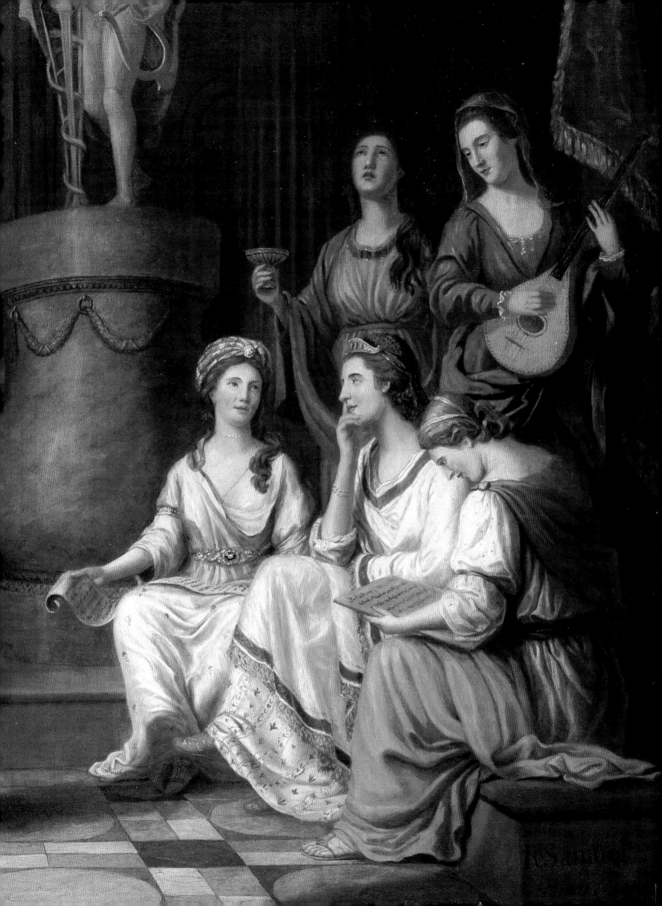

Contents

Director's Foreword

Richard Samuel's *Portraits in the Characters of the Muses in the Temple of Apollo (The Nine Living Muses of Great Britain)* of 1778 (see p.60) reveals much more than the achievements and likenesses of the women depicted within it. As a group portrait it offers an idea of how and why the subjects were admired at a particular time in British history. These women were exceptional not only for their individual accomplishments and the diversity of their professional achievements, but also for their breaking of boundaries of what women could be expected to undertake or achieve in the eighteenth century. Several produced and published texts of popular interest, which gave them some economic independence and allowed them a freedom and a voice that was rare among women of the same social status or position.

The reconsideration and promotion of individuals whose reputations may have been obscured by time or changing social or political interests is a natural part of the Gallery's work. In the case of the bluestockings the neglect is more systematic, with the term shifting from one of appropriate recognition to something denoting 'comedy and abuse', as Elizabeth Eger and Lucy Peltz neatly describe. This book, and the exhibition that it accompanies, follows and draws on feminist studies from the past thirty-five years that have revived some interest in *The Nine Living Muses*, but this is the first occasion that portrait imagery and biography have been examined together to encourage a much fuller sense of how the intellectual achievements of the bluestockings were received and understood at the time.

I am enormously grateful to Elizabeth Eger for initiating this project and to Lucy Peltz for taking it up so energetically, and then producing between them an exhibition and publication of such importance. The National Portrait Gallery is very grateful for the assistance of the Arts and Humanities Research Council (under the Collaborative Doctoral Award Scheme), which supported the collaboration between King's College London and the Gallery, and allowed for the development of a vocational Ph.D. studentship and the recruitment of Clare Barlow, to whom I would like to give special acknowledgement for her dedicated research. Fuller acknowledgements are given elsewhere, but I would like to offer my thanks to all those who have contributed to the project in its

research and publication, and in its realization as an exhibition. Particular thanks are also due to the many generous lenders who have agreed to part with precious works.

The exhibition is kindly sponsored by BlackBerry and I am not only grateful to the company for its support for the project, but also for the support for a display of contemporary 'brilliant women' that they have made possible.

Sandy Nairne
Director

Sponsor's Foreword

'Brilliant Women' are women who define a generation, are passionate for a cause, and live their lives according to their own personal rule rather than allowing themselves to be governed by social convention. Research In Motion (RIM) is absolutely delighted to be working with the National Portrait Gallery to highlight and profile some truly extraordinary women in this book.

In the eighteenth century salons and the pursuit of conversation helped generate a social forum in which creative exchange and collaboration could take place. Today, through modern technology and social networks, it is easier to find like-minded people with shared interests and ideas than ever before. Across the globe there is now the virtual equivalent of thousands of bluestocking salons, where ideas are exchanged and grown. The BlackBerry® Women and Technology Awards, begun in 2005, in many ways reflect the same philosophies that were encapsulated in the eighteenth-century concept of the nine sister Muses as active and creative figures that epitomized the arts and sciences. To launch the awards, RIM commissioned Bryan Adams to create a photographic essay examining the concept of a 'modern-day Muse' with a selection of photographs from this project for display at the National Portrait Gallery.

Technology is an exciting, fast-moving and dynamic sector. It is one of the few industries that has no boundaries in terms of ideas, scope or gender. It is a sector that year after year pushes further what can be achieved, and then from nowhere a paradigm shift takes place and suddenly there is a new normal in the way we learn, communicate and connect with each other. And this is why the BlackBerry Women and Technology Awards were established. We at BlackBerry want others to be as passionate about technology as we are, and we want to profile and celebrate those incredible women who are playing a central part in the industry, so that they can be an inspiration to many more women and encourage them into the sector to have their own ideas and fruitful career.

I believe that some of the members of the Bluestocking Circle, as well as the wider world of the eighteenth-century bluestockings, would have worked in technology today and would definitely have been included in

RIM's photographic essay of 'modern muses'. For more information on the
BlackBerry Women and Technology Awards, please visit:
www.blackberrywomentechnologyawards.com/

Charmaine Eggberry
Vice President and Managing Director, EMEA at Research In Motion

Acknowledgements

Our collaboration on *Brilliant Women: 18th-Century Bluestockings* began in summer 2001 in Pasadena, where we both held Huntington Library Research Fellowships, for which we are extremely grateful. During the past seven years we have met with generosity from colleagues willing to share their knowledge and expertise in our quest to understand and illustrate the bluestockings and their culture.

For stimulating discussions and research advice, we would like to thank: Clare Baitley, Aileen Dawson, Judith Doré, Markman Ellis, Robin Emmerson, Moira Goff, Charlotte Grant, Antony Griffiths, Anne Janowitz, Ludmilla Jordanova, Bill McCarthy, Anne Mellor, Margery Morgan, Sheila O'Connell, Marcia Pointon, Kate Retford, Mary Robertson, Angela Rosenthal, Kim Sloan, Nick Smith and Susan Wiseman. We are grateful to the Arts and Humanities Research Council for granting us one of their first Collaborative Doctoral Awards – a Ph.D. studentship with a vocational element that is shared between King's College London and the National Portrait Gallery, which enabled us to appoint Clare Barlow as an assistant curator on this project. We feel enormously lucky to have enjoyed the benefit of Clare's enthusiasm, energy and research skills, which have contributed immeasurably to the realization of *Brilliant Women*.

A project such as *Brilliant Women* could not be organized without significant debts of gratitude. We join the Gallery's Director in thanking all those institutions and private individuals who loaned their works to the National Portrait Gallery and that are illustrated here. The Department of English Literature and Language at King's College London has provided practical and intellectual support for the project, and special thanks is due to Clare Brant, Trudi Darby, Christine Saunders, Mark Turner and Neil Vickers. The Paul Mellon Centre for Studies in British Art and King's College contributed generously to an academic conference on bluestockings and representation. At the National Portrait Gallery, we are grateful to Sandy Nairne for his enthusiastic support, and for helping elicit some potentially difficult loans. We would also like to thank the Exhibitions Managers, Sophie Clark and Rosie Wilson, assisted by Alexandra Willett, as well as Andrea Easey, Ian Gardner, Annabel Dalziel and Jude Simmons for their work on the interpretation and

design of the exhibition. Editor, Susie Foster, Publishing Manager, Celia Joicey, and the designer, Zach John worked tirelessly to bring this book to fruition. We would also like to acknowledge the contribution of the following: Stuart Ager, Pim Baxter, Rosie Broadley, Caroline Brooke-Johnson, Rebeka Cohen, Naomi Conway, Denise Ellitson, Neil Evans, Claire Everitt, Peter Funnell, Sylvain Giraud, Richard Hallas, Rab MacGibbon, David McNeff, Tim Moreton, Ruth Müller-Wirth, Jonathan Rowbotham, Juliet Simpson, Anne Sørensen, Alison Stagg, Cath Stanton, Elaine Tierney and Sarah Tinsley. Lastly, special thanks must go to Nick Harrison and Michael Willis for their unswerving support throughout this project over a number of years.

Elizabeth Eger, King's College London
and Lucy Peltz, National Portrait Gallery, London

Bluestocking
a scholarly or intellectual woman. [from the blue worsted stockings worn by members of a C18 literary society]

Preface

The word 'bluestocking' describes a literary or learned woman and has a curious but fascinating history. Its shifting meaning reveals much about changing attitudes towards women who have sought a life of the mind. Today the term is often used in a disparaging sense, to suggest a certain type of bookish and dowdy woman. Conversely, some claim 'bluestocking' as a positive term, arguing that it has a counter-cultural edge that is connected to a tradition of feminist pioneers. This ambivalence surrounding the word reflects society's perennial anxiety about intelligent women, too often regarded with suspicion rather than admiration.

This book sets out to introduce the original, eighteenth-century bluestockings – a remarkable group of writers, artists and thinkers who met to debate contemporary ideas and promote the life of the mind. The Bluestocking Circle assembled in the London homes of Elizabeth Montagu, Elizabeth Vesey and Frances Boscawen, innovative literary hostesses whose salons allowed women to flourish and be brilliant in every sense of the word. Although principally a female phenomenon, these assemblies included famous men – such as Edmund Burke, Samuel Johnson and David Garrick – who supported the idea of female learning. Indeed, few people today know that the label 'bluestocking' was originally applied to both sexes, and was coined to describe the botanist Benjamin Stillingfleet, who wore blue worsted stockings (rather than the more formal white silk) to one of Montagu's evening parties. The initial cultivation of 'bluestocking philosophy', in this mixed company, may be seen as the social expression of an Enlightenment belief in freedom of enquiry irrespective of nature or gender.

The bluestocking model of sociability was an idealistic one. Although it was experienced by only a privileged section of society, the bluestocking hostesses were concerned that their social innovations should be felt beyond the walls of the salon. Indeed, Elizabeth Montagu, 'Queen of the Blues', helped forge a public identity for the female intellectual through her own scholarship as well as her encouragement and financial support of other women writers. Montagu's *Essay on Shakespeare* (1769), in which she powerfully refuted Voltaire's criticisms of England's national poet, consolidated her reputation as a critic and showed that women could compete as equals in a traditionally masculine genre.

From the 1770s the term 'bluestocking' was applied more specifically to women. The combined literary and cultural output of the bluestockings was voluminous, and included poetry, educational tracts, history, philosophy, political pamphlets, classical translation, drama, novels and criticism. Female artists similarly worked in a wide range of genres, from portraits and decorative work to ambitious history paintings. The professional achievement of the bluestockings challenged traditional stereotypes of female accomplishment, drawing attention to a need for equality between the sexes. While these women had few legal rights, they demonstrated their right to a 'life of the mind'. Writing provided a route to autonomy and the control of one's income. 'Who would not be a bluestockinger at this rate?' wrote Fanny Burney in her diary in 1780.

Brilliant Women: 18th-Century Bluestockings traces the rise and fall of bluestockings in relation to the economic, social and political history of Britain. Publicly celebrated in their time, the bluestockings' achievements in the worlds of art, literature and political thought at once became symbolic of the progress of a civilized and commercial nation, and provoked anxiety about women's proper place in society. Chapter One introduces members of the Bluestocking Circle and explains how a tight-knit group of men and women who first began to meet in the 1750s became a model for rational 'Enlightenment' forms of sociability. By focusing on Elizabeth Montagu's salon, this chapter explores the spread of bluestocking ideas through the friendship, patronage and charity that characterized bluestocking interaction and ideology.

Chapter Two broadens the discussion outwards from Montagu's circle to explore the status, reputation and representation of the educated and creative woman in a period when women's contribution to art and literature was celebrated patriotically and taken as a measure of Britain's cultural superiority. Although this was an unusually positive climate in which to be a bluestocking, intellectual and creative women still had to consider their moral reputation when venturing into the public eye. This tension is apparent in portraits, which show how professional creative women adapted the language of feminine iconography and deployed various classical references to advance themselves and their work.

At the end of the century, in the aftermath of the American and French revolutions, Britain witnessed a conservative reaction against emerging radical ideas. Chapter Three concentrates on the rise and fall from grace of the republican historian Catharine Macaulay and the early 'feminist' Mary Wollstonecraft. Both greeted the French Revolution with enthusiasm and spoke out for women's rights. But their troubled reputations were due less to their uncompromising politics than their transgression of female conventions, especially in their liberal attitudes and unconventional sexual lives. In a changing moral landscape, which imposed new limits on self-expression, the traditional roles of the sexes were emphasized once again. A new model of female activism – and the acceptable face of the bluestockings at the start of the nineteenth century – is embodied by Hannah More, an Evangelical conservative reformer.

Chapter Four investigates the legacy of the bluestockings and explores the reasons that these eighteenth-century women's cultural achievements were ignored during the nineteenth century. By the end of the eighteenth century, the combined social and intellectual prominence of so many intelligent women began to be greeted with suspicion and even disgust by many literary men. 'Bluestocking' became a term of abuse, echoing earlier distrust of learned women's 'slipshod' appearance and morality. The conservative and masculine backlash against intellectual women can be held largely responsible for the original bluestockings' fall from public view. By the end of the nineteenth century, as women renewed their campaign for education and equality, 'bluestocking' remained a derogatory label. One of the more unsettling suggestions of this book is that the history of feminism is not one of simple progress, but rather has included cycles of recognition and neglect of women's capacities and achievements. *Brilliant Women* concludes by considering the links between the early bluestockings and the rise of feminism, between women's creative achievements and women's rights, and the opportunities that exist for the bluestockings to be rediscovered.

The women in this book certainly do not form an exhaustive list of candidates for a bluestocking hall of fame. In choosing to focus on female artists

and writers, we have left unexplored some other professions in which women excelled – for example, the eighteenth-century theatre, an important environment for female creativity and professional careers. Our narrative, based on the material culture of the bluestockings, is inevitably shaped by the chance survival and discovery of keepsakes, satirical prints and literary artefacts, as well as paintings. Nonetheless, we believe that the portraits at the heart of the book offer real insight into the history, significance and changing reputation of bluestockings and their culture.

Elizabeth Eger and Lucy Peltz

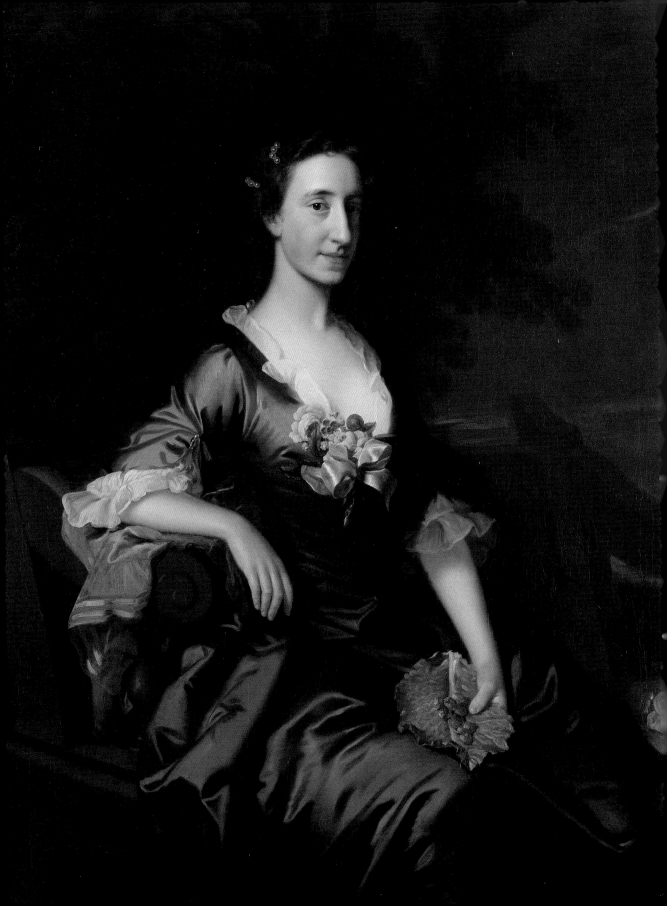

The Bluestocking Circle
Friendship, Patronage and Learning
ELIZABETH EGER

The Origins of the Bluestocking Circle

The Bluestocking Circle first met in the 1750s in the London homes of
Elizabeth Vesey, Frances Boscawen and Elizabeth Montagu (see opposite and
pp.22 and 49), wealthy women who invented a new kind of informal sociability
and nurtured a sense of intellectual community. These three fashionable
hostesses replaced popular amusements and alcohol with the more refined
pursuits of literary conversation and tea drinking. As their contemporary the
writer Hannah More (see p.23) expressed in her exuberant poem *The Bas Bleu:
or, Conversation* (1786), civilized communication was in danger of being
overtaken by society's violent addiction to card playing and dancing:

> Long was Society o'er-run
> By Whist, that desolating Hun;
> Long did Quadrille despotic sit,
> That Vandal of colloquial wit;
> And Conversation's setting light
> Lay half-obscur'd in Gothic night.[1]

Here the word 'Gothic', taken with 'Hun' and 'Vandal', signifies all that is
primitive and barbaric. This was an age of conspicuous consumption: the
aristocracy habitually squandered vast sums on gambling, regardless of the high
cost of imperial wars with France. More addressed her poem to Mrs Vesey,
describing her as one of the three bluestocking saviours, with Boscawen and
Montagu, who could restore integrity to polite society:

> At length the mental shades decline,
> Colloquial wit begins to shine;
> Genius prevails, and Conversation
> Emerges into *Reformation*.[2]

Educated and elegant conversation was an index of civilized society in the
eighteenth century. The bluestockings were original in that they 'reformed'

Frances Boscawen,
1719–1805
Allan Ramsay, *c.*1747–8
Oil on canvas, 1350 x
1090mm (53⅛ x 42⅞")
Private Collection

Ramsay shows Frances
Boscawen holding a cabbage
leaf filled with redcurrants,
suggesting, perhaps, that she
is resting after gathering fruit
in her garden. She was
appreciated by many as
a spritely correspondent.
Hannah More wrote a poem,
'To Sensibility: an Epistle
to Mrs Boscawen', first
published in 1782,
celebrating her friend's ability
to balance reason with feeling.

Elizabeth Vesey, 1715?–91
Unknown artist, *c.*1770?
Black crayon with touches of
sepia and grey wash,
238 x 200mm (9⅜ x 7⅞")
National Portrait Gallery,
London (NPG 3131)

Elizabeth Vesey was known
by her friends as the 'Sylph',
in allusion to her girlish
figure and flirtatious wit.
In 1781 Elizabeth Montagu
wrote to Vesey, 'We have lived
with the wisest, the best, and
the most celebrated men of
our Times, and with some
of the best, most accomplished,
most learned Women of
any times.'

Hannah More, 1745–1833
John Opie, 1786
Oil on canvas, 690 x 590mm
(27⅛ x 23¼")
The Mistress and Fellows,
Girton College, Cambridge

This portrait, commissioned
by Hannah More's friend,
the bluestocking Frances
Boscawen, shows More as
a woman of purpose, with
fiery eyes and fashionably
powdered hair. More proved
a reluctant sitter, writing to
Boscawen that she had 'such
a repugnance to having my
picture taken, that I do not
know any motive on earth
which could induce me to it
but your wishes.'

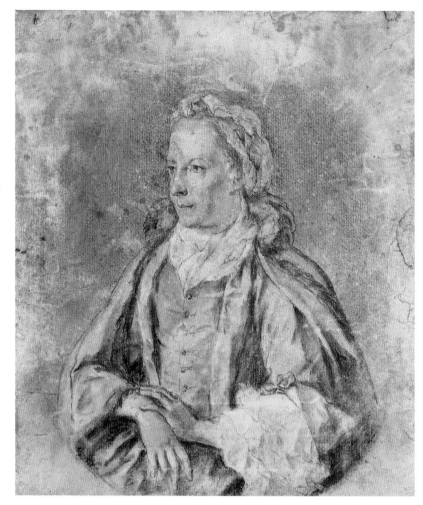

conversation in both a moral and a literal sense: Montagu and Vesey were
known not only for their virtue but also for their careful orchestration of social
space. While Montagu arranged her guests in a large semicircle, in order to
promote unity of discussion, Vesey preferred random, scattered groups in the
hope of relaxed company. The novelist Fanny Burney (see p.25) observed of
Vesey, 'Her fears were so great of the horror, as it was styled, of a circle, from the
ceremony and awe which it produced, that she pushed all the small sofas, as
well as chairs, pell-mell about the apartments, so as not to leave even a zigzag
of communication free from impediment.'[3]

For More, conversation was an agent of reform but also something dazzling,
to be displayed and exchanged like desirable currency:

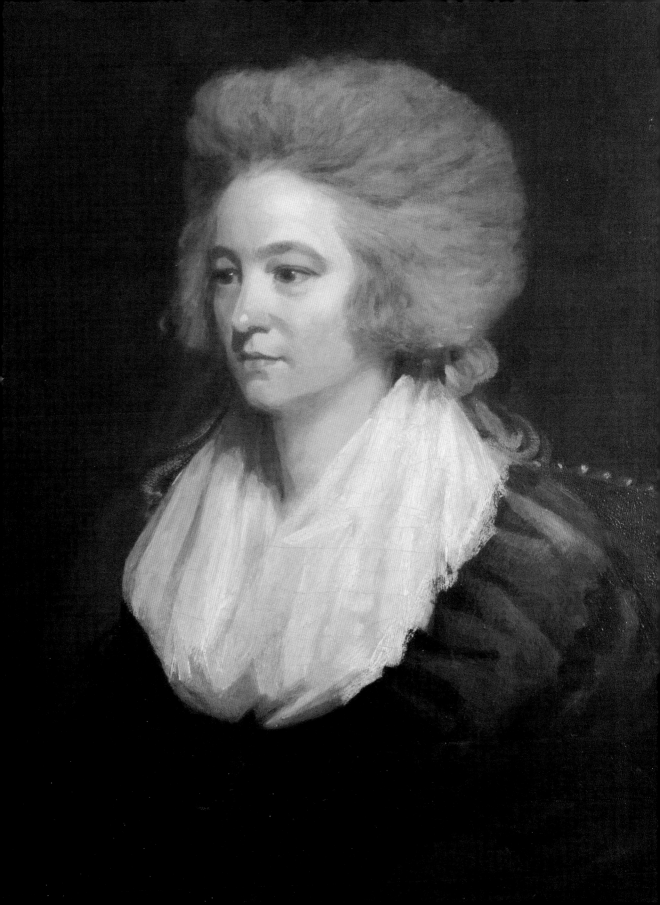

Our intellectual ore must shine,
Not slumber idly in the mine.
Let education's moral mint
The noblest images imprint;
Let taste her curious touchstone hold,
To try if standard be the gold;
But 'tis thy commerce, Conversation,
Must give it use by circulation;
That noblest commerce of mankind,
Whose precious merchandize is MIND![4]

More expresses the sense in which the bluestockings embraced fashionable
society while also transforming it. The vocabulary she chooses is redolent of the
energy and competition of a commercial age, in which the practices of
metropolitan life embodied a new spirit of progress. Luxury goods such as
coffee, tea, porcelain, silk, sugar and chocolate were being imported on a wider
scale than ever before, stimulating new modes of eating and socializing.
Domestic dining and tea drinking complemented more public leisure in coffee
houses, shops, pleasure gardens, exhibition halls, assemblies and theatres. Such
material novelties provoked debate about the moral significance of commercial
progress and its relation to social and intellectual change.

More's metaphor of conversation as a kind of 'commerce' not only suggests
the profit to be gained from intellectual exchange but also conveys the sense
in which the bluestockings wanted to moralize their relationship to a new
consumer culture while encouraging women to pursue a life of the mind.
Elizabeth Montagu (1718–1800; see p.49) was the daughter of a country squire,
a member of the comfortable gentry class. On her marriage in 1742 to Edward
Montagu, a member of the aristocracy, she acquired extensive coal mines in the
north of England. Edward, a mathematician, was much older than Elizabeth
and preferred his study to managing his estates. Elizabeth, however, was a
shrewd businesswoman and a patron of the arts. She devoted her efforts to
managing and improving productivity at the mines in order to promote the
visual and literary arts in London, showing that women could take an active
role in the contemporary economy. She divided her time between winter in
London, the setting for her assemblies; spring and autumn at Denton near
Newcastle, where she managed her collieries; and summer at her country estate
at Sandleford in Berkshire, where she retreated from the demands of society and
work. She also travelled to Bath, Tunbridge Wells and the country seats of her

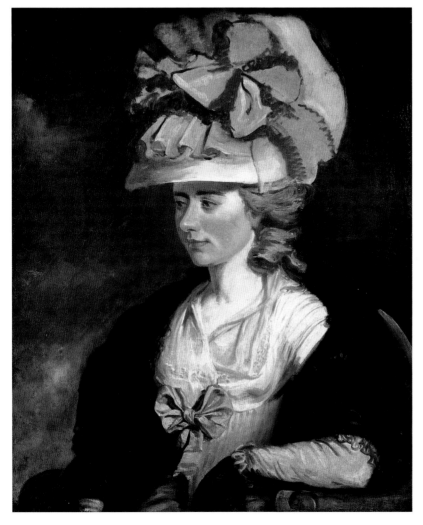

Fanny Burney, 1752–1840
Edward Francisco Burney,
*c.*1784–5
Oil on canvas, 762 x 635mm
(30 x 25")
National Portrait Gallery,
London (NPG 2634).
Purchased with help
from The Art Fund

The novelist Fanny Burney's
diaries provide some of the
most vivid and witty
descriptions of bluestocking
society. She also wrote a
satirical play about learned
women, *The Witlings*, which
her father advised her not to
publish in case it offended
Elizabeth Montagu. Burney
was vehemently opposed to
sitting for this portrait by
her cousin, a fact that may
account for her refusal to
meet the viewer's gaze.

noble friends. Known as 'Fidget' in her youth, she had unstinting energy for
entertaining, whether as a matter of intellectual delight or social duty. As she
wrote to her sister in 1767, she considered herself 'a Critick, a Coal Owner,
a Land Steward, a sociable creature'.[5] These roles were inter-connected for
Montagu, who consciously positioned herself at the heart of her cultural world.

Her first London home, at Hill Street, was renowned for its perfect balance
between culture and commerce, intellect and pleasure. On Christmas Eve in
1752, she described how the previous evening 'the Chinese-room was filled by
a succession of people from eleven in the morning till eleven at night'.[6] The
following spring she told her husband, 'I had rather more than an hundred

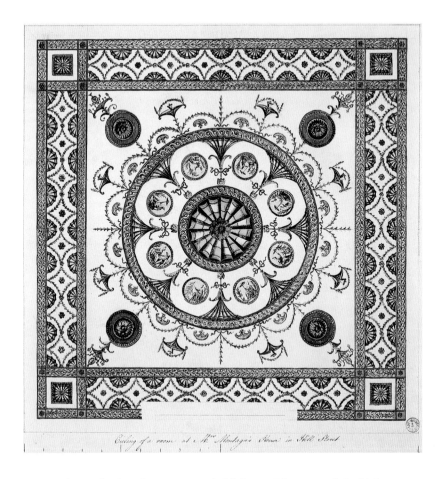

Ceiling of a room at Mrs Montagu's House in Hill Street

visitants last night, but the apartment held them with ease, and the highest
compliments were paid to the house and elegance of the apartments.'[7] When
her Chinese room needed refining and redecorating fifteen years later, she
persuaded the architect and designer Robert Adam (1728–92), who was deeply
committed to, and preferred, a style of simple, classical elegance, to undertake
the rare exercise of working in the Chinese style. The results were stunning: he
produced intricate designs for the ceiling, and a particularly interesting carpet
which incorporated a circular motif, suggesting the social circle that would
gather upon it. It was against a backdrop of pagodas, mandarins with heads
bowed and paintings on gauze that Montagu's guests were to concentrate on
improving their minds. The delicate balance of fashionable and intellectual
polish required is conveyed in this concise description of Montagu by the
bluestocking writer Hester Thrale (1741–1821): 'Brilliant in diamonds, solid
in judgement, critical in talk'.[8] As More suggested so evocatively in her poem,

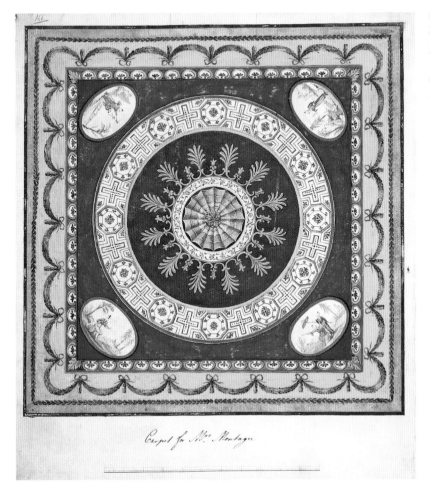

Carpet for Mrs Montagu

Carpet design for Mrs Montagu, Hill Street
Robert Adam, *c.*1766
Watercolour, 390 x 390mm
(15⅜ x 15⅜")
The Trustees of Sir John Soane's Museum

the bluestockings combined the sensual pleasures of metropolitan life with 'education's moral mint'.

The distilled description provided by *The Bas Bleu* of bluestocking social practices and beliefs makes it a rare monument to the nature of the circle's achievement. The author and lexicographer Samuel Johnson (see p.28) considered the work to be 'in my Opinion a Very Great performance', adding that 'there is no name in poetry, that might not be glad to own it'.[9] First published in 1786, by the Strawberry Hill printing press owned by Horace Walpole (1717–97), *The Bas Bleu* was probably written a decade earlier, and circulated in manuscript. Although the poem was addressed to Mrs Vesey, More was a frequent and enthusiastic visitor to Montagu's salon, which was the most famous, elegant and influential of all the bluestocking gatherings. More wrote

in a letter of 1775 to her sister of her excitement at meeting, at Montagu's house, the painter Sir Joshua Reynolds (1723–92), Samuel Johnson, who christened Montagu 'Queen of the Blues', the poet and educationalist Anna Letitia Barbauld (1743–1825; see p.66) and the classical scholar Elizabeth Carter (1717–1806; see p.33):

> Mrs Montagu received me with the most encouraging kindness; she is not only the finest genius, but the finest lady I ever saw: she lives in the highest style of magnificence; her apartments and her table are in the most splendid taste; but what baubles are these when speaking of a Montagu! Her form (for she has no body) is delicate even to fragility; her countenance the most animated in the world; the sprightly vivacity of fifteen, with the judgement and experience of a Nestor.[10]

Nestor, King of Pylos, is depicted in Homer's *Iliad* as an elder statesman renowned for his wisdom. More goes on to praise Montagu's assembly, with its 'diversity of opinions' and 'argument and reasoning'. She enjoyed meeting her fellow female writers in particular, and was attracted to those admitted, like herself, for talent rather than rank.

Samuel Johnson, 1709–84
James Barry, 1778–80
Oil on canvas, 606 x 530mm
(23⅞ x 20⅞")
National Portrait Gallery,
London (NPG 1185)

Montagu welcomed men and women of high society, such as William Pulteney, the Earl of Bath (1684–1764), and George, Lord Lyttelton (1709–73), as well as those from the emerging professions who were celebrities in their own right. The famous actor and theatre manager David Garrick and his Austrian wife, Eva Maria, a professional dancer (whose stage name was 'Violette'), were particular favourites of Montagu. Hogarth's 1757 portrait of the Garricks (see opposite) suggests the intimate and teasing relationship between the couple: he is pausing and looking up from his desk, where he has been writing the Prologue to Samuel Foote's farce *Taste*, while she stands behind her husband, hand poised archly to take his pen. Hogarth's painting introduces a sense of dialogue between the two figures, suggesting a companionate marriage in which man and wife challenge, as well as support, each other. The close bond between the two is emphasized by the fact that Eva is wearing a miniature portrait of David round her left wrist. Hogarth's image is powerfully suggestive of the bluestocking spirit, whereby a woman can steal some male authority in a complicit and playful fashion. Garrick seems at ease in his posture of abandonment, a benign and affectionate husband whose expression appears to acknowledge his wife's superior stance as somehow inevitable.

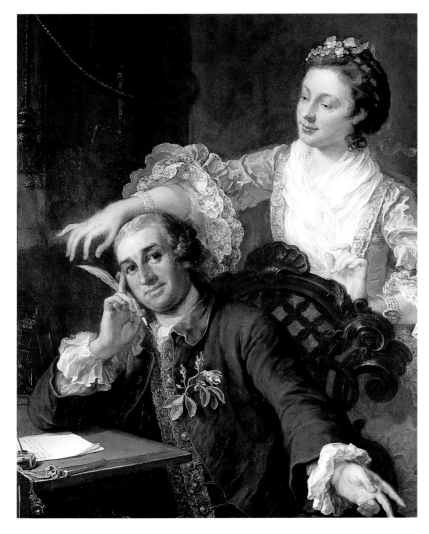

David Garrick, 1717–79,
and his wife Eva Maria,
1724–1822
William Hogarth, 1757
Oil on canvas, 1326 x
1042mm (52¼ x 41")
The Royal Collection

 Supportive friendship between men and women, in which female
intelligence was valued and encouraged, was vital to the early development of
the Bluestocking Circle. This can be seen in the shifting history of the term,
which was originally applied to both sexes. By the time of Montagu's death in
1800, 'bluestocking' was synonymous with women writers and intellectuals in
general, irrespective of whether they had participated in one of the early salons,
but it had been gender-specific only since the 1770s. Originally used to abuse
Puritans of Cromwell's 'Little Parliament' in 1653, the term was revived in
1756, when the eccentric scholar Benjamin Stillingfleet appeared at one of
Montagu's assemblies wearing blue worsted stockings, normally the garb of

Benjamin Stillingfleet,
1702–71
Johan Zoffany, *c*.1761
Oil on canvas, 913 x 707mm
(36 x 27⅞")
National Portrait Gallery,
London (NPG 6477)

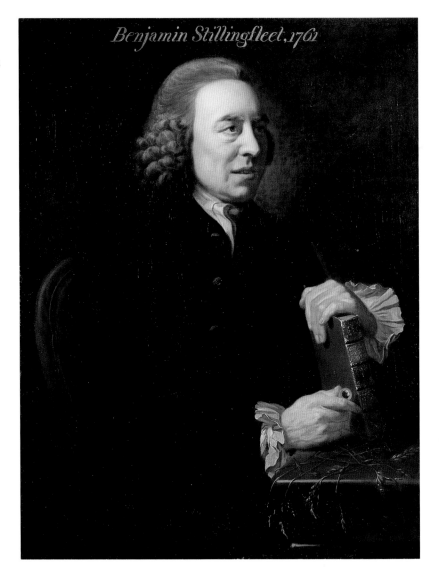

working men, instead of the more formal and courtly white silk. James Boswell repeated this story in his *Life of Johnson*, adding that the excellence of Stillingfleet's conversation was so greatly missed when he was absent that it used to be said, 'We can do nothing without the blue stockings.'[11] Stillingfleet, a good friend of Montagu's, was a gifted scholar and botanist, and one of the first English advocates of the Linnaean system of plant classification according to their sexual parts. In 1759 he published his *Miscellaneous Tracts* (translations from Linnaeus and his own *Observations on Grasses*), in which he made an

important plea for the study of natural science, arguing that what appeared to be 'mere curiosity' in one age might have practical benefits in the next. Zoffany's portrait of Stillingfleet, painted around 1761, depicts him proudly holding a volume of Linnaeus's works in one hand and a magnifying glass in the other, beside a table scattered with grasses (see opposite). He is the image of a 'virtuoso', a term first used in the seventeenth century to convey men with scientific and artistic interests who might collect antiquities or natural curiosities for private interest and public discussion (in the papers of the Royal Society, for example). As a young man, Stillingfleet published an enthusiastic poem *An Essay on Conversation* (1737), suggesting his future affinity with Montagu's world.

Stillingfleet was one of many men, including the Earl of Bath and George Lyttelton, who nurtured Montagu's literary ambitions. Such encouragement was important to the development of women's writing, and other intellectual pursuits, in the eighteenth century: bluestocking women were often supported by liberal fathers, brothers or family friends. When Montagu first published *An Essay on the Writings and Genius of Shakespeare, compared with the Greek and French Dramatic Poets, with Some Remarks upon the Misrepresentations of Mons. de Voltaire* anonymously in 1769, Stillingfleet corrected the proofs. He also compromised her anonymity, it seems; in a letter to her father, Montagu explained how the 'secret' of her authorship was revealed: 'The printer at last unluckily owned that Mr Stillingfleet corrected the Press, & as he is an intimate friend of mine this circumstance has in some degree betray'd ye secret.'[12] Intimate friendships like this often provided women with access to scholarly resources and gave them confidence to broach the traditionally masculine preserve of a genre such as literary criticism or classical translation and enter the public world of print. The eighteenth century witnessed an enormous increase in literacy and a parallel explosion in the number of books printed – a development that involved more women readers and writers than ever before. Women writers were singled out in patriotic appeals to Britain's cultural strength, and Montagu's *Essay on Shakespeare* proved a popular defence of Britain's national literary hero. Initially worried about publishing her work, Montagu wrote to her father, 'there is a general prejudice against female Authors especially if they invade those regions of literature which the Men are desirous to reserve to themselves'.[13] Once the work was well received, however, and reprinted, she was happy to put her name to it.

By the time of this triumph, 'bluestocking' was a fashionable term applied to all Montagu's visitors, men and women. The contacts made through conversation at bluestocking meetings were extended through networks of

correspondence and patronage well beyond their original London hub. The Bluestocking Circle became engaged in a wide range of social and philanthropic activities that promoted, in particular, women's role as writers, thinkers, artists and commentators, and by the 1770s the term started to refer exclusively to women. The jocular variants they used to describe themselves provide a certain amount of insight into the manner in which the bluestockings perceived their role in society.[14] Montagu referred, on a number of occasions, to the 'Bluestocking philosophers', suggesting her engagement with Enlightenment ideas of progress. She also mentioned, in her correspondence with Elizabeth Vesey, the 'Bluestocking Lodge' and 'Bluestocking Club'. Women's participation in urban club life was generally limited and women were excluded from secret societies such as the Freemasons, with their 'lodges'. In an age during which women were subordinated by law, education, religion and marriage, and frequently dismissed as inferior in mental powers, few cultural or political institutions permitted their participation. Montagu also used the phrase 'Bluestocking college', which conveys the sense in which the circle invested in an idea of education at a time when women were denied access to university. Montagu's sister, Sarah Scott (1720–95), wrote *A Description of Millenium Hall and the Country Adjacent* (1762), a novel that depicted a utopian vision of a harmonious female community, which, secluded from the public gaze, pursued a life of various arts, manufactures and acts of charity. Here she developed the earlier feminism of the religious writer Mary Astell (1666–1731), who, in her *A Serious Proposal to the Ladies* (1694–7), had urged the foundation of Protestant convents, or 'seminaries', in order to offer space for the life of the mind and spirit. Education, alongside morality and refined sociability, was central to the bluestocking project.

Female Education and 'Conduct'
In order to understand the full extent of bluestocking achievement, it is important to acknowledge the constraints under which the bluestockings worked and to consider wider contemporary ideas about female education and 'conduct'. Elizabeth Montagu's sense of being denied certain things because of her sex was apparent from a very young age, as was her ambition. As she wrote to her friend Lord Lyttelton in 1763, 'If I had been a boy, when I had gone a birds nesting, I should have indeavour'd to have climb'd to the Eagles Ayerie.'[15] She was consistently and instinctively drawn to the idea of improving her intelligence but also fearful of a hostile reaction. As she told Lyttelton, 'Extraordinary talents may make a Woman admired, but they will never make

her happy. Talents put a man above the World, & in a condition to be feared and worshipped, a Woman that possesses them must be always courting the World, and asking pardon, as it were, for uncommon excellence.'[16] This ambivalence was shared by many bluestockings. When Montagu proposed to set up 'a kind of Literary Academy for ladies' to rival male establishments, the poet Anna Letitia Barbauld responded in a way that revealed her difficult relation to the privilege of her own education:

> Young ladies, who ought only to have a general tincture of knowledge as to make them agreeable companions to a man of sense, and to enable them to find rational entertainment for a solitary hour, should gain these accomplishments in a quiet and unobserved manner: … the thefts of knowledge in our sex are only connived at while carefully concealed, and if displayed, punished with disgrace.[17]

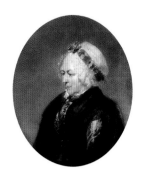

Elizabeth Carter,
1717–1806
Sir Thomas Lawrence,
1788–9
Pastel on vellum, 311 x
273mm (12¼ x 10¾")
National Portrait Gallery,
London (NPG 28)

As Barbauld stresses, the public display of learning was dangerous for women and could jeopardize their social situation, which was expected to be one of deference and obedience. The existing inequality in contemporary conversation was commented on wryly by Elizabeth Carter, in a letter to Montagu describing a typical social gathering:

> As if the two sexes had been in a state of war, the gentlemen ranged themselves on one side of the room, where they talked their own talk, and left us poor ladies to twirl our shuttles, and amuse each other, by conversing as we could. By what little I could overhear, our opposites were discoursing on the old English poets, and this subject did not seem so much beyond a female capacity, but that we might have been indulged with a share of it.[18]

Indeed, the discussion of 'old English poets' was arguably particularly suited to women, who were important contributors to a new sense of national literary tradition. Carter was famous for having defied standard assumptions of 'female capacity' by making her living as a classical scholar. Her translation of the ancient Greek Stoic philosopher Epictetus remained the standard English version until the beginning of the twentieth century (see p.73). Conversant as she was with several languages, including Portuguese and Arabic, a little light discourse on the English poets would hardly have presented a challenge.

Women of the eighteenth century received very little formal education in comparison to their male counterparts. While some boarding schools existed,

they focused on the 'accomplishments' that were considered necessary to secure a woman's success in the marriage market. The social expectations of female education and behaviour can be found in contemporary 'conduct literature', a genre derived from medieval courtesy literature that transferred its focus during the eighteenth century from the court to the middle-class household, thus giving a central role to the domestic woman. Wetenhall Wilkes's *A Letter of Genteel and Moral Advice to a Young Lady* (1740) and John Gregory's *A Father's Legacy to his Daughters* (1774) are typical of the genre in their focus on the moral education of young, middle-class female relatives (in Wilkes's case his niece) on the verge of adulthood. Gregory was an Edinburgh physician and a friend of Elizabeth Montagu, who approved of his style of educating his girls 'in a philosophical simplicity'.[19] His *Father's Legacy* was written solely for his daughters, after their mother's death, to equip them for the marriage market. Published posthumously by Gregory's son, James, the work achieved immediate success. Gregory recommended modesty and elegance as the means to attract the opposite sex. He advised his female readers that if they 'happen to have any learning', they should 'keep it a profound secret, especially from the men.'[20] This view was later to be attacked by the radical intellectual Mary Wollstonecraft (1759–97) in her *Vindication of the Rights of Woman* (1792).

The conduct book genre relied upon an ever-expanding and aspiring reading public, many of whom sought advice on how to better themselves in the world. The printer and publisher Samuel Richardson (bap.1689, d.1761) provides a compelling example of the remarkable transformation in the British publishing trade that occurred in the eighteenth century. The son of a rural joiner, Richardson rose to literary fame through hard work and astute networking in the printing trade. He made his early reputation as a publisher of controversial political pamphlets but went on to become a more comfortable member of the establishment, printing parliamentary bills and reports and having a share in the *Daily Gazetteer*. When Richardson began writing his famous novel *Pamela: or, Virtue Rewarded* (1740), he had been in the process of composing a manual 'of familiar letters' on the 'common concerns of human life', a project commissioned by his friend the publisher Charles Rivington (1688–1742) in order to address a perceived niche in his market.[21] One of these letters was from a servant girl's father, giving her advice on how to protect her virtue after the master's 'vile attempt' to seduce her, and clearly forms the basis for *Pamela*, in which the beautiful young heroine resists the advances of her rakish master, 'Mr B.', until she is rewarded by social elevation in the form of his hand in marriage.

The novel, a curious blend of titillating seduction narrative and moral conduct book, was a runaway success. Within a year it had already gone through five editions, and was soon translated into several European languages, adapted for the stage and pirated and parodied, notably in Henry Fielding's *Shamela* (1740) and Eliza Haywood's *Anti-Pamela; or, Feign'd Innocence Detected* (1741). In 1743 Richardson commissioned the painter Francis Hayman (1707/8–76) to produce twenty-nine designs that were engraved as book illustrations by the French (expatriate) printmaker Hubert Gravelot (1699–1733). The novel opens at the moment that Pamela's elderly mistress, who had taken unusual care with Pamela's education, has died and left her uncertain about her future. The first plate depicts an elegant Mr B., the mistress's son and heir, who has surprised Pamela in the act of composing a letter home. He is holding up her letter and admiring Pamela's handwriting. Her down-turned head suggests modesty and bashfulness as he praises her duty towards her parents: 'You are a good Girl, Pamela, to be kind to your aged Father and Mother. I am not angry with you for writing such innocent matters as these; tho' you ought to be wary what tales you send out of a Family.' From the start, Mr B.'s words include an element of vaguely threatening surveillance that hint at the development of the novel into a claustrophobic world of unremitting sexual pursuit and voyeurism.

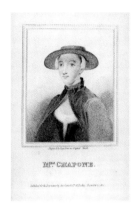

Hester Chapone, 1727–1801
R. Page after an unknown artist, 1812
Stipple engraving,
168 x 102mm (6⅝ x 4")
National Portrait Gallery,
London (NPG D2046)

The key moral message of Richardson's novel, however, lies in the fact that Pamela converts her master's predatory desire into humble admiration through the power of her writing. As Mr B. later remarks, while Pamela's beauty 'made me her *Lover* ... they were the Beauties of her Mind, that made me her *Husband*'. Pamela's letters form the virtuous narrative of the novel and the means by which she reforms her master. At a time when novels were generally perceived as morally suspect and potentially corrupting of their female readers, Richardson aimed to create a heroine that society approved of, one whom young women could emulate. The Preface advertises the novel's purpose as 'to Divert and Entertain, and at the same time to Instruct, and Improve the Minds of the YOUTH of both Sexes'.[22] One of the novel's most provocative and appealing qualities was to suggest that even the most rigid barriers of social class could be overcome through education, virtue and inner resolution, rather than by the more traditional methods of dissimulation and superficial disguise.

Richardson's success transformed him into a literary lion and he was particularly sought out by women, including Elizabeth Carter and her friend, the strenuously self-educated Hester Chapone, one of Elizabeth Montagu's

protégées. Chapone originally wrote her *Letters on the Improvement of the Mind* (1773) for the private perusal of her 15-year-old niece. Once published, it was a popular success and she dedicated the third edition to Montagu. The appeal of the book was immediate and enduring – it had been reprinted at least sixteen times by 1800. A further twelve editions appeared between 1800 and 1829, when it was translated into French. One of the most influential and popular educational books for women, Chapone's work was intended to help her niece cultivate rational understanding through her reading of the Bible, history and literature. In her otherwise scathing critique of conduct writings, Mary Wollstonecraft later singled out *Letters on the Improvement of the Mind* for praise: 'Mrs Chapone's Letters are written with such good sense, and unaffected humility, and contain so many useful observations, that I only mention them to pay the worthy writer this tribute of respect.'[23] Chapone proposed a rigorous curriculum, including a systematic study of the Bible; training in book-keeping and other aspects of household management; reading of translations of classical literature and a range of modern literature in French and English, only avoiding sentimental novels; botany, geology, astronomy, geography and history, particularly the history of the British empire, arguing that such study would 'supply the defect of that experience, which is usually attained too late to be of much service to us'.[24]

Chapone's prescribed range of study is undoubtedly impressive, and is intended to extend the range of female experience. However, she seems almost frightened of its implications, advising that one should have 'a competent share of reading, well chosen and properly regulated', but that 'the danger of pedantry and presumption in a woman – of her exciting envy in one sex and jealousy in another – of her exchanging the graces of imagination for the severity and preciseness of a scholar, would be, I own, sufficient to frighten me from the ambition of seeing my girl remarkable for learning'.[25] Women's experience of learning was inevitably double-edged. Compare Chapone's unease with the apprehension of the more overtly political Wollstonecraft as she contemplated her daughter's future: 'I feel more than a mother's fondness and anxiety, when I reflect on the dependent and oppressed state of (my daughter's) sex. ... I dread to unfold her mind, lest it should render her unfit for the world she is to inhabit. – Hapless woman! What a fate is thine!'[26]

Both Chapone and Wollstonecraft betray a poignant anxiety for the future generation of women. But the bluestockings were able to develop intimate bonds of friendship – as well as more formal networks of patronage – in order to resist or subvert the limits placed on women by culture and environment.

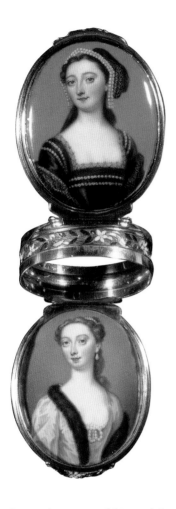
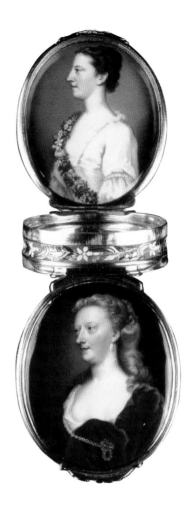

'Friendship' Box
Christian Friedrich Zincke,
*c.*1740
Enamel and gold, 42 x 52 x
25mm (1⅝ x 2 x 1")
The Stuart Collection

Bluestocking Friendship and Patronage

One of the most intriguing insights into the nature of female friendship in this period can be found in the form of a 'friendship' box commissioned by Margaret Cavendish (Harley), Duchess of Portland (1715–85), in the early 1740s. Four miniature portraits in enamel by Christian Friedrich Zincke (1684?–1767) – of the Duchess herself, Elizabeth Montagu, the letter writer and artist Mary Delany (1700–88) and, probably, Mary Howard, Lady Andover (d.1803), a correspondent to all three – are encased in a gold and enamel setting to form an exquisite and luxurious item that is more akin to a piece of jewellery, appealing on the grounds of its novelty and delicacy rather than its usefulness. Zincke's enamels were highly fashionable and expensive at the time the box was made, and the gold setting increased their value. The oval miniatures are only 4.5 centimetres (1¾ inches) high, so need to be held close to the eye to be

appreciated. In order to see all four portraits the viewer must open the box, thus experiencing a kind of physical intimacy that evokes the bond between its subjects. The portraits are mounted in an interdependent relationship that is highly suggestive of the close connection between these four women, bound together by their interests in natural history, literature and the arts.[27]

The portrait of the Duchess of Portland in a blue dress and fur stole forms one of the exterior images of the box. She chose never to be portrayed without her pearls, which form earrings and strands in her hair as well as trimmings to her dress. The Duchess had met Elizabeth Montagu as a young girl when, as Lady Margaret Cavendish Harley, she was living at Wimpole Hall near Cambridge. Her father, Edward Harley, 2nd Earl of Oxford (1689–1741), had a valuable and extensive library (it forms an important part of the British Library's collection today). Elizabeth's step-grandfather, the Cambridge scholar Conyers Middleton (1683–1750), may well have been librarian to the Cavendish family and it was through him that she made one of the guiding friendships of her life. Lady Margaret was seventeen and Elizabeth twelve when the two girls met. The elder encouraged the younger to write and the two formed an immediate bond, which they kept up through a vivacious and often mischievous correspondence. Their surviving letters contain salacious gossip as well as more serious discussions of their reading and visits to the theatre. Lady Margaret moved to Bulstrode, Buckinghamshire, a large estate with elegant park and gardens, on her marriage to the Duke of Portland in 1734. Here she became, like her father, a passionate collector of books, 'natural curiosities' and classical art. One of her most treasured possessions, the classical Portland vase, was loaned to the British Museum in 1810 by a descendant and has remained there ever since. Equally significant, the Duchess's herbarium, a collection of rare botanic specimens from around the world, was given to Kew Gardens on her death. Her fondness for botany brought her into contact with Joseph Banks (1743–1820), who visited her after his return from Captain Cook's first voyage to the South Pacific (1768–71). In her youth she satisfied her desire for collecting feathers and shells by asking her naval brothers to bring back specimens from their travels. Lady Margaret and Elizabeth took great pleasure in arranging shells into ornate grottoes and feathers into decorative collages.

On the reverse of the Duchess of Portland's portrait is that of Mary Delany, in a russet dress with a blue ribbon in her hair. Delany was well known in literary circles of this time as a witty correspondent and friend to the Irish poet, satirist and clergyman Jonathan Swift (1667–1745). She was a close friend of the Duchess and later in life, during her widowhood, spent all her summers at

Bulstrode, where she invented her method of cutting intricate paper collages of plants. These images, nearly a thousand of which survive in the British Museum as *Flora Delanica*, were astonishingly accomplished in their botanical accuracy and vivid design. Delany is said to have deceived the Duchess into thinking she was seeing a real geranium when she revealed her first collage.

The other cover of the box similarly contains portraits of two more of the Duchess's friends: Elizabeth Montagu and probably Mary Howard. Montagu forms the exterior image, wearing the black Tudor costume of Anne Boleyn, a queen famous for her learning and vivacity. Mary Howard is believed to be the woman depicted on the interior in profile and wearing a white dress decorated with a garland of flowers, picked up in the narrow body of the gold box, which is enamelled with white flowers and green foliage. The Duchess left the portrait box to Howard in her will, where she refers to it as 'my Snuff box with the four Enamel pictures by Zincke'.[28] The will also refers to drawings in 'cut paper' done by Howard (like Delany, she was an amateur artist).

The stories behind Zincke's miniature portraits immediately establish a sense of the multiple intersections and shared interests within networks of female friendship, providing valuable insight into a group of women who formed an important precursor to the more formal Bluestocking Circle, of which the Duchess and Delany were members. While this 'friendship' box was clearly a personal, luxury object, commissioned to commemorate the Duchess's closest female friends, it can also be seen as the private analogue to contemporary biographical anthologies that celebrated learned and virtuous women in a more public fashion. The Duchess's governess from 1739 was Elizabeth Elstob (1683–1756; see p.64), an Anglo-Saxon scholar who had published the first Anglo-Saxon grammar with scholarly apparatus in English rather than in Latin. She was also an adviser to George Ballard (1705/6–55) when he compiled his *Memoirs of Several Ladies of Great Britain Who Have Been Celebrated for Their Writings or Skill in the Learned Languages, Arts and Sciences* (1752), which he dedicated to Mary Delany, whom he called, 'the truest judge and brightest pattern of all the accomplishments which adorn her sex'.[29]

Networks of female friendship, once investigated, frequently lead to the discovery of other, related networks – family, literary, intellectual and, of course, patronage. The Duchess and Montagu were both powerful cultural patrons in their day, promoting the work of scholars, painters and writers. Montagu's role as patron was recorded as 'a distinguished example of female excellence' in James Barry's *The Distribution of Premiums to the Society of Arts*, the fifth painting in his grand series of murals, *The Progress of Human Knowledge and*

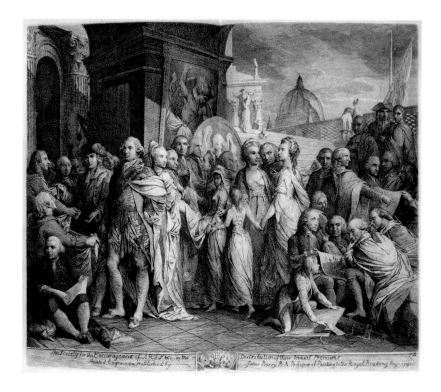

Culture, painted for the Society for the Encouragement of Arts, Manufactures
and Commerce, at his own suggestion, during 1777 and adjusted and improved
until 1801. Montagu is shown protecting and ushering forth two young girls
who are about to receive prizes for their handiwork. She had enrolled as a
member of the society in 1758. Scholars have been unable to deduce much
about the level of her involvement, although it is almost certain that she acted
as a patron.[30] An example of her own sketches in ink also survives.[31] Behind
Montagu, surrounded by duchesses of the realm, stands the 'venerable sage,
Dr. Samuel Johnson, who is pointing out this example of Mrs Montagu, as a
matter well worthy their graces most serious attention and imitation'.[32] Barry's
model of a busy and productive society ever aspiring towards progress includes
men and women – and men paying tribute to women. The Society for the
Encouragement of Arts, Manufactures and Commerce admitted women from
its foundation and bestowed premiums on female artists. Barry's painting
celebrated Montagu's benevolence as part of social progress.

By the time Barry painted Montagu, she was an independent widow and
had embarked upon building 'Montagu House' in Portman Square, Mayfair.
This opulent mansion, which took some twenty years to complete, formed an

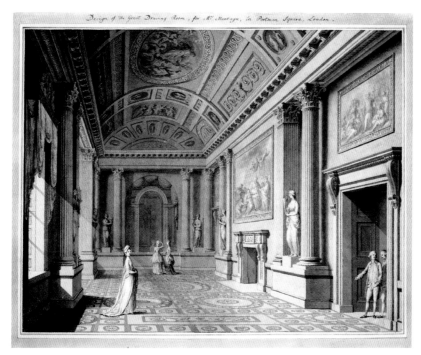

Design for the Great Drawing Room in Mrs Montagu's House, 22 Portman Square, London
Joseph Bonomi, 1782
Watercolour and wash on paper, 450 x 580mm (17¾ x 22⅞")
RIBA Library Drawings Collection: Loaned by A. de Cosson, 1972

impressive monument to bluestocking patronage. Montagu referred to it as a 'Temple of virtue and friendship' and 'a palace of chaste elegance.'[33] She oversaw the building's planning, design and interior decoration with enormous vigour and enthusiasm. Among the several artists and craftsmen she employed were the decorative painters Angelica Kauffmann (1741–1807), Giovanni Battista Cipriani (1727–85) and Biagio Rebecca (1734/5–1808). Montagu originally intended to employ as her architect James 'Athenian' Stuart (1713–88), famous for his drawings of Grecian antiquities, but his unprofessional and dilatory behaviour prompted her to replace him with Joseph Bonomi (1739–1808), whose design for Montagu's Great Drawing Room was particularly fine. This grand and semi-public space was conceived of on a monumental scale and was very different from the more intimate rooms of Montagu's Hill Street home, site of the original bluestocking meetings. The literary scholar Sir William Pepys (1740–1825) wrote to Montagu, after visiting her house, 'while I was surveying the grandeur of the Apartments, and the Exquisite Workmanship of the Ornaments, my Mind could not help dwelling upon the whole as a Monument of that judicious Charity for which you have always been so distinguished.'[34]

Unsurprisingly, Montagu's image was not always reproduced in such a positive light. She was frequently the butt of literary and visual satire,

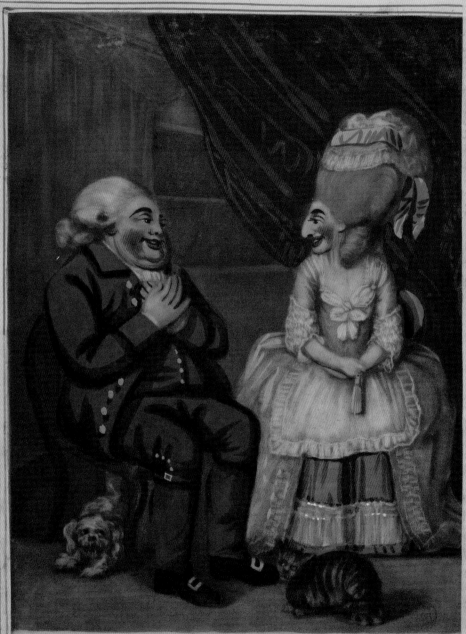

Madam your wond'rous Beauty I admire. ABELARD Madam, my Gout and Dropsy are no Crimes.
Sir, your Politeness all my thanks require? AND O Sir! they're merits in these modish times.
Madam, I love you most sincerely well ELOISA. My Person Ma'am eternally is thine?
Your Passion Sir I by my own can tell. Sir, my Charms and Fortune I to thee resign.

582 Printed for & Sold by BOWLES & CARVER, at their Map & Print Warehouse, N°.69 in S.ᵗ Pauls Church Yard, LONDON. Published as the Act directs

appearing, for example, as a hideously ugly society figure in a caricature of Abelard and Eloisa (see opposite), together with the simpering William Mason (1725–97), an aspiring clergyman-poet who had every reason to wish for favour. The title would bring to mind Pope's *Eloisa to Abelard* (1717) and Rousseau's *La Nouvelle Héloïse* (1761), both of which were inspired by the well-known medieval love story of Peter Abelard (1079–1142), a famous theologian, and Héloïse (1101–64), the erudite pupil whom he fell in love with when he was forty and she was eighteen. Montagu, of course, was not Mason's pupil and, unlike Abelard, Mason was far from being a brilliant theologian. The image was published shortly after Montagu became a widow and perhaps suggests that Mason is seeking her hand in what would have been an extraordinarily lucrative marriage. It can also be interpreted more broadly as a satirical jibe at Montagu's capacity to attract aspiring and sycophantic writers.

Montagu preferred her role as literary patron above all other social duties, describing it as a luxury to be indulged. As she wrote to the Scottish poet James Beattie (1735–1803), 'Vulgar wretchedness one relieves because it is one's duty … but to assist merit in distress is an Epicurean feast.'[35] She did not forget her business skills in the literary world, negotiating with booksellers and publishers on behalf of aspiring authors. Montagu brought Beattie's poem *The Minstrel* to the attention of an impressive network of contacts, including the statesman Lord Chatham (1708–78) and Lord Lyttelton, thus securing his reputation. She advised him on how best to advertise the poem, as appealing 'to all people of taste', and wrote to her London bookseller with instructions to recommend the work.[36] In addition to her particularly close relationship with Beattie's career, Montagu granted annuities to fellow female authors after her husband's death in 1775, including Elizabeth Carter, Hester Chapone and Sarah Fielding (1710–68). Many female authors about whom little is known today felt indebted to Montagu, who appears in several contemporary dedications as a beacon of female learning. Mrs H. Cartwright, for example, dedicated *Letters on Female Education, Addressed to a Married Lady* (1777) to her. Montagu's encouragement of women to publish work that might otherwise have remained privately circulated gave them a sense of independence and cultural authority.

Her role as patron of impoverished women writers was documented in 1785 in a contemporary ladies' magazine, under the heading 'the most fashionable dresses of this year'. The image is titled *Miss More presenting the Bristol Milkwoman to Mrs Montagu* (see p.45). The milkmaid in question was Ann Yearsley (bap.1753, d.1806), who came from a humble background, following her mother in selling milk from door to door in her home town of Bristol.

Abelard and Eloisa
Published by Bowles and Carver, *c.*1775–8
Hand-coloured mezzotint, 350 x 245mm (13¾ x 10")
The British Museum, London

Painted by Sarah Shiells Engraved by Joseph Grozer

Ann Yearsley.

The Bristol Milkwoman.

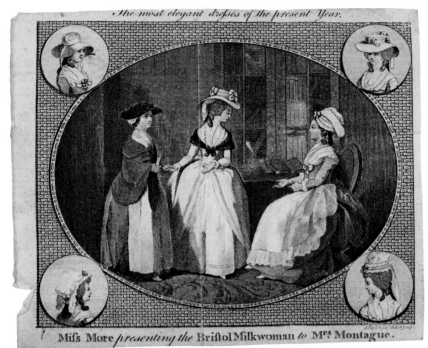

The most elegant dresses of the present Year.

Miss More *presenting the* Bristol Milkwoman *to* Mrs Montague.

Miss More presenting the Bristol Milkwoman to Mrs Montagu
J. Taylor Jnr., published 1785
Engraving, 105 x 130mm
(4⅛ x 5⅛")
Private Collection

Ann Yearsley, bap.1753, d.1806
Joseph Grozer after Sarah Shiells, 1787
Mezzotint, 447 x 332mm
(17⅝ x 13⅛")
National Portrait Gallery, London (NPG D4452)

Hannah More learned about Yearsley's talent as a poet through her cook, from whom Yearsley was in the habit of collecting pigswill. As More reported to Montagu in August 1784, 'tho' she never allowed herself to look into a book till her work was done and her children asleep, yet in those moments she found that reading and writing cou'd allay hunger and subdue calamity'.[37] Both More and Montagu were attracted by the idea of bringing her genius to public attention through their role as patrons. Montagu expressed her enthusiasm for Yearsley's poetry in glowing terms: 'Indeed she is one of nature's miracles. What force of imagination! What harmony of numbers! In Pagan Times one could have supposed Apollo had fallen in love with her rosy cheek, snatched her to the top of Mt. Parnassus, given her a glass of the best Helicon, and ordered the nine muses to attend her call.'[38] With Montagu's help, More organized the publication of Yearsley's poems by subscription. By June 1785, when her *Poems, on Several Occasions* was published, over 1,000 subscribers had been found, including several members of the aristocracy and a number of bishops, as well as Sir Joshua Reynolds, the poet Anna Seward (see p.46), Fanny Burney, Horace Walpole, Frances Boscawen and several prominent bluestockings.

Yearsley was grateful to her patrons at first and paid tribute to Montagu in a poem addressed to her. Montagu is painted as an inspiring force, a 'bright

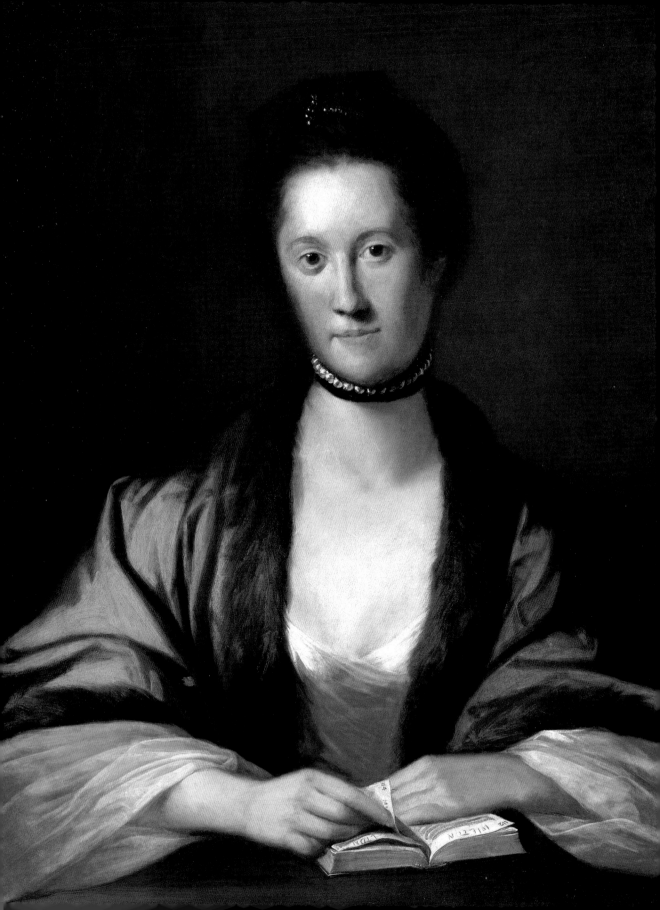

Moralist' who has opened 'the glories of the mental world', rescuing the poet's 'innate spark which lay immersed, Thick-clogged, and almost quenched in total night'.[39] Yearsley's forceful poetic style was influenced by her early readings of Milton and Edward Young and has an original energy. However, the phenomenal success of her work caused her patrons anxiety rather than pleasure – they were unwilling to see Yearsley raised above her station and expressed fear that she might not be able to manage her celebrity as an author. The episode ended in scandal when Yearsley accused More of defrauding her by retaining control of the profits gained from her literary success. Montagu advised More to renounce all interest in the case as soon as the story appeared in the press.

After the very public break from her patrons, Yearsley continued to publish, encouraged by favourable reactions to her poetic boldness. The intriguing mezzotint of Yearsley, after a painting by the untraced artist Sarah Shiells, depicts the poet in confident, even defiant pose (see p.44). She looks up from her writing with a knowing stare, as if aware that she confounds contemporary assumptions and proud of the fact. By 1793 she had opened a circulating library in Bristol. Her last collection of verse, *The Rural Lyre*, published in 1796, contained a frontispiece by her son, whom she had apprenticed to an engraver in 1790. Montagu and More had been wrong to doubt Yearsley's ability to manage her success without neglecting her family responsibilities. Rather, the episode reveals Montagu's need to exercise control, suggesting that her attitude to social station remained rigid in certain important respects.

Bluestocking 'Philosophy' and the Enlightenment

Through friendship and patronage, bluestocking women formed their own distinctive intellectual networks, or 'circles' of learning, as a means of overcoming some of the prejudices and constraints they experienced. Salon culture could propel women into the public sphere of print, though here they were often remarked upon for their achievement as women above all else. Bluestocking achievement inevitably raised important questions about women's relationship to mainstream culture. On the one hand, women felt excluded from their culture and yet, on the other, they felt compelled to contribute to its future definition. Against this background, it is interesting to explore the bluestockings' contribution and response to the major literary and intellectual developments taking place, particularly in France, from the middle of the eighteenth century.

The frontispiece to Eliza Haywood's *Female Spectator* (see p.48), a periodical launched in 1744, suggests something of a female 'republic of letters', a phrase often used to describe an imaginary space in which like-minded individuals

Anna Seward, 1742–1809
Tilly Kettle, 1762
Oil on canvas, 737 x 622mm
(29 x 24½")
National Portrait Gallery,
London (NPG 2017)

Anna Seward, known as the 'Swan of Lichfield', remained in Lichfield all her life, unlike her fellow townsfolk Samuel Johnson and David Garrick, who sought fame in London. Her provincial salon was frequented by several important members of the Midlands Enlightenment, including Erasmus Darwin, whose *Memoirs* she wrote. Tilly Kettle has depicted Seward reading Milton, her favourite poet.

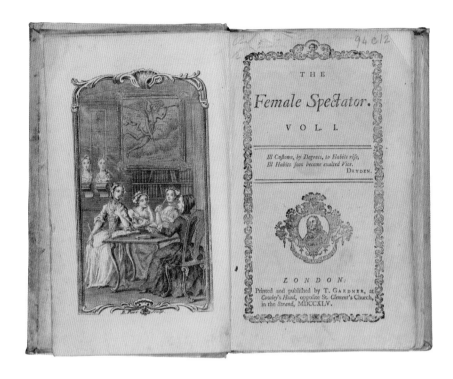

could exchange thoughts in what has been termed the Age of Reason or the Enlightenment. It depicts a group of intelligent women in discussion around a table, equally at ease with the books all about them and with the fans they hold, which seem to be used as an expressive extension of conversation rather than as mere fashion accessories. The women are seated in a library that includes an impressive array of books and two portrait busts, one of the French scholar Madame Dacier (1654–1720), whose prose translation of the *Iliad* and *Odyssey* introduced Homer to many French readers for the first time, and the other of the Greek female poet Sappho (sixth century BC). Haywood's periodical covered a wide range of topics, including politics, science, fashion, literary criticism and social analysis (especially of courtship and marriage), and conjured up a group of intelligent, engaged women as contributors, readers and discussants. Her work formed a model for future female editors, such as novelist Charlotte Lennox (1730/1?–1804), who advocated the study of history and natural philosophy as suitable pursuits in her essay 'Of the Studies Proper to Women', concluding that 'the arts are in themselves too amiable to need any recommendation to the sex: all the objects they offer to their view have some analogy with women, and are like them adorned with the brightest colours'.[40] The learned female was still less of a threat if she could be admired almost

like a work of art rather than seen as the overt practitioner or connoisseur of art.

While few French Enlightenment philosophers accorded women rational or political equality, certain key figures of the Scottish Enlightenment assigned them a central role in the rise of civil society. Philosopher and historian David Hume (1711–76) observed in the 1740s, 'the more the refined arts advance, the more sociable men become'. He emphasized that 'Particular clubs and societies are everywhere formed' where 'both sexes meet in an easy and sociable manner'.[41] Hume included men and women in his vision of progress, but he believed that women possessed a particular gift for conversation that allowed them to take the lead. He argued, in 'Of Essay-Writing', that women presided over the 'conversable world' because of their ability to 'join to a sociable disposition, and a taste for pleasure, an inclination of the easier and more gentle exercises of the understanding, for obvious reflections on human affairs, and the duties of common life, and for observations of the blemishes or perfections of the particular objects that surround them'.[42] Here Hume anticipated the way the bluestockings valued social duty and perceived a strong link between virtue and self-improvement. There is a sense in which women were held to 'civilize' their male contemporaries, their conversation having a 'polishing' effect upon the naturally rough terrain of masculinity. Hume realized that women needed to be educated better if they were to fulfil such a role. He disapproved of the lack of proper education for women and the reigning prejudice against the public display of female learning, asserting:

> Women, that is, women of sense and education (for to such alone I address myself) are much better judges of all polite writing than men of the same degree of understanding; and that it is a vain panic, if they be so terrified with the common ridicule that is levelled against learned ladies, as utterly to abandon every kind of books and study to our sex.[43]

Hume wanted to persuade his 'fair readers' to discount contemporary prejudice and 'common ridicule' against learned ladies, and to encourage them to believe that a union between the scholarly and sociable, the masculine and feminine, was not only possible but also necessary for a reformed 'republic of letters'.

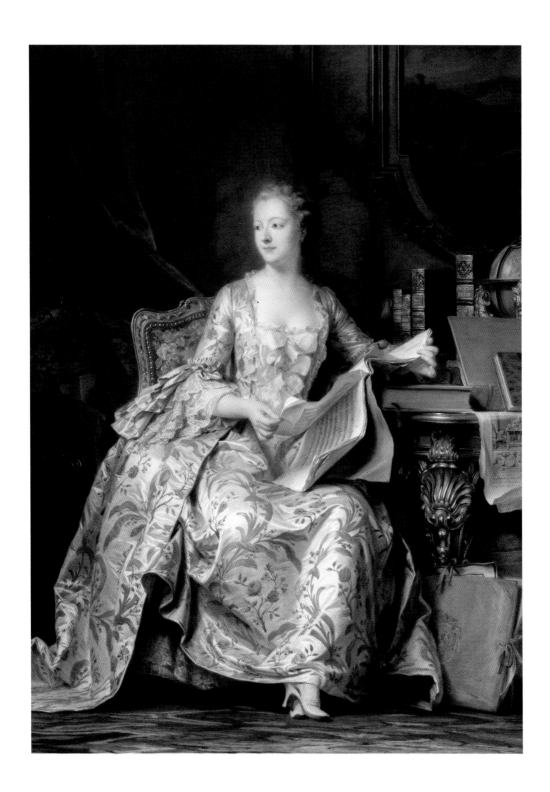

Allan Ramsay's remarkable portrait of Montagu from 1762 depicts the perfect embodiment of ease, elegance and learning (see p.49). Her sparkling black eyes and raised eyebrows lend spirit to a calm and dignified pose. She gazes out of the frame, not directly at the viewer but somewhere to her right, as if looking through a window, or simply lost in reverie. Her exquisite gown, in rose-pink silk with a frothy complexity of lace embellishments, conveys her sophistication and social status. The painting is not ostentatious, however, but rather full of quiet grace. Ramsay was at the peak of his professional career when he painted Montagu, having secured valuable royal patronage from George III, for whom he painted the official coronation portrait in 1760. He was a fashionable and expensive artist, in high demand among the aristocracy, especially as he had spent a great deal of time on the Continent. His painting of Montagu is reminiscent of the French tradition, including Jean-Marc Nattier's several portraits of French *salonnières* or Maurice Quentin de La Tour's Madame de Pompadour (see p.51), in which the royal mistress is posed in front of a desk that bears a careful arrangement of books, including the latest volume of d'Alembert and Diderot's *Encyclopédie*, epitomizing the sceptical, rational and scientific spirit of the Enlightenment. Bluestocking hostesses shared the principles of rational exchange and polite sociability with French *salonnières* such as Julie de Lespinasse (1732–76), Suzanne Necker (1739–94; see p.85), the mother of Germaine de Staël (1766–1817; see p.86), and Marie-Thérèse Geoffrin (1699–1777). Montagu visited Paris in 1776 and was struck by the sophistication and glamour of the French salons, writing 'I have not spent a dull or insipid hour in company since I came to Paris.'[44] Ramsay, like his French contemporaries, allows his female sitter to radiate a contemporary intelligence – the third volume of Hume's *History of England*, on which Montagu rests her elbow, was published only the year before. This intimate yet stunning portrait, commissioned by Montagu, connects her with both the Scottish Enlightenment and the French tradition of salon culture, in which women played a central role in the nation's philosophical and cultural life.

The bluestockings created new spaces for the pursuit of learning and their influence can be detected in the work of women writing at the end of the century. The novelty of this phenomenon, the sense in which a full literary life was freshly available to women, can be sensed in the following passage taken from novelist and educationalist Maria Edgeworth's *Letters for Literary Ladies*, published in 1795, in which Edgeworth is defending women's right to literature:

Considering that the pen was to women a new instrument, I think they have made at least as good a use of it as learned men did of the needle some

centuries ago, when they set themselves to determine how many spirits could stand upon its point, and were ready to tear one another to pieces in the discussion of this sublime question. Let the sexes mutually forgive each other their follies; or, what is much better, let them combine their talents for their general advantage.[45]

As long as the spectre of learning in a female appeared to be threatening or remarkable, women were inevitably expected to justify their intellectual pursuits and their identity as authors. Edgeworth's witty turning of the tables illustrates the sense in which men needed to be educated to listen to women's arguments, be they in letters, conversation or published writings. Writing, like the active sphere of benevolence and virtue advocated by bluestocking friendship and patronage, gave women a role in public life. As their writings became recognized and celebrated, the question of their agency in other spheres was inevitably raised, as was the nature of their rights, which Mary Wollstonecraft (see p.109) so famously addressed. Her *Vindication of the Rights of Woman* (1792) called for reforms in female and male virtue, seeing mutual chastity as vital to the progress of equal rights. She perceived a direct connection between private and public virtue, arguing that manners must change if reason and morality were to triumph. By strengthening the association of reason and virtue in women's minds, the bluestockings, while not fully political in intent, formed an important precursor to Wollstonecraft's more radical arguments.

Chapter Notes

1 Hannah More, *Florio: A Tale, For Fine Gentlemen and Fine Ladies: and, The Bas Bleu; or, Conversation: Two Poems* (London, 1786), p.70.

2 Ibid., p.70.

3 Frances Burney, *Memoirs of Doctor Burney: Arranged from his own Manuscripts, from Family Papers, and from Personal Recollections, by his Daughter, Madame d'Arblay* (London, 1832), p.276.

4 Hannah More, *Florio … The Bas Bleu*, pp.82–3.

5 Letter from Elizabeth Montagu to Sarah Scott, 26 December 1767, MO 5871, Huntington Library, San Marino, CA.

6 Emily J. Climenson, *Elizabeth Montagu, the Queen of the Bluestockings: Her Correspondence from 1720 to 1761*, 2 vols. (London, 1906), Vol.II, p.20.

7 Ibid., p.20.

8 Charlotte Barrett and Austin Dobson (eds.), *The Diary and Letters of Madame D'Arblay*, 6 vols. (London, 1904), Vol.I, pp.460–61.

9 Alice C.C. Gaussen (ed.), *A Later Pepys: The Correspondence of Sir William Weller Pepys, Bart., Master in Chancery 1758–1825*, 2 vols. (London, 1904), p.47.

10 Hannah More, *Selected Writings*, ed. Robert Hole (London, 1996), pp.5–6.

11 James Boswell, *The Life of Samuel Johnson, LL.D., Comprehending an Account of His Studies and Numerous Works, … In Three Volumes, The Second Edition Revised and Augmented*, 3 vols. (London, 1793), Vol.III, p.562.

12 Letter from Elizabeth Montagu to Matthew Robinson (father), 10 September 1769, MO 4767, Huntington Library, San Marino, CA. The letter is also published in Elizabeth Eger (ed.), *Elizabeth Montagu*, Vol.I of *Bluestocking Feminism: Writings of the Bluestocking Circle, 1738–1785*, gen. ed. Gary Kelly, 6 vols. (London, 1999), pp.185–6.

13 Ibid.

14 See Kelly (ed.), *Bluestocking Feminism: Writings of the Bluestocking Circle, 1738–1785*, Vol.I, 'General Introduction', p.x.

15 Letter from Elizabeth Montagu to George Lyttelton, 1st Baron Lyttelton of Frankley, 22 November 1763, MO 1428, Huntington Library, San Marino, CA.

16 Letter from Elizabeth Montagu to George Lyttelton, 1st Baron Lyttelton of Frankley, 21 October 1760, MO 1403, Huntington Library, San Marino, CA.

17 *The Works of Anna Letitia Barbauld. With a Memoir. By Lucy Aikin*, 2 vols. (London, 1825), Vol.I, pp.xvii–xviii. The letter appears to be from 1774, as Lucy Aikin dates it from just before Barbauld's move to Palgrave, Suffolk, where she assumed co-management, with her husband, of Palgrave School for Boys.

18 Montagu Pennington (ed.), *Letters from Mrs. Elizabeth Carter, to Mrs. Montagu, Between the Years 1755 and 1800. Chiefly Upon Literary and Moral Subjects*, 3 vols. (London, 1817), Vol.III, p.68.

19 Letter from Elizabeth Montagu to Elizabeth Carter, 9 September 1766, MO 3183, Huntington Library, San Marino, CA.

20 John Gregory, *A Father's Legacy to his Daughters, by the late Dr John Gregory of Edinburgh* (London, 1774), p.31. For an excellent discussion of conduct literature, see Jennie Batchelor, University of Kent, 'Conduct Books', 9 July 2004, *The Literary Encyclopedia* (The Literary Dictionary Company, http://litencyc.com/php/stopics.php?rec=true&UID=216).

21 Samuel Richardson, *Letters written to and for Particular Friends, on the most Important Occasions. Directing not only the requisite style and forms to be observed in writing familiar letters; but how to think and act justly and prudently, in the common concerns of human life* (London, 1741), title page.

[22] Samuel Richardson, *Pamela: or, Virtue Rewarded. In a Series of Familiar Letters from a Beautiful Young Damsel to her Parents*, 2 vols. (4th edition, London, 1741), Vol.I, p.4; Vol.II, p.258; Vol.I, p.iii.

[23] Mary Wollstonecraft, *A Vindication of the Rights of Men* and *A Vindication of the Rights of Woman*, ed. Sylvana Tomaselli (Cambridge, 1995), pp.187–8.

[24] Hester Chapone, *Letters on the Improvement of the Mind, Addressed to a Young Lady. In Two Volumes. By Mrs. Chapone*, 2 vols. (London, 1773), Vol.II, p.125.

[25] Ibid., pp.121 and 125, and Letter 8, 'On Politeness and Accomplishments'.

[26] Mary Wollstonecraft, *A Short Residence in Sweden, Norway and Denmark* (London, 1796), Letter 6, p.66.

[27] See Marcia Pointon, '"Surrounded with Brilliants": Miniature Portraits in Eighteenth-Century England', *Art Bulletin*, Vol.LXXXIII, No.1, March 2001, pp.48–71, p.63.

[28] I am grateful to Clare Barlow for this information.

[29] See George Ballard, *Memoirs of Several Ladies of Great Britain Who Have Been Celebrated for Their Writing or Skill in the Learned Languages, Arts and Sciences* (1752), p.241. Ballard dedicates the section of his study that covers women of the seventeeth and eighteenth centuries to Delany.

[30] See Charlotte Grant, 'The Choice of Hercules: The Polite Arts and "Female Excellence" in Eighteenth-Century London', in *Women Writing and the Public Sphere, 1700–1830*, eds. Elizabeth Eger, Charlotte Grant, Clíona Ó'Gallchoir and Penny Warburton (Cambridge, 2001), pp.75–103.

[31] In a private collection.

[32] James Barry, *An Account of a series of Pictures, in the Great Room of the Society of Arts, Manufactures, and Commerce, at the Adelphi* (London, 1783), p.74.

[33] Letter from Elizabeth Montagu to Leonard Smelt, 22 July 1778, MO 5019, Huntington Library, San Marino, CA. For accounts of Montagu's role as architectural patron, see Kerry Bristol, '22 Portman Square: Mrs Montagu and her "Palais de la Vieillesse"', *British Art Journal*, Vol.II, No.3, 2001, pp.72–85; and Rosemary Baird, *Mistress of the House: Great Ladies and Grand Houses 1670–1830* (London, 2003). See also Elizabeth Eger 'Luxury, Industry and Charity: Bluestocking Culture Displayed', in *Luxury in the Eighteenth Century: Debates, Desires and Delectable Goods*, eds. Maxine Berg and Elizabeth Eger (Basingstoke, 2003), pp.190–206.

[34] Letter from Sir William Pepys to Elizabeth Montagu, 4 August 1781, MO 3513, Huntington Library, San Marino, CA.

[35] See Sir William Forbes, *An Account of the Life and Writings of James Beattie*, 2 vols. (Edinburgh, 1806), Vol.II, pp.159–60.

[36] See Chauncey Brewster Tinker, *The Salon and English Letters: Chapters on the Interrelations of Literature and Society in the Age of Johnson* (New York, 1915), pp.189–99.

[37] Roger Lonsdale, *Eighteenth Century Women Poets: An Oxford Anthology* (Oxford, 1989), p.392.

[38] Tinker, *The Salon and English Letters*, p.205.

[39] Ann Yearsley, 'On Mrs. Montagu', in Lonsdale, *Eighteenth Century Women Poets*, pp.395–6.

[40] Charlotte Lennox, *The Lady's Museum*, 2 vols. (London, 1760), Vol.I, pp.14–61.

[41] David Hume, *Essays, Moral, Political and Literary* (Oxford, 1963), p.278.

[42] Ibid., p.568.

[43] Ibid., p.570.

[44] Letter from Elizabeth Montagu to Leonard Smelt, August 1776, MO 5010, Huntington Library, San Marino, CA.

[45] Maria Edgeworth, *Letters for Literary Ladies*, ed. Claire Connolly (London, 1993), p.25.

Living Muses
Constructing and Celebrating the Professional Woman in Literature and the Arts
LUCY PELTZ

To Greece no more the tuneful maids belong,
Nor the high honours of immortal song;
To MORE, BROOKS, LENOX, AIKIN, CARTER, due,
To GREVILLE, GRIFFITH, WHEATLEY, MONTAGU!
Theirs the strong genius, theirs the voice divine;
And favouring Phoebus owns the British NINE.[1]

Portraits in the Characters of the Muses in the Temple of Apollo (The Nine Living Muses of Great Britain) (detail)
Richard Samuel, 1778
Oil on canvas, 1321 x 1549mm (52 x 61")
National Portrait Gallery, London (NPG 4905)

This light-hearted verse appeared in a review of Hannah More's drama *The Inflexible Captive* (1774). The reviewer celebrates the 'strong genius' of nine female writers of the eighteenth century by representing them as modern British equivalents to the nine Muses of antiquity. The Muses and other figures of classical mythology had, of course, enjoyed a constant presence in western literature and art since the Renaissance. While Chambers's *Cyclopaedia* of 1728 defined the Muses as 'fabulous divinities of the ancient heathens, who were supposed to preside over the arts and sciences … and to inspire and assist the poets', in art and literature they had often been interpreted as passive inspirations to male creativity.[2] But – as the panegyric above proclaims – the mood was changing and Britain now had its own active Muses, blessed for their artistic creativity by Phoebus (Apollo), the presiding deity of the arts. These new Muses were a means through which Britain could celebrate the special contribution that women made to the social and cultural progress and economic well-being of the nation.

Antiquity was omnipresent in the minds of those of liberal education, status and taste. With a monarchy limited by Parliament, a free press and a growing empire, Britain considered herself the heir to the freedoms of the Roman Republic; as Voltaire caustically remarked, 'The members of the English Parliament are fond of comparing themselves to the old Romans.'[3] Generations of upper-class boys (although rarely girls) were taught civic virtue reading Homer, Cicero and Plutarch, where the heroes and gods 'reminded Britain's elite of its duty to serve and fight, but in addition, affirmed its superior qualification to do both'.[4] As the classical past appeared to provide both precedent and justification for contemporary behaviour, it was also taken as an

The Nine Muses and Apollo
Josiah Wedgwood, c.1778–80
Blue jasper plaque,
155 x 640mm (6⅛ x 25¼")
National Museums Liverpool,
Lady Lever Art Gallery

inspiration for artists. Some, however, such as Sir Joshua Reynolds, President of the Royal Academy of Arts, believed that to produce great art the artist had to transcend 'servile copying' and 'enter into a competition with his original, and endeavour to improve what he is appropriating to his own work. Such imitation … is a perpetual exercise of the mind, a continual invention.'[5]

A Moment for Muses

No one more responded to this call for 'continual invention' than the entrepreneur and industrialist Josiah Wedgwood (1730–95). Exploiting the new fashion for all things classical, Wedgwood began in the 1760s to pioneer 'ornamental wares' in the 'antique style'. Drawing on acclaimed classical prototypes and working with newly invented industrial materials, he manufactured a series of ceramics that catered to and shaped polite taste.

One indicative piece showing the growing taste for the Muses was the tablet that depicts the nine sister goddesses with Apollo. Wedgwood had been keen to commission designs for the Muses as early as 1775. Writing to his business partner Thomas Bentley in 1777, he describes how he had 'laid all our bass-relief Goddesses and ladies upon their backs on a board before me in order to contemplate their beauties … I instantly perceived that the six muses we want might be produced from this lovely group.'[6] Drawing on these models, Wedgwood produced large Jasper tablets decorated with the Muses in the late 1770s and vases with equivalent designs in the 1780s and 1790s. The inspiration for the iconography was probably the Roman poet Ausonius, whose works were in Wedgwood's library.[7] His *Twentieth Idyll* details that:

> Clio sings the history of times past.
> Melpomene tells a sad tale with a tragic air.
> Thalia light-heartedly performs comedy.
> Euterpe plays a flute in sweet tones.
> Terpsichore stirs and rouses the emotions with her lyre.

Erato strums her lyre and dances.
Calliope tells of heroic deeds from her book.
Urania studies the motion of heaven and the stars.
Polyhymnia communicates with her hand, speaking with gesture.

Wedgwood's library also provided advice on how to use such figures for interior decoration. Thus, following Joseph Spence's *Polymetis* (1747), Wedgwood encouraged one aristocratic client to take a tablet 'with the Muses for a frieze' as decoration for his library chimneypiece.[8] The library setting for the Muses highlights their connection, in the eighteenth-century mind, with literature in general and poetry in particular. This is underlined by Wedgwood's frequent pairing of *The Nine Muses and Apollo* with another, *The Apotheosis of Homer*. In short, the Muses and poetry belonged together.

The Nine Living Muses of Great Britain

Although the Muses were perceived by many to be passive handmaidens to male inspiration, Chambers's *Cyclopaedia* of 1728 asserted that Plato allowed them a vital and active role as practitioners of the arts. That female creative genius should be vaunted publicly was argued by Wetenhall Wilkes in *An Essay on the Pleasures and Advantages of Female Literature* (1741). Since 'Women as well as Men have intelligent Souls, why,' he asked rhetorically, 'should they be debarr'd from the Improvement of them? If it were intended by Nature, that Man should Monopolize all Learning to himself, why were the Muses Female who … were the Mistresses of all the Sciences, and the Presidents of Music and Poetry?'[9] Against a tyranny of male castigation, he and John Duncombe, the author of *The Feminiad* (1754), praised Britain's literary women both individually and collectively as Muses:

Shall lordly man, the theme of ev'ry lay,
Usurp the muse's tributary bay,
In kingly state on *Pindus*' summit sit,
Tyrant of verse, and arbiter of wit?
…
Justice forbid! and every muse inspire
To sing the glories of a sister-quire [choir]![10]

These honorific texts react to the prevailing climate in which female participation in the arts provoked responses ranging from ambivalence to

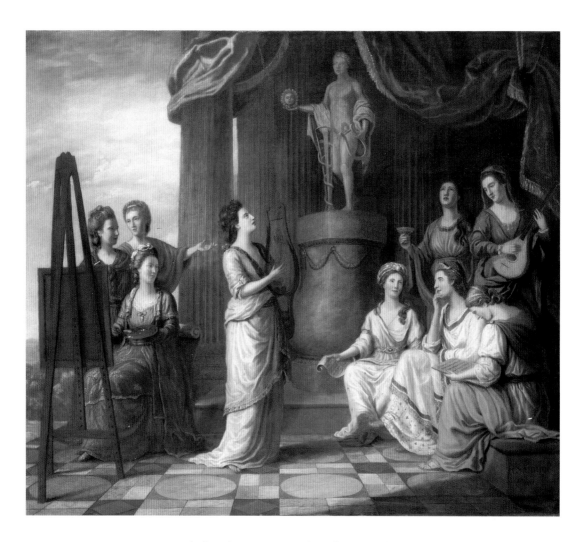

Portraits in the Characters of the Muses in the Temple of Apollo (The Nine Living Muses of Great Britain)
Richard Samuel, 1778
Oil on canvas, 1321 x 1549mm (52 x 61")
National Portrait Gallery, London (NPG 4905)

outright hostility. Women seeking fame and fortune were often condemned, while those who put domestic and family concerns first were held up as exemplary. By adopting the nine Muses as a framework, Wilkes and Duncombe defended female creativity and envisaged a world where women's genius might be nurtured, fulfilled and promoted for their contribution to the rising power and cultural prowess of Britain in the mid-eighteenth century.

The achievement of Britain's creative women was triumphantly celebrated by Richard Samuel in a painting displayed at the Royal Academy exhibition of 1779.[11] Samuel's unusual painting portrays nine contemporary creative women dressed in vaguely classical garb. They are assembled in a temple of Apollo, under a monumental sculpture of the god, as if members of a new

pantheon of arts and letters. In choosing this allegorical and classicizing approach to his subject, Samuel shows his debt to Sir Joshua Reynolds's influential *Discourses* on art, which were delivered to the Royal Academy at first annually and then biennially after 1772. In both theory and practice, Reynolds advocated the propriety of representing women in classical dress, poses and settings, as exemplified by his portrait of *Lady Sarah Bunbury Sacrificing to the Graces* (1766). Modern women dressed in classical robes and engaged in ancient rituals augmented the fantasy of the continuity between classical civilization and the present. Thus Reynolds advised that the 'antique air' added a timeless dignity which ennobled the sitter and, at the same time, allowed a portrait painter to aspire beyond the limitations of modern fashion and particular likeness.[12] In his discourse of 1776, Reynolds therefore opined that by combining portraiture with allegory and thus achieving a 'greater variety of ideal beauty, a richer, a more various and delightful composition … such a picture not only attracts, but fixes the attention'.[13]

The portraits in Samuel's composition are highly idealized, as befits a work inspired by Reynolds's most recent lectures. It is no surprise, then, that Elizabeth Carter complained, 'by the mere testimony of my eyes, I cannot very exactly tell which is you, and which is I, and which is anybody else'.[14] The women depicted here were between the ages of twenty-three and sixty, and there is no evidence that they ever met as a group. Samuel did not take sittings for the work and produced the painting speculatively in an attempt to advance his career as a 'Portrait and History Painter' – a rank he later claimed in his *Remarks on the Utility of Drawing and Painting* (1786). Ironically, the painting – which went unremarked at the exhibition in 1779 – was less successful than the popular print on which it was based. Prepared two years earlier, in 1777, the print is inscribed with names that identify the subjects and as such acts as a guide to those women included in the painting (see p.62). On our left in the painting are Elizabeth Carter, translator of the classics and poet, Anna Letitia Barbauld, poet and writer, and Angelica Kauffmann, the artist, who, seated at her easel, may be intended as Urania, Muse of Astronomy and thus universal vision. In the centre is Elizabeth Sheridan (1754–92), the singer, posed with a lyre as Erato, Muse of Love Poetry. On our right are Charlotte Lennox, novelist and poet, Hannah More, the playwright, Elizabeth Montagu, literary critic, Elizabeth Griffith (1727–93), novelist and playwright, and Catharine Macaulay (1731–91), the historian – who appears to be the figure seated with a writing tablet as Clio, Muse of History. Samuel did not care to represent each Muse with iconographic exactitude, any more than he

Lady Sarah Bunbury Sacrificing to the Graces
Edward Fisher after
Sir Joshua Reynolds, 1766
Mezzotint, 595 x 368mm
(23 ⅜ x 14 ½")
The British Museum, London

For viewers familiar with the sitters in a portrait, allegory might be reduced from its lofty status to playful game or ribald irony. This is clear in the bluestocking Hester Thrale's comment that Bunbury 'never did sacrifice to the Graces ... but used to play cricket and eat beefsteaks on the Steyne at Brighton.'

Samuel delin. Page Sculp.

The NINE LIVING MUSES of GREAT BRITAIN.

Miſs Carter, M.ʳˢ Barbauld, M.ʳˢ Angelica Kauffman, on the Right hand; M.ʳˢ Sheridan, in the Middle;
M.ʳˢ Lenox, M.ʳˢ Macaulay, Miſs More, M.ʳˢ Montague, and M.ʳˢ Griffith, on the Left hand.

The Nine Living Muses of
Great Britain
Page after Richard Samuel,
published November 1777
Etching with some engraving,
109 x 140mm (4¼ x 5½")
The British Museum, London

studied their likeness. What interested him – and what departed from the
usual selection of literary Muses – was the introduction of new artistic
professions such as painting and singing. Moreover, all the women presented,
except for Montagu, were professionals who earned a living from their work.
By including Apollo but placing him in the shadows, Samuel's intention was
to relegate the god and therefore prioritize the Muses – and so celebrate the
achievements of the professional creative women of the day. This point is
underlined by the print's title: *The Nine Living Muses of Great Britain*.

Commissioned by the publisher Joseph Johnson and energetically promoted
as a 'capital' and 'masterly' engraving, the print became the main attraction
in the *Ladies New and Polite Pocket Memorandum-Book for 1778*.[15] The most
telling reaction came from Elizabeth Montagu, who reported to her friend
Elizabeth Carter:

A Lady in the newest full Dress and another in the most fashionable Undress and ***The Nine Living Muses of Great Britain***
Etching with some engraving in *The Ladies New and Polite Pocket Memorandum-Book*, 1778
Folger Shakespeare Library, Washington, DC

Pocket books issued especially for women appeared in large quantities in late eighteenth-century Britain. They were small leather-covered books, which served principally as diaries. They often included decorative prints of the latest fashions and celebrities, as well as poems, songs and puzzles.

Pray do you know, that Mr Johnson, the editor of a most useful pocket book, has done my head the honour to putt it into a print with yours, & seven other celebrated heads, & to call us the nine Muses. He also says some very handsome things, & it is charming to think how our praises will ride about the World in every bodies pocket … I do not see how we could become more universally celebrated. We might have lived in an age in which we should never have had ye pleasure of seeing our features … in Pocket books, Magazines … literary & monthly reviews, Annual Registers, &c &c &c … I think it extraordinary felicity even to enjoy a little brief celebrity, & contracted fame.[16]

A long-time advocate of the female 'right to literature' and education, Montagu was enthused at the idea of belonging to an age in which the status of creative women was in the ascendant. This status stemmed from the belief, promoted particularly by Scottish Enlightenment thinkers, that women could make a vital contribution to the refinement of a commercial nation, both as consumers and as producers.

What Montagu did not mention was the juxtaposition of Samuel's print in the *Ladies New and Polite Pocket Memorandum-Book* with a fashion plate showing women in the latest dresses. This brought the 'Living Muses' down from their heavenly pinnacle and put them on a contemporary stage, thereby encouraging modern women to identify with them. The importance of contemporary women and their collective contribution to the cultural and economic vitality of the nation was also asserted in Samuel's print by Apollo crowning Britannia – and thus by extension all British women. The ultimate

patriotic allegory, Britannia had come to represent the country's confidence and trading prowess following the victories of the Seven Years War (1756–63). The wide currency of Britannia is seen in many examples, a notable case being J.F. Moore's *Britannia, Reviver of Antique and Promoter of Modern Arts*, a prize-winning bas-relief presented to the Society for the Encouragement of Arts, Manufactures and Commerce in 1766.[17] The society – of which Samuel was an active member – was founded to promote the arts and sciences through awards for inventions and artistic excellence. Both it and his bas-relief sculpture embodied the view, rehearsed by Samuel in his *Remarks on the Utility of Drawing*, that 'a just taste in the fine arts, derived from rational principles, is a fine preparation for acting in the social state with dignity and propriety'.[18]

Creating a Canon of 'Female Worthies'

Samuel's *Nine Living Muses of Great Britain* is a patriotic group portrait that brought together living and creative British women under Britannia's watchful gaze. Although his vision of a pantheon of creative women was an innovation, the idea had literary precedents. In the 1750s the first of a number of biographical anthologies was published that detailed the lives of eminent women from the past. In these books women were praised for their 'genius, learning, piety, virtue, or some peculiar excellencies, which rendered … [them] eminent'.[19] The purpose of such publications was to hold up women's collective intellectual and artistic ability as a mark of Britain's civilized status and thereby construct a tradition of female achievement.

The first collective biography of women was George Ballard's *Memoirs of Several Ladies of Great Britain Who Have Been Celebrated for Their Writings or Skill in the Learned Languages, Arts and Sciences* (1752). A mantua-maker turned antiquarian, Ballard wanted to 'preserve from oblivion' the fame of learned women from the past.[20] His book included sixty-four biographies, beginning with the fourteenth-century nun Juliana 'Anchoret of Norwich' and ending with Constantia Grierson, an Irish classical scholar who had died in 1733. But Ballard's policy of including only women with unblemished reputations indicates that learning had to be mediated by virtue in order to satisfy the construction of ideal femininity. And in order to develop and increase a national canon of female literature, Ballard claimed any female writer with a link to Britain, however tenuous.[21]

Ballard's work built on an earlier attempt at a collective female biography by Elizabeth Elstob, a pioneer Anglo-Saxon scholar who had fallen on hard times. Having suffered from social disdain for her learning, she wrote to Ballard

A Biographical Dictionary of the Celebrated Women of Every Age and Country by Matilda Betham, 1804
The British Library

Author Matilda Betham (1776–1852) was a self-taught miniature painter with a love of history, who sought to earn a living from her wide historical reading. Her *Biographical Dictionary of the Celebrated Women*, though anecdotal and unsystematic, was a late contribution to the campaign to improve women's status.

bitterly, 'I am sorry to have to tell you the choice you have made for the Honour of the Females was the wrongest subject you could pitch upon. For you can come into no company of Ladies and Gentlemen, where you shall not hear an open and vehement exclamation against Learned Women.'[22] Despite Elstob's reservations, however, the genre thrived in a variety of forms, with some twenty similar publications appearing in the next fifty years. A late example is Matilda Betham's *A Biographical Dictionary of the Celebrated Women of Every Age and Country* (1804). The encyclopedic ambition of this publication is revealed by the frontispiece, which depicts Lady Jane Grey, Lady Rachel Russell, Mary Queen of Scots, Joan of Arc and Madame de Sévigné. The point of this and other compilations was to bring the lives of a great many learned and gifted women from the past to public attention and thereby boost the position of the modern woman of genius.[23]

Illustrious and Illustrated Moderns
The increasing celebration of Britain's learned ladies was soon articulated in a variety of materials. Wedgwood began a series of Jasper medallions in 1773 under the title 'Heads of Illustrious Moderns, from CHAUCER to the present Time'. This included portraits of Elizabeth Montagu and Anna Letitia Barbauld (see p.66).

The production of comparatively cheap portrait multiples in ceramic
was – as with all Wedgwood's undertakings – based on a keen commercial
understanding of the market. In his sales catalogue, reproductions of ancient
gems and cameos were listed alongside 'Grecian Statesmen, Philosophers, Poets,
&c'; 'Illustrious Romans', 'Popes' and 'Cesars'.[24] This inclusion of 'Illustrious
Moderns' in his stock was a deliberate attempt to match figures from antiquity
with contemporary counterparts. The majority of the portraits were not original
but adapted from existing medals or prototypes in other media. In the case of
Montagu and Barbauld, however, new portrait heads were created, although
these were never intended as a pair. Wedgwood's comment that he would
'take Mrs Montagu in hand' indicates that this was under way as early as June
1775.[25] And by July his first dispatch of '4 or 6 Mrs. Montagues, 2 Mrs.
Barbaults' to London suggests that both medallions were ready for sale.[26]

Unlike most others in the series, the portraits of Montagu and Barbauld
are shown in severe profile, as if imitating ancient coins and cameos. The
classicizing style of the heads is accentuated by Barbauld's laurel wreath
– a symbol of poetic achievement – and Montagu's veil – an allusion to the
virtues of Roman matrons. Samuel Johnson's appreciation of the latter is
reflected in his poem 'On Seeing a Portrait of Mrs Montagu':

Had this fair figure which this frame displays,
Adorn'd in Roman times the brightest days,
In every dome, in every sacred place,

Her statue would have breath'd an added grace,
And on its basis would have been enroll'd,
'This is Minerva, cast in Virtue's mould'.[27]

As one of Montagu's friends, Johnson may have known the medallion.
The image, however, gained wider circulation through an engraving in the
Westminster Magazine. Illustrating an article titled 'Observations on Female
Literature', this shows Montagu and Barbauld supported by allegorical figures
that provide a visual commentary on their achievements. Minerva, the goddess
of wisdom, flatters Montagu's perspicacity as critic and patron, while Apollo,
god of the arts, emphasizes Barbauld's poetic excellence. The print epitomizes
the article's self-congratulatory opening statement: 'Happily we do not live in
those days when prejudice condemned our women to ignorance.'[28] As in
Samuel's print of *The Nine Living Muses of Great Britain*, the achievements of
modern women, and the supremacy of Britain in the arts, are presented and
validated through the deployment of classical imagery. In the *Westminster
Magazine* even the follower of the latest fashions for notoriously high hairstyles
was not exempt. She is urged to 'think the "enlargement of her mind as well
as the expansion of her head", worth her attention with particular pleasure'.[29]

**Mrs Montagu and Mrs
Barbauld in the
Westminster Magazine, 1776**
After Thomas Holloway
Line engraving, 159 x 98mm
(6¼ x 3⅞")
National Portrait Gallery,
London (NPG D4458)

Women in the Public Eye

While the trope of the nine Muses helped justify creative woman as a collective
category, becoming a public spectacle remained fraught for individuals.
Actresses are the best-known case in point. Some might have been painted as
Muses of Comedy or Tragedy, Reynolds's *Mrs Siddons as the Tragic Muse* (1784)
being the most celebrated example, but classical allegory did not free most
actresses from the moral questionability of being on display – on the stage, in
exhibitions of paintings or in print-shop windows. Women in literature and the
fine arts might lead more private lives but they too were not exempt from such
concerns. When Joseph Johnson published the pocketbook containing Samuel's
The Nine Living Muses of Great Britain, Elizabeth Carter sarcastically described
it as 'the highest dispenser of human fame' and commented to her friend
Elizabeth Montagu, 'O Dear, O dear, how pretty we look, and what brave
things has Mr. Johnson said of us! Indeed, my dear friend, I am just as sensible
to present fame as you can be … but I think it is much better to be celebrated
by the men, women, and children, among whom one is actually living.'[30]

Carter was sensitive to the issue of fame, for she had a long and complex
relationship with celebrity. Since the 1730s her scholarship as a translator of the

classics, a polyglot and a poet had singled her out as an icon of national progress and a paradigm of female learning. But like all women active in art and literature, she had to negotiate the relationship between public exposure and potential censure. The remarkable portraits and literary representations of her attempted to achieve this in a number of ways.

Inventing the Female Scholar

Born in 1717, Elizabeth Carter was the daughter of a cleric who, rather unusually, educated both his sons and his daughters to a high level. Elizabeth, the eldest, was a prodigy. Excelling in ancient and modern languages as well as astronomy, mathematics and history, she first came to public attention in 1734 – at the age of seventeen – with a poem in the *Gentleman's Magazine*.[31] Run by their family friend Edward Cave (1691–1754), this was one of several new periodicals which encouraged women writers. Keen to capitalize on Elizabeth's talents, her father encouraged her to join Cave's stable of minor writers in London.

Like many female authors, Carter published anonymously or under pseudonyms in an attempt to safeguard her modesty and guarantee her an unbiased critical response. However, her youth, talent and sex encouraged Cave to promote her as a sensation. By 1735 her identity became widely known when the poet John Duick encouraged her 'to with her sister muses charm the age'.[32] Cave further advanced Carter's position as a rising star by publishing a series of epigrams and poems that claimed that she was the rightful heir to Alexander Pope (1688–1744; see opposite). This was a pointed proposition. Pope had been England's leading poet and satirist since the 1710s. Along with his political allies, he was also an infamous scourge of women writers, who, he believed, typified all that was threatening and offensive in society.[33] Such was the notoriety of Pope's published reactions to literary women that Carter's father had been warned, 'there is hardly any instance of a woman of letters entering into an … acquaintance with men of wit … particularly poets, who were not thoroughly abused and maltreated by them, in print … and Mr Pope has done it more than once'.[34] Despite these reservations Carter was encouraged to challenge Pope and his reputation.

In 1738 Carter gained entrance to Pope's famous garden retreat near Twickenham. Samuel Johnson commemorated the visit with a Latin epigram in the *Gentleman's Magazine*. This prompted a number of responses, among them 'To Eliza plucking Laurel in Mr. Pope's Garden', which develops the literary conceit that Carter had stolen Pope's 'laurel crown' during the visit:

Desirous of the laurel bough,
She crops it to adorn her brow;
Yet do not steal it, lovely maid,
The wreath you wish shall grace your head;
If *Pope* refuse it as your due,
Phoebus himself shall give it you.[35]

In the same issue Carter dealt with the accusation in a Latin and English verse-answer, at once ostentatious yet typically self-deprecating, in which she playfully demurred:

Remov'd from *Pope's*, the wreath must fade
On ev'ry meaner brow.[36]

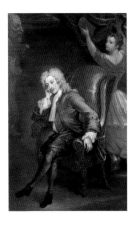

Alexander Pope, 1688–1744
Attributed to Charles Jervas,
c.1713–15
Oil on canvas, 1778 x
1270mm (70 x 50")
National Portrait Gallery,
London (NPG 112)

Joseph Highmore's portrait of Carter (see p.71) provides a visual analogue of the literary celebration of her visit to Pope's garden. Ostensibly, the image represents a genteel woman with a book – a fashionable motif for flattering the intellectual pretensions of cultivated ladies. However, a number of details show that the picture was designed to advance Carter's professional identity. The plinth and vase indicate a garden setting, while the female figure on the right receives a laurel wreath in her hand. These refer directly to Pope's garden and the literary conceit that she had acquired the laurel crown of fame with which Pope is often connected, and which is shown, for example, in Jonathan Richardson's 1738 portrait. In addition, Carter's pose with one hand raised is loosely derived from the conventions for depicting 'Meditation' in Renaissance emblem-books such as Cesare Ripa's popular *Iconologia*. This pose was used repeatedly by Pope to represent himself as a brooding genius, and was widely associated with him through the distribution of prints after his many portraits. Carter adapted the iconography not only because she had no female portrait tradition on which to draw as a professional woman writer, but, more confrontationally, as part of her challenge to Pope's literary supremacy.

The degree to which Carter engaged with Pope's thinking is shown by her scholarly translation of Jean Pierre de Crousaz's *An Examination of Mr. Pope's Essay on Man* from French in 1739. In the same year she also translated Francesco Algarotti's *Sir Isaac Newton's Philosophy Explain'd for the Use of Ladies* from Italian, which was published by Edmund Cave. Although neither had Carter's name on the title page, they soon received reviews declaring her pioneering genius. One by Thomas Birch described her as 'a very extraordinary

Elizabeth Carter,
1717–1806
Joseph Highmore, *c.*1738
Oil on canvas, 1220 x
1000mm (48 x 39⅜")
Owned by Deal Town
Council on behalf of the
People of Deal

Phaenomenon in the Republick of Letters … justly to be Rank'd with the Cornelia's, Sulpicia's, and Hypatia's of the Ancients, and the Schurmans and Daciers of the Moderns'.[37] This hyperbole contrasting Carter with famous female achievers from ancient and modern times was evidently a public embarrassment. Within days of Birch's review, Carter had returned to her father's home in Kent, having been previously advised to reduce the tone and scale of her public lifestyle – especially as, her father observed, 'you intend never to marry'.[38]

Carter's departure was a blow to the *Gentleman's Magazine.* In 1741, perhaps in an attempt to win her back, Cave published a panegyric entitled 'On Miss CARTER's being drawn in the Habit of Minerva, with Plato in her Hand'.[39] In the days before public exhibitions, this poem, written by Samuel Boyse, drew attention to the remarkable portrait *Elizabeth Carter as Minerva* (see p.72), painted by John Fayram (*fl.*1727–43). This, together with its poetic response, reveals how Carter was advanced as a role model for learned, creative and professional women.

Although the picture was painted some time between 1735 and 1741, Fayram's unusual painting was influenced by seventeenth-century traditions of *portrait historié* in which sitters were presented in a variety of courtly roles and playful guises. But his depiction of Carter as Minerva was rather more serious. Neither arbitrary nor vacuous, the portrait was consciously contrived to promote Carter's status as an exemplary British woman in whom personal virtue and learning were inseparable. Minerva, we learn from a popular primer on 'heathen gods', was understood to represent wisdom 'join'd with discreet Practice … the Understanding of the noblest Arts, the best Accomplishments of the Mind, together with all Virtues, but most especially that of Chastity'.[40] In Fayram's adaptation of the traditional iconography, the goddess wears her customary helmet and armour; her spear, however, is set aside and in her hand is, instead, a book labelled 'Plato'. This reiterates the depth of Carter's intellect, discounting any suggestion of empty role play. Boyse underlined this by celebrating the painting and its iconographic conception:

> Say, *Fayram*! Say, whose is th'enliv'ning face?
> What *British* charmer shines with *Attick* grace …
> Have we a nymph, who midst the bloom of youth,
> Can think with *Plato*? – and can relish truth?
> One who can leave her sex's joys behind,
> To taste the nobler pleasure of the mind?

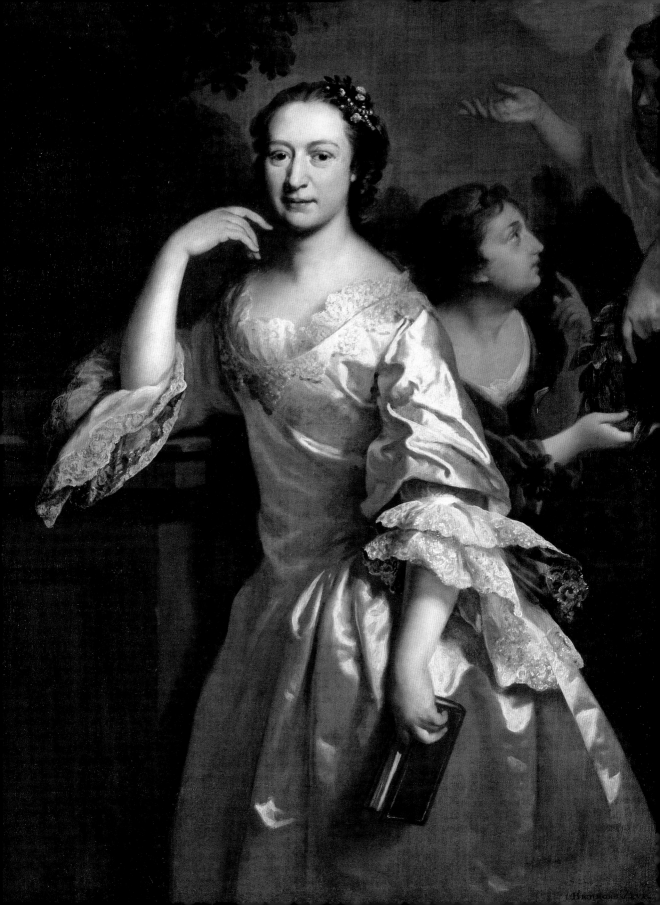

Well, *Carter*, suits thy mien this apt disguise,
This mystic form to please our ravish'd eyes;
Well chose thy friend this emblematic way
To the beholders strongly to convey
Th'instructive moral, and important thought
Thy works have publish'd, and thy life has taught …[41]

For Boyse it is Carter's preference for the 'nobler pleasures of mind' that distinguishes her from other women. And while the poem praises Fayram for having adopted a full-blown 'emblematic way', at the same time Carter herself is praised as an emblem of the moral instruction that her scholarly publications and her 'life has taught'. The inference is clear. Minerva is an 'apt disguise' for Carter because she excelled all other women and combined wisdom and virtue. In the quickening debate about women's education, virtue and respectability were key. In the genre of 'conduct literature', those opposed feared that learning would fill 'the minds of the sex with a conceited vanity, which sets them above their proper business'.[42] Those in favour, however, insisted that '*Virtue* and *Felicity* are equally requisite in private, as in public station, and *learning* is a necessary means to both'.[43] This was highlighted at an early stage in the periodical the *Athenian Mercury*, which declared that Minerva and the Muses were always chaste virgins and had been designed by the ancients to exhort women to education. 'For 'tis a thing hitherto unheard of that a Woman was learn'd and not Chaste'.[44] We could not ask for a clearer justification for the representation of Carter as Minerva – goddess of wisdom.

Reason and Virtue

Carter had retreated from metropolitan life in 1739 partly on the advice of family friends. As a woman she needed to avoid over-exposure in order to retain her virtue. Having elected not to marry, to preserve her freedom to study and write, she had to adopt a more modest lifestyle. Carter's return to Kent added to the construction of her public reputation as a virtuous, pious, even domesticated woman writer.

In the decades following her 'withdrawal' from London, she established a network of friends, most notably Catherine Talbot (1721–70), an author and scholar. With her adoptive father Archbishop Secker, Talbot persuaded Carter to translate the works of Epictetus, whose Stoic philosophy seems to have appealed due to his emphasis on reason and emotional self-discipline.[45] The translation from the Greek was published in 1758 by subscription, under the

Elizabeth Carter as Minerva
John Fayram, *c.*1735–41
Oil on canvas, 900 x 690mm
(35⅜ x 27⅛")
Miss Paddy Barrett

John Fayram's composition has no precedent in eighteenth-century British painting. While it is reminiscent of seventeenth-century courtly portraiture, its purpose went beyond role play to stage Elizabeth Carter as the foremost female intellectual of the day.

title *All the Works of Epictetus, which are now extant.* A work of intense literary scholarship, it was the first of Carter's books to carry her name on the title page. It was prefaced by a legitimizing ode to Carter, by Hester Chapone, which framed the work in terms of 'Virtue', 'real Wisdom, real Force' and 'sweet fraternal Love'.[46]

All the Works of Epictetus was an immediate critical success, and served to resurrect and crystallize Carter's reputation as not only Britain's leading female scholar but also, with the onset of the Seven Years War, the advance guard in the cultural battle with France. The *Monthly Review* celebrated this fact in nationalistic and gendered terms by comparing Carter to France's seventeenth-century scholarly great Madame Dacier:

> Many Ladies have been very witty; some few have been very learned; but we have never, till now, seen these accomplishments united with an acute understanding and solid judgement, sufficient to unravel the intricacies of Philosophy. France can now no longer boast her *Dacier*, but must be compelled to own that our women excel theirs in Sense and Genius, as far as they surpass them in Modesty and Beauty.[47]

Carter's translation 'made a great noise all over Europe'.[48] More prosaically, it made her financially secure. Her increased independence and social life led to her introduction to Elizabeth Montagu. Longing for her own female mentor, Montagu was taken by Carter's quiet dignity, classical education and literary accomplishments.

Montagu's admiration for her new friend was such that she commissioned a portrait from Katharine Read (1723–78). Working in oil and pastel, Read was one of the leading portrait painters in the years before Reynolds transformed British art and taste. Like that of other women artists, Read's work was often praised for its 'feminine softness', 'grace and elegance'.[49] This gendered preconception can be discerned in Talbot's praise of Carter's portrait as 'mild, unaffected … quite unlike the common run of staring portraits'.[50] Talbot's explicit reference to the gaze highlights the importance of Carter's averted eyes, a device suggesting modesty, 'absorption' and self-denial, qualities with which she was often associated due to her work on Stoicism.

The leather-bound volume and quill in Carter's hand were included because the portrait coincided with plans for a second edition of *All the Works of Epictetus*. The costume – a version of what the artist and theorist Jonathan Richardson (1667–1745) termed 'arbitrary loose dress' – was intended to lend

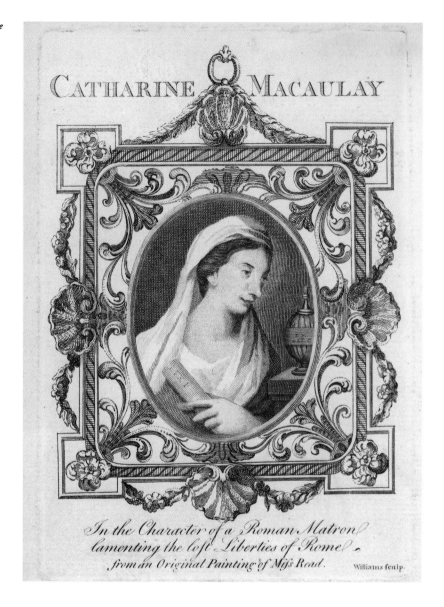

Catharine Macaulay in the Character of a Roman Matron lamenting the lost Liberties of Rome
Williams, after Katharine Read, 1770
Engraving, 147 x 103mm (5¾ x 4")
National Portrait Gallery, London (NPG D31845)

CATHARINE MACAULAY

In the Character of a Roman Matron lamenting the lost Liberties of Rome. from an Original Painting of Miss Read.

Williams fculp.

'grace and greatness' through its generic associations with all things classical.[51] The long veil draped over her head was derived from sculptures of Roman matrons, a convention signalling modesty that was familiar from statues like *Pudicity*, a copy of which was in Westminster Abbey.[52] Read introduced this device to suggest that 'Mrs' Carter was an exemplary, mature figure celebrated for her 'publick virtue', her 'strictness of modesty' and her self-sacrifice for the good of the nation – all qualities associated with the Roman matron.[53] Read

had previously appealed to this iconography in a now-lost miniature of Catharine Macaulay which was exhibited in 1763. A later engraving after this is inscribed 'Catharine Macaulay in the Character of a Roman Matron lamenting the lost Liberties of Rome'.[54] Here the veil is, however, put to very different ends and signals Macaulay as a politicized figure who had begun to publish an important republican *History of England* (1763).

Having painted Macaulay and Carter, Read was keen to embark on a series of illustrious women and invited Montagu to sit. But she refused, writing, 'I cannot see what can give me admission to the set of distinguished Ladies.' Like Carter, Montagu relished her privacy and refused to believe that there was anything to recommend her to the 'select & sacred number nine' – a direct reference to the nine Muses.[55] With a self-deprecation that is often seen in the way that women felt the need to project themselves in this period, Montagu attested to being distinguished only for 'making good marmalade'. That the ideal was to combine both domesticity and learning is brought into sharp focus by Samuel Johnson's famous praise of his 'old friend, Mrs. Carter, [who] could make a pudding as well as translate Epictetus … and work a handkerchief as well as compose a poem'.[56]

Hannah More: Professionalism and Identity

There was a huge growth in the reading public during the eighteenth century. This created opportunities for middle-class women, because professional writing did not necessarily pose a threat to their respectability. Nevertheless, both women and men were concerned that gentility and intellectual freedom would be compromised if they were seen to be labouring solely for money. Authors eschewed the stigma of 'Grub Street', which was synonymous with commercially generated works of little quality or value. These concerns reflected the division of the social order into 'liberal' and 'mechanic' classes that was embedded in the civic humanist thought of early eighteenth-century Britain. By the end of the century, however, a middle ground had developed. Writers and artists could advance themselves through identities at once genteel and professional – a combination which is manifest in many portraits. Although this representational strategy was predominantly male, some women ventured to portray themselves as respectable professionals, chiefly by manipulating the prevailing conventions for men. This is particularly apparent in one portrait of the playwright Hannah More (see p.78).

This painting by Frances Reynolds (1729–1807) – sister of Sir Joshua – attempts to present More as a professional yet genteel author. Quite

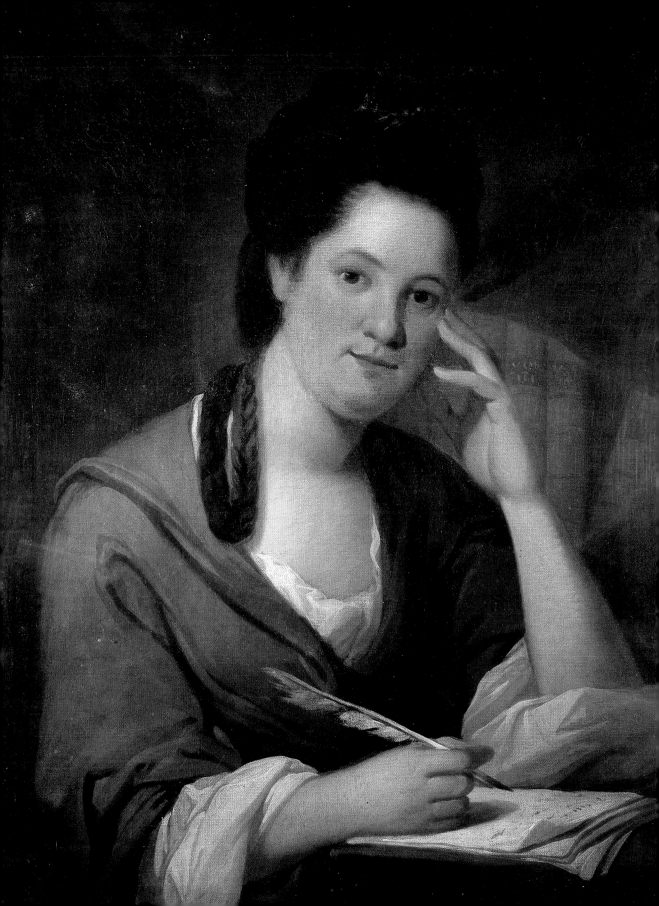

exceptionally for a woman, she is shown in the act of writing. Her hand is at her temple, indicating that she is lost in thought, and she has the slightly dishevelled look reserved for people of genius. Her informal costume is derived from the way 'men of letters' were shown in a state of domestic 'undress' when closed in their libraries, away from public duty and polite company. The books behind her have large and heavy bindings to indicate the seriousness of their contents and, by extension, the importance of More's own writing. The dignified library interior deliberately signals the distance between More's setting and a Grub Street hack's garret. These pictorial conventions are not especially innovative; what is new is their use to represent a respectable British 'woman of letters'. Reynolds understood the need to establish a public persona for the professional female author, and the power of portraiture generally. This is shown in her *Enquiry Concerning the Principles of Taste, and of the Origin of our Ideas of Beauty &c.* (1785), where she states that 'in cultivated nations, every precept for exterior appearances ... has for its object ... a desire to impress upon the spectator a favourable idea of our mental character'.[57]

Frances Reynolds and Katharine Read were just two of many professional women artists in the eighteenth century. Working as a portrait painter could nonetheless be fraught. Samuel Johnson summarized the problem when he complained that portrait painting was an 'improper' employment for women: 'Public practice of any art ... and staring in men's faces, is very indelicate in a female.'[58] These genuine concerns might explain why Reynolds, who painted both men and women, publicly exhibited only one painting – a flower piece.

Mary Moser: Institutional Identities

The leading flower painter of the late eighteenth century was Mary Moser (see p.81).[59] Her greatest success in this genre was a lucrative and high-profile commission for the decorations at Queen Charlotte's summer pavilion at Frogmore in the 1790s. Painted twenty-five years earlier, George Romney's portrait of Moser skilfully conveys her youthful ambitions as a founder member of the Royal Academy and, like the other pictures examined in this chapter, seeks to assert that a woman's professional status was compatible with femininity.

The Royal Academy was established in 1768 to promote art as a professional and liberal activity subject to appropriate rules. Although its charter stipulated that members be 'of fair moral characters, of high reputation in their several professions', it did not specify what genres should be practised,

Hannah More, 1745–1833
Frances Reynolds, 1780
Oil on canvas, 883 x 756mm
(34¾ x 29¾")
Bristol's Museums, Galleries
& Archives

In 1780, Hannah More wrote to her sister describing sitting for this portrait: 'I went to Mrs. Reynolds and ... just as she began to paint, in came Dr. [Samuel] Johnson, who staid the whole time, and said good things to me by way of making me look well.'

The Academicians of the Royal Academy
Richard Earlom after Johan Zoffany, 1773
Mezzotint, 506 x 721mm
(19⅞ x 28⅜")
National Portrait Gallery, London (NPG D21304)

Mary Moser, 1744–1819
George Romney, *c.*1770–71
Oil on canvas, 763 x 642mm
(30 x 25¼")
National Portrait Gallery, London (NPG 6641).
Purchased with help from the Heritage Lottery Fund and The Art Fund (with a contribution from the Wolfson Foundation), 2003

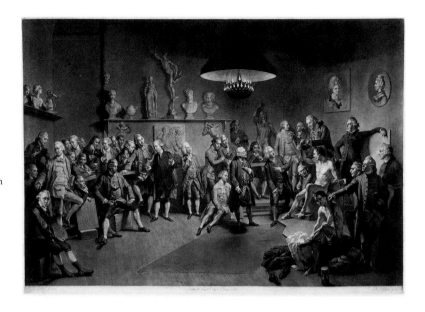

making it possible for Moser – a flower painter – to gain admission.[60] Her inclusion was nevertheless remarkable on two counts. First, women were excluded from membership of nearly all the new learned societies and, after Moser's death, no woman was elected a full Royal Academician until Dame Laura Knight in 1936. Second, Sir Joshua Reynolds, the academy's president, advocated a 'hierarchy of genres' – that is, a sliding scale of values that prioritized history painting, the depiction of noble and exemplary human actions. Still-life and flower painting were relegated to the bottom, being decorative and with little didactic content. Johan Zoffany's famous group portrait depicting the life class of the Royal Academy manifests this ideology which especial clarity. The space is one of masculine sociability, with the thirty-six founding academicians gathered in conversation as a naked male model is posed. Skill in drawing the male nude was the bedrock of successful history painting. Women, however, were excluded from the life class to safeguard their modesty and to avoid masculine embarrassment. So although Moser and Angelica Kauffmann were members of the Academy, Zoffany was obliged to simultaneously include and exclude them from the life class. His pictorial solution to this professional restriction was to show them as portraits hanging on the wall. Women, in any case, were not believed to have the capacity for abstract thought that history painting required. They were judged instead to have a heightened ability for detailed observation and mimesis commensurate with copying or capturing a likeness in portraiture.

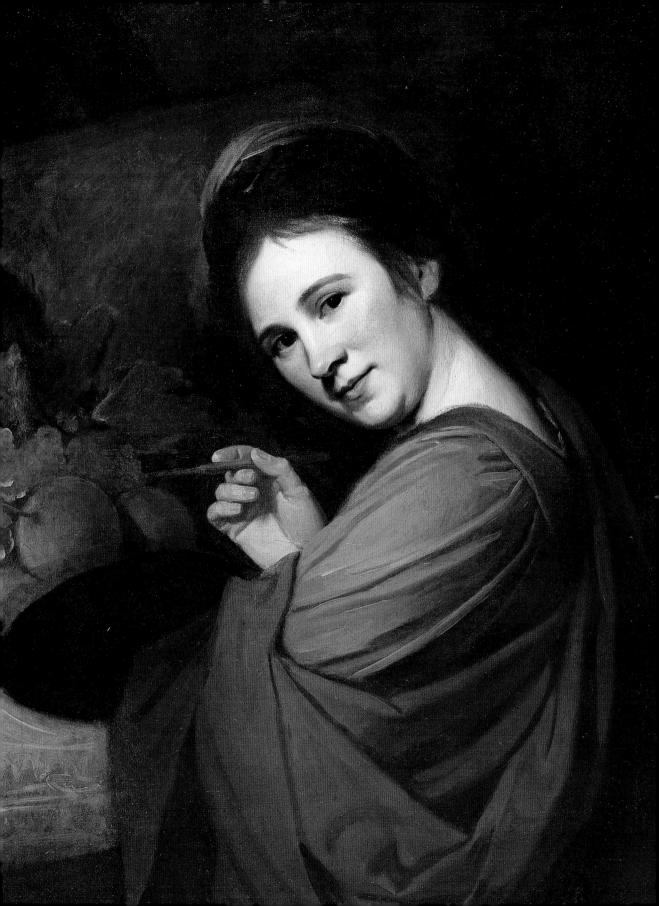

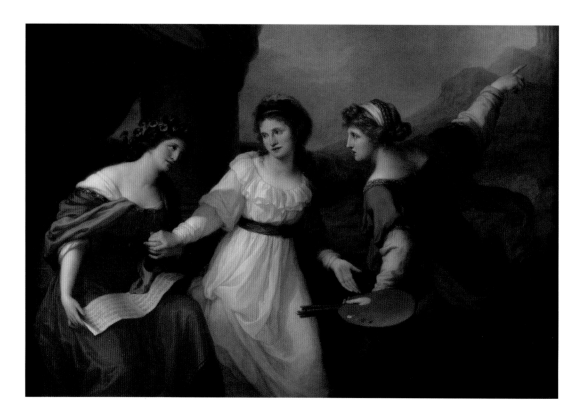

**The Artist Hesitating
Between the Arts of Music
and Painting**
Angelica Kauffmann,
1741–1807
Self-portrait, 1791 or 1794
Oil on canvas, 1473 x
2159mm (58 x 85")
Nostell Priory, The St Oswald
Collection (The National
Trust, acquired with the help
of the Heritage Lottery Fund
in 2002)

In Romney's portrait, Moser is presented as a professional artist. She wears pseudo-classical painter's robes, placing her in a long line of (male) artists dating back to the Renaissance. Yet the composition's close focus, dramatic lighting and sidelong glance emphasize that her status as an academic artist need not compromise her allure. Moser was proud to be an academician, often signing her paintings with the Latin word '*fecit*' (he or she made it) and the initials 'R.A.'

Like Hannah More, Moser is shown holding the primary tools of her profession – oil palette and brush. This served to distinguish her from the many amateur artists who practised flower painting in watercolour. Painting in watercolours had been increasingly popularized in the eighteenth century as one of several 'accomplishments' suitable for young genteel women. In opposition, Moser's portrait constructs a distinct identity, separate to the amateur and part of a professional artistic body. She not only has oils in her hands but stands before an oil painting on which she is working. However, in distinguishing herself in this way she transgresses the boundaries of convention between 'liberal' and 'mechanic'. The mess and labour of oil painting did not accord with the discourse of academic art, which idealized drawing as the proper way

for an artist to explore his intellectual inventions. So although Moser's paintbrush might have set her apart from women amateurs, it also separated her from Britain's male academicians, who usually sought, at least in their public presentations, to distance themselves from the 'mechanical' aspect of their work.

Kauffmann's Choice

Angelica Kauffmann, Moser's only other female colleague at the Royal Academy, produced nearly two dozen self-portraits.[61] Always careful to exploit her noted beauty, these define and advertise her personal ambitions and special position as a woman artist. The majority show her with a charcoal holder, and sometimes a drawing portfolio, rather than a paintbrush. This repeated reference to drawing is part of a pictorial language that reminds the viewer of her early training, travelling through Italy with her artist father, studying Old Masters and antique sculpture. Drawing also asserted the intellectual basis on which her exceptional career as a history painter was founded. Her prowess did not go unremarked:

> Miss Kauffman still maintains her character as one of the first history-painters of the age; and so strong is the turn of her genius to that sublime branch of art, that while most of the male pencils in the kingdom are employed in portraits … she gives us, every succeeding year, fresh proofs of the vigour of her mind by producing something excellent in the historical way.[62]

Perhaps the most celebrated, and theorized, of Kauffmann's self-portraits is the one depicting her hesitating between the arts of music and painting (see opposite). This is not an intimate self-portrait but an impressive public work with the ambition and referential structures of a history painting. It combines symbolic, allegorical and mythological approaches to create an ideal and acceptable image of female creativity and to stage the 'birth' of the artist.

Painted in Rome, where Kauffmann had settled after leaving London in 1781, the scene recalls the moment when she had to choose between music and painting, fields in which she was equally precocious as a girl. This was subsequently explained by her artist husband, Antonio Zucchi: 'Angelica is holding Music's hand as a final adieu, and she gives herself entirely to Painting, who shows her in the distance the temple of Glory where she will be able to arrive by the road of drawing and painting.'[63]

By including personifications of Music and Painting, Kauffmann crafted an allegorical narrative, which can be read simultaneously on literal, psychoanalytic and symbolic levels. In simple terms, she presents her choice between music and painting, expecting viewers to understand the outcome. With her international reputation, and a huge canvas before them, the self-promotional argument is that Kauffmann had attained the public goal set forth by Painting – the 'temple of Glory' high on the hill.

The composition ultimately draws on the iconography of the choice made by Hercules between the easy road to vice and the thorny road to virtue. This parable was well known, having been used in the Earl of Shaftesbury's influential aesthetic treatise *Characteristicks of Men, Manners, Opinions, Times* (1711) to promote the intellectual status and moral purpose of art as a public medium. By reinventing this 'choice' and inserting herself as the central character, Kauffmann dared to fashion herself as a female version of a male hero and moral exemplar. This elevated and moralized her choice to become an artist.

The representation was given contemporary resonance by referring also to Sir Joshua Reynolds's famous *David Garrick between Tragedy and Comedy* (1761). But instead of that mock-heroic and titillating encounter, Kauffmann constructs a positive image of a woman making a determined and rational decision. Her affectionate squeeze of Music's hand, coupled with her open acceptance of Painting's promise, suggests that Music and Painting represent Kauffmann's alter egos and that the story is one of continuity rather than rupture. This serves to indicate the multiple accomplishments expected of genteel femininity. Moreover, the educated viewer would have seen in the female triad an obvious reference to the Three Graces, the givers of joy, charm and beauty, who also represented ideal friendship. This allusion softened the potential impropriety of Kauffmann casting herself as Hercules. Furthermore, the connection between the three figures points to the interrelation of the 'sister arts' and, like the Muses, their mutual fostering of each other. The triumph of Kauffmann's career in the male sphere is here set against an allegoricized backdrop of female achievement and networks of friendship and support.

Madame de Staël: Empowered Female Genius

Allegorical portraiture became increasingly popular across Europe from the 1770s. It appealed to Kauffmann and other artists with academic ambitions because it closed the gap between portraiture – particular likenesses of 'defective models' – and the abstract art of history painting, the most prized of all genres because it conveyed moral truths of an enduring nature.[64] By drawing on

Scripture, literature and classical antiquity, allegorical compositions introduced a host of honorific meanings to the interpretation of a portrait and a sitter. This was especially effective if a cogent match was achieved between the allegory and the sitter's life, as happened in Elisabeth Vigée-LeBrun's portrait of *Madame de Staël as Corinne* (see p.86). This represents the novelist, literary critic, philosopher and political writer as her own literary alter ego and as such is the period's ultimate icon of empowered feminine genius.

Anne Louise Germaine, Madame de Staël-Holstein, known usually as Germaine de Staël, was one of the richest and most influential women in Europe from the French Revolution to the defeat of Napoleon. She was the daughter of Jacques Necker, a Swiss Protestant who rose to be finance minister to Louis XVI. Her mother Suzanne Necker held one of the most illustrious literary and intellectual salons in Paris and it was there, from an early age, that she developed her legendary talent for conversation. The English historian Edward Gibbon (1737–94) noted that even as a teenager she had 'a much larger provision of wit than beauty'.[65] It was this want of good looks, paired with an indelicate and strident nature – virtual crimes for an upper-class woman – that critics would levy against her throughout her life.

In print and in person, de Staël aspired to play a political role. She started her own salon, which was attended by a group of progressive aristocrats and intellectuals who wanted to reshape France as a British-style constitutional monarchy. Although shocked by the extremes of the Revolution, she remained dedicated to civil rights, equality before the law, elections and other fundamentals of liberal government. Her moderate republican views, wealth and manly assertiveness led to her being mistrusted by revolutionary Jacobins and aristocratic émigrés alike. Her successful novel *Delphine* (1802) depicted a free-thinking female protagonist who advocated political liberty, the right to divorce and the importance of literature.[66] Along with her *On Literature Considered in its Relations to Social Institutions* (1800), *Delphine* promoted the idea of the writer as defender of originality, independent thought and political freedom. This was anathema to Napoleon, for whom writers were useful only in the service of the state. Concerned that de Staël was plotting against him, he finally banished her from Paris in 1803.

Napoleon's decree led to a ten-year exile. It was during this period that she travelled widely and wrote a number of books, the most important of which was *Corinne, or Italy*. Published in 1807, it quickly gained an international reputation, being immediately translated into English. Jane Austen was enamoured and Maria Edgeworth thought it 'a work of splendid genius'.[67]

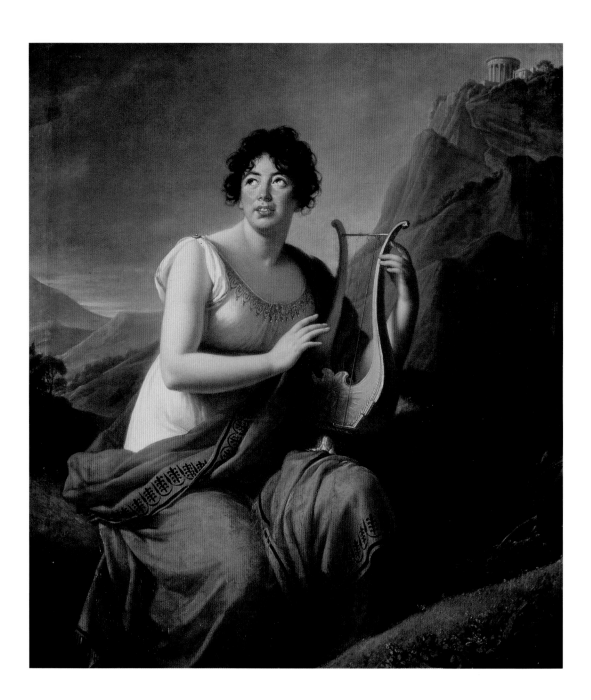

A combination of romance, social commentary and picaresque travel narrative, *Corinne* is the story of an extraordinary woman who does not fit the submissive role convention has set out for her. The eponymous heroine is a poet, writer, '*improvisatrice*' and beauty. She is introduced to the reader as the 'most celebrated woman of Italy', about to be crowned before ecstatic crowds on the Capitol in Rome: 'Long live Corinne! Long live Genius. Long live Beauty.'[68]

This public event of Olympian proportions is watched by a puritan Scottish peer, Oswald Nelvil, who, though repelled by the exuberance of the foreign spectacle, immediately falls in love with the beautiful and sensual poet. Addressing the theme of national temperaments, the novel then recounts Oswald and Corinne's ill-fated love as they travel through Italy. The anti-Napoleonic subtext of the novel is manifest in its description of the war-ravaged country's poverty and in its constant praise for British politics, law and society. Ultimately, Oswald chooses a more conformist English woman, leaving Corinne broken-hearted and unable to function creatively. Thus *Corinne* explores the relationship between female happiness and self-expression and a woman's desire to be loved and accepted. In giving Corinne such a strong voice, de Staël tackled the dominant image of the ideal woman as submissive and repressed. But if Romantic thought had established a new paradigm of male genius as innate, inexorable and rule-breaking, then *Corinne* was the first work in which a heroine was allowed to enact a female version of that genius.

Art and Female Genius Intertwined

While *Corinne* is a thinly veiled self-projection of its author, Elisabeth Vigée-LeBrun's painting of *Madame de Staël as Corinne* is an overt assertion that the two figures are one. The leading female artist in France, Vigée-LeBrun (1755–1842) had been Marie Antoinette's favourite portraitist and was promoted to the Académie Royale de Peinture et de Sculpture in 1778. Like de Staël, she had her own salon in Paris and had also experienced exile from France, albeit in different political circumstances. Travelling in Switzerland in 1807, she visited de Staël's 'salon in exile', where a discussion of this portrait took place.

As the painting was under way, de Staël wrote to a friend, telling her, 'Madame LeBrun has made a portrait of me that [every]one finds very remarkable … . It captures me as a sibyl or as Corinne, if you like that better.'[69] While the letter confirms the sitter's recognition of the different levels on which this allegorical portrait functions, the ownership of the formative idea for the portrait was a matter of quiet contest. In an earlier letter, de Staël had reflected,

Madame de Staël as Corinne
Elisabeth Vigée-LeBrun, 1809
Oil on canvas, 1400 x
1180mm (55⅛ x 46½")
Collection des Musées d'art
et d'histoire de la Ville de
Genève

On meeting Madame de Staël, Elisabeth Vigée-LeBrun was captivated by her animated conversation and formidable personality. 'To tell you the truth,' she wrote, 'one cannot paint you as one paints everyone else.' The result was this monumental rendition of an author portrayed as her own literary heroine – one of the most audacious allegorical portraits of the age.

'I do not know if I dare have myself painted as Corinne', her concern being more the question of her heroine's fabled beauty than one of literary or personal impropriety.[70] In Vigée-LeBrun's *Souvenirs* (1835–7) the artist later asserted the inescapable correlation between the sitter and her fictional creation, writing: 'I have just finished reading her last novel, *Corinne*; her sparkling and inspired personality gave me the idea of painting her as Corinne, seated on a rock, holding her lyre and dressed in the costume of ancient Greece.'[71]

The portrait takes direct cues from the novel. De Staël is posed as Corinne, her dark hair tousled by the wind, her eyes turned heavenward in a state of enraptured inspiration, her lips parted in the act of declaiming a poem and her hands plucking the lyre. The scene is based on an episode in the book where Corinne sings an improvised poem for Nelvil during a visit to Cape Miseno near Vesuvius. Although the portrait was begun in de Staël's Swiss garden, Vigée-LeBrun incorporated the Bay of Naples in the distance to make this link. The building on the hilltop represents what eighteenth-century antiquarians thought was the Temple of Sibyl at Tivoli, near Rome. Letters indicate that Vigée-LeBrun included the temple at de Staël's request. As the Sibyl of Tivoli was the oracle who foretold the fall of Rome and its conversion to Christianity, by associating herself with this temple de Staël indicates her politicized identity as a critic of the Napoleonic empire. Like the 'temple of Glory' on the hilltop in Kauffmann's self-portrait, the Temple of the Sibyl points to a symbolic apex of female empowerment. The generic Italianate and classicizing landscape in both paintings offers an idealized tableau on which great and powerful women could project their talents without inhibition and social constraint.

Corinne, 'C'est moi'

Vigée-LeBrun was proud of the composition, calling it simply *'my* Corinne'.[72] Although the painting does not appear to have been exhibited, it was seen by many in the artist's studio. One enthusiastic viewer wrote a eulogy which revels in the theme of the mutual inspiration between these two women:

> I can see and hear her; your inspired brush
> Has given colour a soul, a life, a mind …
> And the same crown entwines the face
> Of the inspired sitter and the immortal painter.[73]

A more diffident response came from de Staël: 'I finally received your magnificent painting … and without thinking about the fact that it is my

portrait, I admired your work. All your talent is there and I very much wish that mine could be encouraged by your example.'[74] But even de Staël found it hard to inhabit the uncompromising colossus. Although she may have resembled Corinne in creativity and intellect, she did not share her legendary looks. Vigée-LeBrun had initially observed, 'Madame de Staël was not exactly pretty, but the liveliness of her features compensated more than adequately for any lack of formal beauty.'[75] A woman of her time, de Staël was troubled by her portrait's monumental limbs and unidealized face, commissioning a reduced copy which, while retaining the Muse-like trappings, gave her a more socially acceptable feminine appearance.

Irrespective of her private unease, both novel and portrait had a lasting impact on the image of the creative woman. The 'lady with the lyre' became a popular European convention for portraying any woman with pretensions to poetry and literature.[76] Her inspiration was strongly felt among a group of English women writers, including Elizabeth Barrett Browning (1806–81), Charlotte Brönte (1816–55) and Felicia Hemans (1793–1835). Hemans wrote that *Corinne* 'has a power over me which is quite indescribable; some passages seem to give me back my own thoughts and feelings, my whole inner being'. And in the margin of her copy, Hemans simply penned, 'C'est moi', thus identifying herself with the empowered Romantic heroine.[77]

De Staël and her novel *Corinne* were seen as definitive symbols of female creativity. No other fictional character – or writer – did as much to influence women across Europe to respond to their need for creative self-expression. That both also stood for genius over political and social tyranny was reflected in de Staël's resistance to Napoleon. Even Byron, here the archetypal misogynist, was forced to admit that de Staël was the pre-eminent female writer of the age: 'She is a woman by herself, and has done more than all the rest of them, intellectually; she ought to have been a man.'[78]

Chapter Notes

[1] *Monthly Review, or Literary Journal*, April 1774, Vol.L, p.243. The poem praises the writers Hannah More, Charlotte Brooks, Charlotte Lennox, Anna Letitia Barbauld (née Aikin), Elizabeth Carter, Frances Greville, Elizabeth Griffith, Phyllis Wheatley and Elizabeth Montagu.

[2] Ephraim Chambers, *Cyclopaedia, or, An Universal Dictionary of Arts and Sciences*, 2 vols. (London, 1728), Vol.II, p.605.

[3] Cited in Philip Ayres, *Classical Culture and the Idea of Rome* (Cambridge, 1997), p.12.

[4] Linda Colley, *Britons: Forging the Nation 1707–1837* (London, 1992), p.168. For a discussion of the civic humanist mode of government and the place of women, see E.J. Clery, *The Feminization Debate in Eighteenth-Century England: Literature, Commerce and Luxury* (Basingstoke, 2004), Introduction.

[5] Sir Joshua Reynolds, *Discourses on Art*, ed. Robert R. Wark (New Haven and London, 1975), Discourse VI, p.107.

[6] *Letters of Josiah Wedgwood*, 3 vols. (reprinted 1903; Manchester, 1973), Vol.II, p.390. David Bindman has suggested the origins of the various figures in *John Flaxman* (London, 1979), p.52.

[7] I am grateful to Robin Emmerson, on whose text I have drawn freely, for letting me see his *Catalogue of Wedgwood Ceramics in the Lady Lever Art Gallery* in typescript. The translation of Ausonius is from his catalogue and derives originally from Michel-Ange de la Chausse, *Romanum Museum*, 2 vols. (Rome, 1746), Vol.II, pp.73–4.

[8] Emmerson makes this observation in his manuscript catalogue entry for this piece (see previous note). Joseph Spence, *Polymetis; or, an Enquiry Concerning the Agreement Between the Works of the Roman Poets and the Remains of the Antient Artists* (London, 1747). See also *Letters of Josiah Wedgwood*, 6 October 1778, Vol.II, p.453.

[9] Wetenhall Wilkes, *An Essay on the Pleasures and Advantages of Female Literature* (London, 1741), p.17.

[10] John Duncombe, *The Feminiad: A Poem* (London, 1754), pp.5–6.

[11] For a discussion of this work, see Elizabeth Eger, 'Representing Culture: "The Nine Living Muses of Great Britain (1779)"', in *Women Writing and the Public Sphere, 1700–1830*, eds. Elizabeth Eger, Charlotte Grant, Clíona Ó'Gallchoir and Penny Warburton (Cambridge, 2001), pp.104–32.

[12] See Reynolds (1975), Discourse VII. See also Marcia Pointon, *Strategies for Showing: Women, Possession and Representation in English Visual Culture 1665–1800* (Cambridge, 1997), esp. Chs.2, 5 and 6.

[13] Ibid., p.129.

[14] Montagu Pennington (ed.), *Letters from Mrs. Elizabeth Carter, to Mrs Montagu, Between the Years 1755 and 1800, Chiefly upon Literary and Moral Subjects*, 3 vols. (London, 1817), Vol.III, p.47–8.

[15] *The Ladies New and Polite Pocket Memorandum-Book for 1778*, advertisement, *London Chronicle*, 8–11 November 1777.

[16] Letter from Elizabeth Montagu to Elizabeth Carter, 24 November 1777, MO 3435, Huntington Library, San Marino, CA, cited in Eger, 'Representing Culture', pp.122–3.

[17] The sculptor John Francis Moore won a premium at the society for this allegorical bas-relief in 1766. He promptly presented it to them and it was erected over the chimneybreast. See *Minutes of the Committee of Polite Arts*, p.31, manuscript, Royal Society of Arts.

[18] Henry Home, Lord Kames, *The Elements of Criticism*, 2 vols. (3rd edition, Edinburgh, 1765), p.8, cited in Richard Samuel, *Remarks on the Utility of Drawing and Painting. To the Society Instituted at London for the Encouragement of Arts, Manufactures and Commerce* (London, 1786), p.3.

[19] *Biographium Faeminium. The Female Worthies: or Memoirs of the most Illustrious Ladies*, 2 vols. (London, 1766), Vol.II, p.x.

[20] George Ballard, *Memoirs of Several Ladies of Great Britain Who Have Been Celebrated for Their Writings or Skill in the Learned Languages, Arts and Sciences* (London, 1752), p.v.

[21] Harriet Guest, *Small Change: Women, Learning and Patriotism, 1750–1810* (Chicago, 2000), p.57.

[22] Bodleian Library, Ballard manuscripts, XLIII, fo.89, quoted in Sylvia Harcstark Myers, *The Bluestocking Circle: Women, Friendship and the Life of the Mind in Eighteenth-Century England* (Oxford, 1990), p.132.

[23] Clery, *The Feminization Debate*, p.167.

[24] *Catalogue of Cameos, Intaglios, Medals and Bas-Reliefs ... made by Wedgwood & Bentley and Sold at their Rooms in Great Newport Street London* (London, 1773), pp.45–6.

[25] *Letters of Josiah Wedgwood*, Vol.II, p.229.

[26] Ibid., p.232.

[27] Samuel Johnson, 'On Seeing a Portrait of Mrs Montagu', *c*.1779, in E.L. Macadam Jr (ed.), *The Yale Edition of the Complete Works of Samuel Johnson*, 18 vols. (New Haven and London, 1964–2005), Vol.VI, p.302.

[28] 'Observations on Female Literature', *Westminster Magazine*, June 1776, pp.283–5.

[29] Ibid., p.283.

[30] Letter from Elizabeth Carter to Elizabeth Montagu, 23 December 1777, in Pennington (ed.), *Letters from Mrs. Elizabeth Carter*, Vol.III, pp.47–8.

[31] My discussion of Carter's career and portraits draws on the research of Clare Barlow, to whom many thanks are due.

[32] 'Sylvius' [John Duick], 'To Miss CART–R, *Author of the Riddle in Nov. 1734*', *Gentleman's Magazine*, Vol. V, June 1735, p.321.

[33] Clery, *The Feminization Debate*, p.79.

[34] Montagu Pennington (ed.), *Memoirs of the Life of Mrs. Elizabeth Carter with a New Edition of Her Poems* (London, 1807), p.30, in response to Alexander Pope's *The Dunciad* (1728) and *Epistle to a Lady* (1739).

[35] *Gentleman's Magazine*, Vol.VIII, August 1738, p.429. For a discussion of this incident see Clery, *The Feminization Debate*, pp.74–5.

[36] Ibid.

[37] Revd Thomas Birch, 'Review', *History of the Works of the Learned*, Vol.I, 1 June 1739, pp.391–408.

[38] Pennington (ed.), *Memoirs of the Life of Mrs. Elizabeth Carter*, p.22. See also Clery, *The Feminization Debate*, pp.77–8.

[39] 'ALCAEUS' [Samuel Boyse], 'On Miss CARTER's being drawn in the Habit of Minerva, with Plato in her Hand', *Gentleman's Magazine*, Vol.XI, May 1741, p.271.

[40] William King, *An Historical Account of the Heathen Gods and Heroes; Necessary for the Understanding of the Ancient Poets* (London, 1710), p.88.

[41] 'ALCAEUS', 'On Miss CARTER's being drawn in the Habit of Minerva, with Plato in her Hand', p.271.

[42] Lady Sarah Penington, *An Unfortunate Mother's Advice to her Absent Daughters* (7th edition, London, 1784), p.41.

[43] Sophia, or a person of quality, *Woman's Superior Excellence over Man. A Short and Modest Vindication of the Natural Right of the FAIR-SEX to a Perfect Equality of Power, Dignity, and Esteem, with Men* (2nd edition, London, 1740), p.27.

[44] *Athenian Mercury*, Vol.XII, No.4, 4 November 1693, n.p.

[45] Norma Clarke, *Dr Johnson's Women* (London and New York, 2000), p.58.

[46] M.H. (Hester Chapone, née Mulso), 'An Irregular Ode. To E.C. who had recommended to me the Stoic Philosophy, as productive of Fortitude, and who is going to publish a Translation of

Epictetus', in Elizabeth Carter (trans.), *All the Works of Epictetus, which are now extant* (London, 1758), n.p.

[47] *Monthly Review, or Literary Journal*, Vol.XVIII, June 1758, p.588.

[48] Montagu Pennington (ed.), *Memoirs of the Life of Mrs. Elizabeth Carter*, 2 vols. (reprint, London, 1808), Vol.I, p.212.

[49] *Letters Concerning the Present State of England, Particularly Respecting the Politics, Arts, Manners and Literature of the Times* (London, 1772), p.257.

[50] *A Series of Letters between Mrs Elizabeth Carter and Miss Catherine Talbot, 1741–1770*, 2 vols. (London, 1808), Vol.II, p.20.

[51] Jonathan Richardson, *An Essay on the Theory of Painting* (London, 1715), p.187.

[52] Francis Haskell and Nicholas Penny, *Taste and the Antique: The Lure of Classical Sculpture* (New Haven and London, 1981), pp.300–301.

[53] E.W. Montagu, *Reflections of the Rise and Fall of Antient Republics. Adapted to the Present State of Great Britain* (London, 1760), p.339.

[54] Macaulay will be a subject of discussion in Ch.3. For an extended analysis of this engraving and Macaulay as a Roman matron, see Kate Davies, *Catharine Macaulay and Mercy Otis Warren: The Revolutionary Atlantic and the Politics of Gender* (Oxford, 2005), pp.109–21.

[55] Letter from Elizabeth Montagu to Elizabeth Carter, 30 June 1765, quoted in Harriet Guest, 'Bluestocking Feminism', in *Reconsidering the Bluestockings,* eds. Nicole Pohl and Betty A. Schellenberg, (San Marino, CA, 2003), pp.59–80, pp.70–71.

[56] J. Hawkins (ed.), *The Works of Samuel Johnson*, 14 vols. (London, 1787), Vol.XI, p.205.

[57] Frances Reynolds, *An Enquiry Concerning the Principles of Taste, and of the Origin of our Ideas of Beauty &c.* (London, 1785), p.26.

[58] James Boswell, *Life of Johnson*, ed. G.B. Hill, 6 vols. (2nd edition, Oxford, 1934–64), Vol.II, p.362, cited in Angela Rosenthal, 'She's Got the Look! Eighteenth-Century Female Portrait Painters and the Psychology of a Potentially "Dangerous Employment"', in *Portraiture: Facing the Subject*, ed. Joanna Woodall (Manchester and New York, 1997), pp.147–66, p.147.

[59] Before the discovery and recent acquisition of this picture by the National Portrait Gallery, a copy in the Museum zu Allerheiligen, Schaffhausen, was incorrectly published as Moser's original self-portrait.

[60] Marcia Pointon, 'Portrait! Portrait!! Portrait!!!', in *Art on the Line: The Royal Academy Exhibitions at Somerset House 1780–1836*, ed. David Solkin (New Haven and London, 2001), p.93.

[61] Kauffmann's self-portraiture is explored in Angela Rosenthal, *Angelica Kauffmann, Art and Sensibility* (New Haven and London, 2006), see especially Ch.7, on which the current account draws.

[62] *London Chronicle*, 30 April–2 May 1773, p.421, cited in Eger, 'Representing Culture', p.118.

[63] Antonio Zucchi, *Memoria delle Pitture*, translated in Lady Victoria Manners and G.C. Williamson, *Angelica Kauffman, R.A.: Her Life and Her Works* (London, 1924), p.160.

[64] Reynolds (1975), Discourse IV, p.70.

[65] Letter from Edward Gibbon to Lady Sheffield, 22 October 1784, in R.E. Prothero (ed.), *The Private Letters of Edward Gibbon 1753–1794*, 2 vols. (London, 1896), Vol.II, p.117.

[66] Maria Fairweather, *Madame de Staël* (London, 2005), p.284.

[67] Angelica Gooden, *Madame de Staël, Delphine and Corinne* (London, 2000), p.64.

[68] Germaine de Staël, *Corinne, or Italy*, 2 vols. (London, 1894), Vol.I, Book 2, Ch.1.

[69] Letter from Germaine de Staël to Henri Meister, 18 September 1807, translation in Mary D. Sheriff, *The Exceptional Woman: Elisabeth Vigée-Lebrun and the Cultural Politics of Art* (Chicago, 1996), p.241. My account of this painting is much indebted to Sheriff's extended analysis.

[70] Letter from Germaine de Staël to Henri Meister, 25 August 1807, reproduced in Yvonne Bezard, *Madame de Staël d'après ses portraits* (Paris, 1938), p.16, my translation.

71 *The Memoirs of Elisabeth Vigée-LeBrun*, translated by Siân Evans (London, 1989), p.281.

72 Undated letter from Elisabeth Vigée-LeBrun to Germaine de Staël, reproduced in Bezard, *Madame de Staël*, p.17, my translation.

73 Mme Beaufort d'Hautpoul, verses translated in Evans, *The Memoirs of Elisabeth Vigée-LeBrun*, p.283.

74 Letter from Germaine de Staël to Elisabeth Vigée-LeBrun, 14 July 1809, cited in Sheriff, *The Exceptional Woman*, pp.260–61.

75 Evans, *The Memoirs of Elisabeth Vigée-LeBrun*, p.281.

76 The phrase comes from Mario Praz's exposition on this subject in his *On Neoclassicism* (London, 1969). See also Helen O. Borowitz, 'Two Nineteenth-Century Muse Portraits', *Cleveland Museum Bulletin*, Vol.LXVI, September 1979, pp.247–67.

77 Ellen Peel and Nanora Sweet, '*Corinne* and the Woman as Poet in England: Hemans, Jewsbury and Barrett Browning', in Karyna Szmurlo, *The Novel's Seductions: Staël's Corinne in Critical Inquiry* (Lewisburg and London, 1999), pp.204–20, p.207.

78 Lord Byron, letter of 20 November 1813, cited in Jonathan Wordsworth and Stephen Hebron, *Romantic Women Writers* (Grasmere, 1994), p.57.

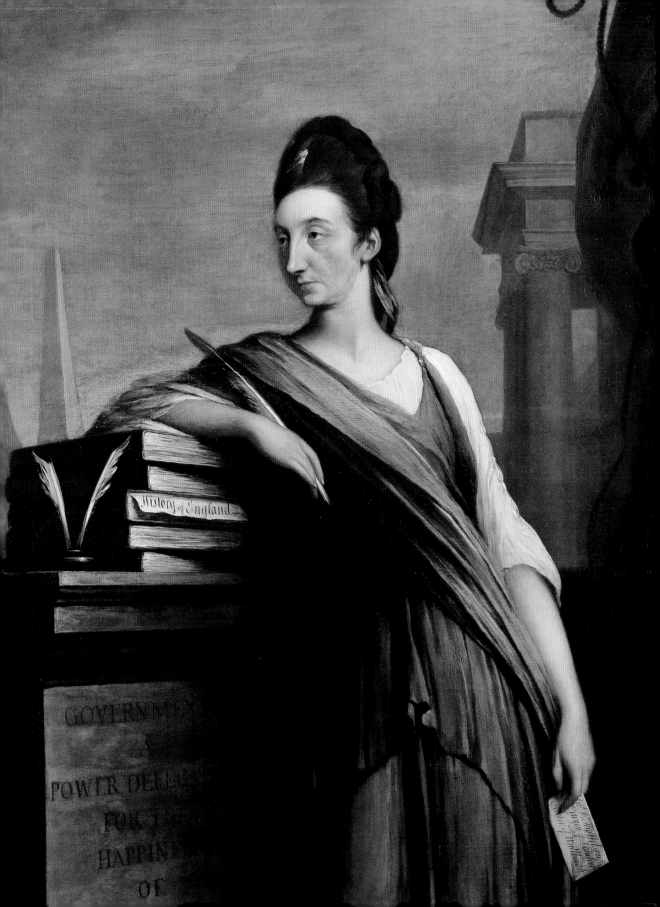

History of England

GOVERNMENT
A
POWER DELEG
FOR
HAPPIN
OF

'A Revolution in Female Manners'
Women, Politics and Reputation in the Late Eighteenth Century
LUCY PELTZ

Those who are bold enough to advance before the age they live in,
and to throw off, by the force of their own minds, the prejudices
which the world … will in time disavow, must learn to brave censure.
We ought not to be too anxious respecting the opinion of others.

Mary Wollstonecraft to Mary Hays, *c*.1797[1]

From the American Declaration of Independence in 1776 to the end of the
Napoleonic Wars in 1815, Britain's economic, social and political stability was
in turmoil. Against this backdrop of revolution in America and France, relations
between the sexes – and the proper roles of each – were increasingly challenged.
While the figure of the respectable female poet or writer of sentimental fiction
and didactic literature had become a cultural commonplace, there was a new
backlash against women asserting their views in the more 'masculine' genres of
history and politics – especially when these views were oppositional or seditious.
A tightening of gendered boundaries and new strictures on female self-
expression can be particularly identified in the reception and troubled
reputations of a new generation of political voices: the republican Catharine
Macaulay, the radical Mary Wollstonecraft and the conservative Hannah More.

Macaulay and the *History of England*
One of the leading political activists of her time, Macaulay came to public
attention with a magisterial eight-volume study of the *History of England*
(1763–83). This was initially welcomed as a radical Whig answer to
David Hume's influential Tory *History of Great Britain* (1754–62). In the
Introduction, Macaulay reflects on her education and the formation of her
political convictions by asserting that her 'natural love of Freedom' was excited
from childhood by reading the 'annals of the Roman and Greek republics'.[2]
What she does not articulate is her participation in radical opposition circles
that critiqued government incompetence, corruption and abuse of the royal
prerogative. They sought to resuscitate the traditional English liberties which
had been reaffirmed after the 'Glorious Revolution' of 1688. For these reasons,
Macaulay's *History* focuses on key seventeenth-century events – the Civil War,

the execution of Charles I and the impact of the Commonwealth – and was a highly charged contribution to the radical Whig programme for political reform.

Macaulay's position was uncompromisingly radical but all critics, irrespective of their leanings, lingered not on the political tenor of her work but on the novelty of the 'Female Cicero' or 'Fair Historian'.[3] The language, ever tempered by gendered expectations, contrasted her sex with the masculine force of her writing. This was the case in the *Monthly Review*, which praised the 'fair Macaulay' for her 'laborious' achievement 'of collecting and digesting … political fragments which have escaped the researches of so many learned and ingenious men'.[4] Still, the *Monthly Review* could not reconcile themselves to the idea of a woman with academic ambitions: 'We would not recommend such a laborious composition to the practice of our lovely countrywomen' for 'intense thought spoils a lady's features'.[5] For those critics who admired Macaulay's work, it was the masculine style that excited them. The *History*, 'untinctured with the weakness of the female pen', was 'bold and fervid' and 'most manly, generous and patriotic'.[6]

On both sides of the Atlantic, Macaulay's *History* and her other political tracts of the 1760s and 1770s had a substantial impact. American Patriots longing for liberty from the swingeing laws and taxes imposed by a distant central government saw the *History* as an inspiration. John Adams (1735–1826), one of the founding fathers of the United States, enthused that it was 'calculated to strip off the Gilding and false Lustre from worthless Princes and Nobles, and to bestow the Reward of Virtue … upon the worthy only'.[7] Even Macaulay's great political opponent, Edmund Burke (1729/30–97), reacting to her radical critique of his *Thoughts on the Cause of the Present Discontents* (1770), exclaimed, 'the virago is the[ir] greatest champion'.[8] While Burke here clearly intended a slight on both Macaulay's femininity and her radical peers, the label 'virago' – a woman who acts with the power and manner of a man – tacitly recognized her masculine prowess as a political figure.[9]

Representing a Republican Ideal

Macaulay was not publicity-shy, unlike many female authors of the time. Throughout the 1760s and 1770s she and her supporters used a variety of media to establish her as a spokesperson and figurehead of the radical cause. Eulogies were written, oil portraits were exhibited and engravings were published – Lord Lyttelton remarked that her face was to be found 'on every printseller's counter'.[10] By 1765 she had been painted twice by Katharine Read,

Catharine Macaulay as Libertas
James Basire, after Giovanni
Battista Cipriani, 1765
Line engraving, 301 x
235mm (11⅞ x 9¼")
National Portrait Gallery,
London (NPG D31912)

once holding the 'Magna Charter' and again 'in the Character of a Roman
Matron lamenting the lost Liberties of Rome' (see p.76). These compositions
signal Macaulay's commitment to the sovereignty of Parliament and
representative government.

The most widely circulated image of Macaulay was Cipriani's engraving
of her as Libertas. Designed and commissioned by Thomas Hollis (1720–74),
a friend and fellow radical, the print appeared in 1765 and was used as the
frontispiece to the third volume of Macaulay's *History* in 1767. Hollis was
a philanthropist who devoted his wealth to promoting liberty, partly by the

production and distribution of pamphlets and engravings that espoused the cause. He based the design on a Republican Roman coin in his collection. The inscription in Hollis's own copy of Macaulay's *History* explains the propagandistic programme behind the design: 'The author … is represented in the print in the character of the Libertas on the Roman denarius stricken by Brutus and Cassius after the exit of Julius Caesar, the tyrant, and the reverse of that denarius sheweth those heroes … going to sacrifice to Liberty.'[11] The print's iconography links Macaulay with the feminine personification of an abstract ideal, Liberty. It also likens her to Brutus, whose uncompromising self-sacrifice for the public good culminated in the execution of his own sons for conspiracy. Hollis thus figured Macaulay as the living embodiment of republican virtue and at the same time implied that her sex afforded her a special objectivity, which others, such as William Pitt (1759–1806) and Edmund Burke, could not share for being active participants in the degenerate arena of government. Moreover, at a time when aspects of public masculinity were tainted by corruption and labelled 'effeminate', it was Macaulay's gender that allowed her to become, like Brutus, the champion of republican probity and potency.

Pleased with Hollis's *Libertas*, Macaulay used the design again in the second edition of her book. But in *The History of England … in a Series of Letters to a Friend* (1778), her next book, she chose another politicized portrait to be engraved for a frontispiece. Painted around 1775 by fellow radical and American sympathizer Robert Edge Pine (1730–88), this shows Macaulay leaning imposingly on the volumes of her *History* and holding an exaggerated quill (see p.94). The painting is one of a small group of portraits that used Roman imagery to convey a contemporary political message associated with the struggle for American independence. In this group, most notably, is Benjamin West's portrait of Macaulay's brother John Sawbridge.[12] He was a Whig MP and founder member of the radical Society of Gentlemen Supporters of the Bill of Rights (1769–75). By showing Sawbridge as a Roman tribune, West connects him with the protection of plebeian interests against patrician tyranny. He rests his hand on a marble plinth inscribed 'S.P.Q.R.' – the Latin abbreviation for the Senate and the Roman people. Macaulay's portrait, perhaps intended as a counterpart to her brother's, shows her wearing a purple sash – the distinctive mark of a man belonging to the ancient Roman Senate or legislature – even though as an eighteenth-century woman she could never have held elected office. As in her brother's portrait, she is shown in a Forum-like setting with a plinth on which is a programmatic inscription:

Alderman John Sawbridge, 1732–95
Thomas Watson after Benjamin West, 1 November 1772
Mezzotint, 622 x 377mm (24½ x 14⅞")

The Political Platonic Lovers
Published in the *Town & Country Magazine*, 1777
Line engraving, 106 x 175mm (4⅛ x 6⅞")
National Portrait Gallery, London (NPG D32138)

The *Town & Country Magazine*'s series of illustrated articles on the 'romantic' history of the subjects depicted, 'Tête-à-Tête', was published between 1762 and 1792. While the format of the illustrations consciously emulated marriage portraits or miniatures exchanged by lovers, the pairings were often rather more scurrilous or cynical than first appeared.

'GOVERNMENT / A POWER DELEGATED / FOR THE / HAPPINESS / OF / MANKIND'. An engraving that records the appearance of Pine's full-length portrait before it was cut down continues the inscription, with the manifestly republican sentiment that the ideal government should be 'CONDUCTED / BY / WISDOM / JUSTICE / AND / MERCY'. While these words epitomize, if they do not exactly quote, Macaulay's views, the letter in her left hand indicates her personal debt to 'Revd. Dr: Thos Wilson / Citizen of London / and / Rector of Wallbrook'. A friend and patron, Wilson probably commissioned Pine's portrait and certainly supported Macaulay in her work after she was widowed and moved to Bath in 1774.

'Frailty, Thy Name is Woman!': Gender, Controversy and Excess[13]

If radical politics in the 1760s and early 1770s had encouraged Macaulay to assume the masculine roles of historian and political commentator, her eventual fall from grace resulted from a profound shift in the political landscape and, concomitantly, a sharp focus on her flagrant transgression of female conventions. By 1783 the *European Magazine* could reflect on events by noting that Macaulay had 'experienced more of the extremes of adulation and obloquy than any one of her own sex in the literary world'.[14]

The turning point was the American Declaration of Independence in 1776. At this juncture, much of Britain came to feel that part of their history and identity was under substantial threat. Open support for an independent republic was a position increasingly difficult to sustain in public life. Macaulay nonetheless remained a staunch republican, although her praise for the

A Speedy and Effectual preparation for the next WORLD.

A Speedy and Effectual Preparation for the Next World
Matthew Darly, 1777
Hand-coloured engraving,
245 x 350mm (9⅝ x 13¾")
The British Museum, London

Darly's satire works on several levels. While Macaulay is primarily critiqued for deluded vanity and flouting female conventions, her American sympathies are suggested in the feathered hairdo reminiscent of native American headdresses.

Commonwealth as 'the brightest age that ever adorned the page of history' made her vulnerable to accusations of favouring regicide.[15] And while many of her radical compatriots adopted a lower profile, her life in Bath became increasingly flamboyant – and a subject of vicious satire.

The focus was her unconventional living arrangements with her admirer, the Reverend Thomas Wilson (1703–84), who was nearly thirty years her senior. Although Macaulay was undoubtedly attracted to his library, his intellectual company and his partisan politics, many assumed her motives were less pure. As David Hume wrote, 'There is one Dr Wilson, a man zealous for Liberty, who has made her a free and full Present of a House of £2000 Value … and intends to leave her all his Fortune, which is considerable.'[16] Macaulay's relationship was first satirized in the *Town & Country Magazine* (see p.99), in its 'Tête-à-Tête' series, which usually brought public attention to illicit romantic liaisons between society figures. Although entitled 'The Political Platonic Lovers', it of course made imputations of sexual impropriety. The relationship was again lampooned in *A Speedy and Effectual Preparation*

for the Next World, in which Wilson's portrait hangs on the wall. Both satires attack Macaulay's 'rather inflated vanity', which, the *Town & Country Magazine* implied, was the result of having her head turned by extensive flattery and her consequent assumption that she was somehow above normal behaviour.[17] *A Speedy and Effectual Preparation* develops the theme of vanity by representing Macaulay as a deluded old widow with an unseemly interest in cosmetics and fashion. Seated at her dressing table, her ludicrous tall hair is bedecked with a hearse drawn by plumed horses. Like so many fashion satires of the period, this mocks the 'present mode for dressing the head' that Hannah More deemed 'absurd, extravagant and fantastical'.[18] The 'rouge' that Macaulay applies was also emotive. It was filled with nationalist and sexual symbolism because make-up was equated with French manners and the perversion of 'natural' and polite femininity. Elizabeth Carter criticized Macaulay in a letter: 'I think one never heard of any body, above the degree of an idiot, who took pleasure in being so dressed out with the very rags and ribbons of vanity.'[19]

This satire's several references to mortality not only turn Macaulay's vanity into *vanitas* but also refer to the illness she had suffered while writing the fifth volume of her *History*. These circumstances were well known, as Macaulay's quack doctor, James Graham (1745–94), had published a long and explicit letter regarding her treatment and return to health. And as if this publicity was not sufficiently compromising, Wilson threw a lavish and theatrical birthday party to celebrate her recovery. An account of the festivities was given in the press. Seated on an 'elevated' throne before a 'polite and brilliant Audience', Macaulay was presented with six adulatory odes that variously extolled her as the 'Genius of Liberty', Minerva – goddess of wisdom – and first among all of Britain's literary women.[20] These hyperbolic panegyrics were then quickly ushered into publication.

Reflecting on the astonishing extravagance of these events, Carter was in no doubt who to blame for this breach of good sense. She wrote sanctimoniously, 'surely nothing ever equalled that farcical parade of foolery with which she suffered herself to be flattered, and almost worshipped, by that poor old wrong-headed firebrand [Wilson]'.[21] Describing her as a 'queen in a puppet show', Carter – and others – were struck by the hypocrisy of the republican Macaulay being feted as 'Queen Catharine'.[22] The *Monthly Review* thought that Wilson and Macaulay were akin to 'FOLLY worshipping at the shrine of VANITY', and this damaging farce turned increasingly into scandal over the ensuing months.[23]

***Catharine Macaulay as
History***
J.F. Moore, 1778
Marble, height 2000mm
(78¾")
Warrington Borough
Council: Libraries, Heritage
and Learning

After the ignominious end
to his relationship with
Macaulay, Thomas Wilson
removed this sculpture from
his church and it was
immediately lost from sight.
On his death, Wilson left his
property to a cousin at Bank
Hall, Warrington, and the
sculpture came into public
ownership 100 years later
when a descendant
sold Bank Hall and its
fixtures to the Corporation
of Warrington for use as a
town hall.

From Minerva to Monster

Five months after the 'ridiculous' birthday party, Wilson unveiled a marble
statue of *Catharine Macaulay as History* in St Stephen's Walbrook, the London
church of which he was absentee rector.[24] The larger-than-life sculpture by
John Francis Moore (d.1809) presents Macaulay in an unusually severe classical
style, which lacks the feminine undulations and softness characteristic of neo-
classical female sculpture. As in Pine's oil painting, Macaulay leans against
a plinth topped by volumes of her *History*. In her hands she holds an unfurled
blank scroll and quill. The drapery is austere and antiquarian in its detail.
The emblems on her brooch and buckle – the owl of Minerva, a liberty pole

THE *AUSPICIOUS* MARRIAGE!

The Auspicious Marriage!
'T.H.', published in T*own &*
Country Magazine, 1778
Engraving,125 x 104mm
(4⅞ x 4⅛")
Private Collection

surmounted by a Phrygian bonnet and Mercury's winged staff with intertwined snakes – for eighteenth-century viewers would have collectively signalled Macaulay as a bellicose fusion of the gods of wisdom, war and international commerce. But as the sculpture was intended to be seen from a distance, these minutiae would be subsumed by the statue's monumental evocation of Macaulay as the personification of History.

The sculpture received considerable public attention, much of it negative. The *Gentleman's Magazine* complained of a 'Christian divine' turning his church into a 'Heathen temple' and the *Lady's Magazine* listed the accusations of 'prostituting the church' and 'giving rise to idolatry'.[25] The churchwardens too were irate, disturbed that a republican, shown as a pagan deity, was positioned in their place of Christian worship. They insisted that the 'church was not a proper place for *enthusiastic Party and politicks*'.[26]

Despite threats of litigation, Wilson refused to remove the statue, at least not until the end of the following year, when Macaulay suddenly married William Graham – the 21-year-old brother of her physician. The prospect of this 47-year-old historian – and champion of the republican cause – marrying a poorly educated ship's mate less than half her age had predictable consequences in polite society. A plethora of salacious satires, both literary and graphic, delighted in exposing the marriage as an abomination. A cheap wood-block satire, *The Auspicious Marriage!* (see p.103), which includes 'emblems of lust, folly and dotage', neatly sums up the charges against her.[27] The overdressed and towering figure of Macaulay – her height exaggerated by her plumed headdress decorated with a fool's cap – is juxtaposed with the diminutive and childlike Graham, who leads her to the altar. In her hurry to flee Wilson's 'Alfred House', she tramples over volumes of her own work, her pen and ink and the liberty pole. These motifs were meant to suggest that her intellect and principles have been eclipsed by carnal passion. With Cupid asleep on the floor and Hymen – god of marriage – hiding his eyes, the match is presented as not only unnatural but sinister. If Graham's love is not real, then the inference is that Macaulay has been seduced by a charlatan for her expected inheritance, the legacy it was assumed that Wilson had left in his will. *The Auspicious Marriage!* was one of many satires. Several took the form of fictitious letters, but all revel – in more or less titillating terms – in Macaulay's struggle with ambition, politics, greed and lust.

Macaulay's marriage was the final straw for many. John Wilkes (1725–97), who had originally been a leader of the radical movement and was sympathetic to Wilson's situation, described her as a 'monster', while Horace Walpole, a former enthusiast for her *History*, reflected more generally on how 'sense may be led astray by the senses'.[28] Elizabeth Montagu, who thought Macaulay's politics made her *History* unreadable, saw the root of the problem as a violation of gender boundaries: 'All this has happened from her adopting masculine opinions and masculine manners. I hate a woman's mind in men's cloaths … I always look'd upon Mrs Macaulay as rather belonging to the lads … than as one of the gentle sex. Indeed, she was always a *strange fellow*.'[29]

The analysis is concise. Women had long been expected to protect themselves through public displays of virtue and respectability. Transgressions of gender and propriety shaped Macaulay's public reputation. To her supporters she was both the 'fair historian' and a female politician; to her detractors she was a vain and deluded old woman or a frightening virago. As Mary Hays (1759–1843), an early feminist commentator, concluded, Macaulay may have

Madam

Now I venture to send you with a name utterly unknown to you in the title 'age, it is necessary to apologize for thus intruding on you — but instead of an apology shall I tell you the truth? you are the only female writer who I coincide in opinion with respecting the rank our sex ought to endeavour to attain in the world. I respect Mrs Macaulay Graham because she contends for laurels whilst most of her sex only seek for flowers.

I am Madam,
your Respectfully

Mary Wollstonecraft

Thursday Morning.

been an exception as 'a female historian' but, having 'stepped out of the province of her sex … [she] was attacked by petty and personal scurrilities, to which it was believed her sex would render her vulnerable'.[30]

'Amazonian Allies': Macaulay and Wollstonecraft[31]

The scandal surrounding Macaulay's second marriage irrevocably compromised her reputation but did not stop her writing. In the 1780s she completed her *History* and in 1784 she journeyed to America, where she was feted by leading figures of the War of Independence. Although she died at the start of 1791, this was not before she had made a foray into feminist debate with her *Letters on Education* (1790). She also wrote *Observations on the Reflections of the Rt. Hon.*

Edmund Burke (1790), a riposte to Burke's conservative reaction to news of the Revolution in France and the dire consequences, in his view, for Britain.

Macaulay's two final works attracted the attention of Mary Wollstonecraft, a relatively unknown writer who was running a school when she published *Thoughts on the Education of Daughters* (1787). This was a 'conduct book', one of the few genres deemed acceptable for women writers (see Ch.1). A year later Wollstonecraft wrote a semi-autobiographical novel, *Mary, a Fiction* (1788), in which she created an independent female protagonist 'whose grandeur is derived from the operations of [her] own faculties, not subjugated to opinion'.[32] Also in 1788 she began to work for Joseph Johnson, who published the radical *Analytical Review*, and it was there that her admiration for Macaulay was first declared, in a review of *Letters on Education*. She praised Macaulay's 'sound reason and profound thought' on the raising and education of children.[33] In *Letters on Education* Wollstonecraft evidently found parallels with her own views on the importance of parental nurture and the coeducation of girls and boys. She empathized as well with Macaulay's attack on the way girls were expected to 'counterfeit … weakness in order to attract the notice of the male'.[34] And while Wollstonecraft had formerly imagined herself the 'first of a new genus' on becoming a published author, in 1790 she was pleased to identify Macaulay as a female role model.[35] Her enthusiastic sense of affinity with the ageing radical is evinced in the unsolicited and bold letter that she wrote to Macaulay in mid-December 1790 (see p.105):

> Madam,
> Now I venture to send you […], with a name utterly unknown to you in the title page, it is necessary to apologise for thus intruding on you – but instead of an apology shall I tell you the truth? You are the only female writer who I consider in opinion with respecting the rank our sex ought to attain in the world. I respect Mrs Macaulay Graham because she contends for laurels whilst most of her sex only seek for flowers.[36]

While the final sentence of the letter captures the spirit of the two writers' shared interest in promoting a new model of assertive womanhood, it is the first (now expurgated) line that indicates Wollstonecraft's principal excuse for writing to Macaulay without prior introduction. With this letter she had enclosed a copy of her pamphlet *A Vindication of the Rights of Men* (1790), an impassioned reply to Burke's reactionary *Reflections on the Revolution in France* (1790). The letter to Macaulay was therefore an attempt to forge a connection

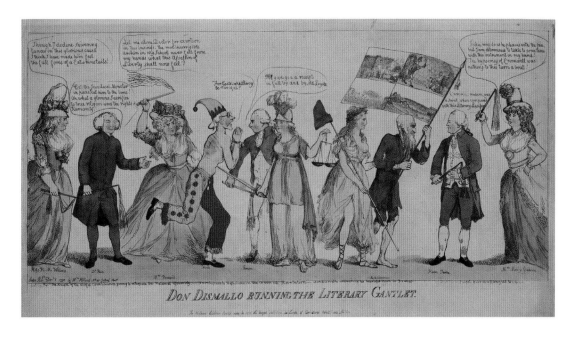

with a kindred political and intellectual woman whose own published attack on Burke's *Reflections* had just appeared. Like other radicals, Macaulay and Wollstonecraft had welcomed the storming of the Bastille in July 1789. Wollstonecraft later summed up the mood in her *An Historical and Moral View of the Origin and Progress of the French Revolution* (1794), stating that a 'new spirit has gone forth, to organise the body-politic … Reason has, at last, shown her captivating face.'[37]

A Vindication was Wollstonecraft's first major success and moved her into the masculine terrain of political discourse. It argued in favour of a more meritocratic society and scorned the privilege and property of aristocratic hierarchy defended by Burke. The first edition of the pamphlet made no mention of her name and many critics assumed it was the work of a male pen. The *Analytical Review* knew better and their critic could not resist mocking Burke on this point: 'How deeply must it wound the feelings of a *chivalrous knight* … to perceive that two of the boldest of his adversaries are women!'[38] For conservatives in Britain desperate to maintain the status quo, the traditional deference between men and women took on an increasingly politicized meaning. In this context, the image of the empowered or transgressive woman – particularly as seen in the French mob – became doubly emotive. A good example of this is the satire *Don Dismallo Running the Literary Gantlet*.

Don Dismallo Running the Literary Gantlet
Published by William Holland, 1790
Hand-coloured etching, 325 x 603mm (12¾ x 23¾")
The British Museum, London

The etching was published by William Holland, a radical print seller, a month after the publication of Burke's *Reflections*. It portrays Burke in the character of Don Dismallo, the deluded knight from the popular novel *Don Quixote*, who champions chivalrous but pointless causes like the French monarchy. Dressed in a fool's costume, Burke is shown running past a line of opponents, each armed with a cat-o'-nine-tails to chastise him. To the left of Burke are the poet Helen Maria Williams (1761–1827), the Dissenting minister and polemicist Richard Price (1723–91) and the poet and essayist Anna Letitia Barbauld. To Burke's right are Richard Brinsley Sheridan (1751–1816), the playwright and MP, who opposed him in the House of Commons, the figures of Justice, holding out her sword, and Liberty, who turns her back on Burke to support a frail figure with a banner bearing scenes from the fall of the Bastille. To their right are John Horne Tooke (1736–1812), another radical MP, and Macaulay. She, like the other women, wears the tricolour ribbons of France.

All of the people in this print are linked by their support for the Revolution. The women were distinguished for refuting Burke in print, or so it seemed. Williams, who was noted for her sympathetic, eyewitness *Letters Written in France* (1790), had composed a poem in praise of the storming of the Bastille in her novel *Julia* (1790). The forthcoming publication of Macaulay's answer to Burke had been announced and appeared at the start of December, and Barbauld, who had first opposed Burke in March 1790 in her *Address to the Opposers of the Repeal of the Corporation and Test Acts*, was also assumed to be writing a reply to his *Reflections*.[39]

While only a handful of the responses to Burke were by women, *Don Dismallo* indicates that the gender of this group raised special anxieties. Horace Walpole, who shared Burke's anti-revolutionary conservatism, dismissed them as cheap hacks who 'spit their rage at eighteen pence a head' and vilified them as 'Amazonian allies, headed by Kate Macaulay and the virago Barbauld, whom Mr Burke calls our *poissardes* [fishwives]'.[40] By citing Burke's description of working-class women in the French mob – the 'furies of hell' – Walpole signalled conservative fears of gender propriety and female activism.[41]

Vindicating the Rights of Woman

Wollstonecraft's *Vindication* appeared just a few days before *Don Dismallo*, which explains why she is not figured in the print. It received 'extraordinary notice', especially once it was identified as the work of a woman.[42] At the same time, her name became associated with other leading revolutionaries who, like Thomas Paine (1737–1809), had attacked Burke's *Reflections*. She met Paine

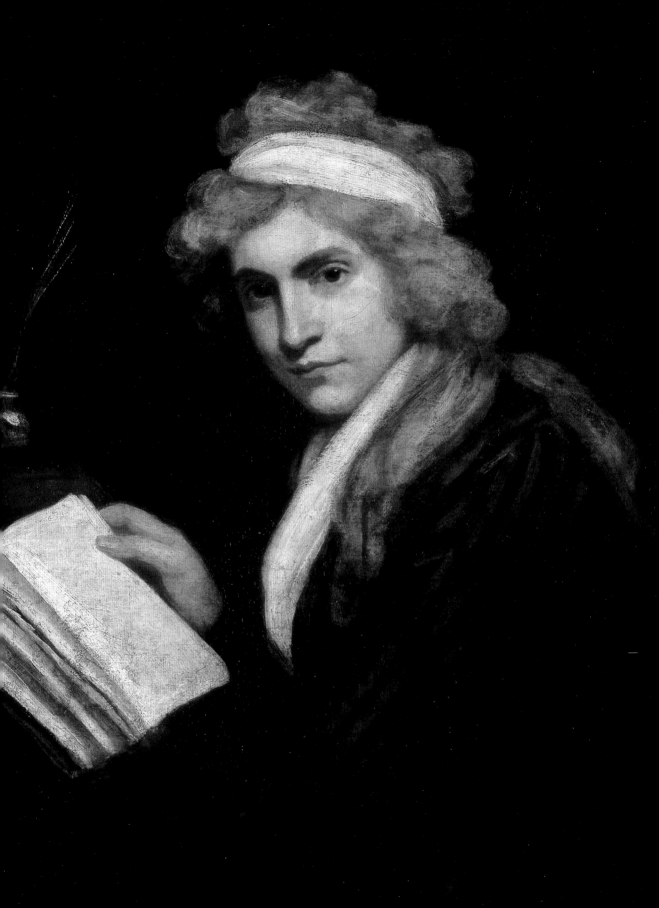

and many others through Joseph Johnson, the bookseller who was something of a father figure. He gave weekly dinners that were a meeting place for London's religious dissenters and political radicals. Among them were Henry Fuseli (1741–1825), an extrovert but married artist for whom Wollstonecraft developed a desperate infatuation and eventually proposed a *ménage à trois*, and William Godwin (1756–1836), a shy and awkward philosopher who was initially irritated by the way she monopolized the conversation but would later become her husband.

It was also due to Johnson that Wollstonecraft met John Opie (1761–1807), the fashionable artist who became her lifelong friend. His first portrait of her was painted in the period immediately following the publication of *A Vindication* (see p.109). It is a sensitive and confident image of a female author, showing her distracted momentarily from her studies. Opie's typically dark palette gives the additional sense that Wollstonecraft is working late into the night. While Fuseli had criticized her unconventional taste for coarse dress and dismissed her as a 'philosophical sloven', Wollstonecraft is shown here with the powdered hair and silk gown of a polite woman of the early 1790s.[43] There is no record of Wollstonecraft's views on this portrait. Her comments on sitting for another portrait at about the same time are, however, revealing. She wrote to her supporter William Roscoe (1753–1831), who had commissioned the portrait, 'I do not imagine that it will be a very striking likeness; but, if you do not find me in it, I will send you a more faithful sketch – a book that *I* am now writing, in which I myself … shall certainly appear, hand and heart.'[44] This comment contains both prosaic and psychological insight – apparently Wollstonecraft doubted the quality of the portrait but she was also uneasy about giving up control over the representation of herself. The book that she refers to in this letter was her next great success and the one with which her name is most commonly associated: *A Vindication of the Rights of Woman* (1792).

To call the *Rights of Woman* autobiography is an overstatement. The work does, however, tackle questions of female education, identity and autonomy that had preoccupied and affected Wollstonecraft for most of her adult life. English women, she argued, had been forced into narrow roles within society, trivialized as frivolous creatures whose purpose was to please men and denied access to education. And women were complicit in their own cultural subordination through their love of sentimental novels, gossip and fashion. In advocating serious study to lift a woman from sensation to intellect, Wollstonecraft's rallying cry was aimed at the radical reform of Britain as a whole: 'It is time to effect a revolution in female manners – time to restore

them their lost dignity – and make them, as part of the human species, labour by reforming themselves to reform the world.'[45]

Wollstonecraft renounced Christianity in 1790 and her proposals were rooted in her belief in 'perfectibility' – the doctrine that people can achieve perfection in this life. The work was also based on a levelling principle which had its inspiration in the French Revolution. Both were contentious positions to adopt and yet the *Rights of Woman* was greeted with approval in 1792. That is because most reviews treated it as 'an elaborate treatise on *female education*'.[46] Even the *Analytical Review* overlooked the radical elements and concluded, 'If the bulk of the great truths which this publication contains were reduced to practice the nation would be better, wiser and happier.'[47] The only periodical to attack the *Rights of Woman* was the Tory *Critical Review*. This correctly identified the revolutionary ambitions and implications of Wollstonecraft's proposals and decried the social impact if women, educated to the level of men, refused to continue in their allotted duties of childcare and nursing the sick. Ironically, the French revolutionary government concurred. Although Wollstonecraft had dedicated the book to the French diplomat Talleyrand (1754–1838), and although he had visited her in England, his report on education to the National Assembly in France expressed the view that women were indeed the weaker sex and should follow the 'will of nature' in pursuing gentler, domestic occupations.[48]

Wollstonecraft, *Memoirs* and Posthumous Reputation

Despite its initial success, *A Vindication of the Rights of Woman* and its author would become synonymous with libertarian immorality and would soon be shunned. The reasons for this fall from grace were manifold: the reception of Wollstonecraft's subsequent writings, the details of her private life and the increasingly repressive social and political situation. The personal details were revealed by her widower, William Godwin, whose *Memoirs of the Author of A Vindication of the Rights of Woman* (1798) was rushed into press four months after Wollstonecraft's gruesome death in childbirth in 1797.

Godwin, now a prominent radical philosopher, was grief-stricken and stayed away from the funeral. As he wrote, 'I have not the least expectation that I can ever know happiness again.'[49] During a deep and prolonged melancholy, his one consolation was reading Wollstonecraft's manuscripts, including an unfinished novel, *Maria, or the Wrongs of Woman*. Within two weeks, he had begun to write the *Memoirs*, which he published with four volumes of her posthumous works. While the exercise in biography may have been cathartic for Godwin,

Mary Wollstonecraft Godwin
James Heath after John Opie, published in *Memoirs of the Author of A Vindication of the Rights of Woman* by William Godwin (2nd edition; 1798)
The British Library

William Godwin had the frontispiece to this memoir engraved after John Opie's portrait of his late wife Mary. It shows her unusually serene around the time of their marriage and when pregnant with their daughter Mary (see p.131), who would elope with Percy Bysshe Shelley and write *Frankenstein, or the Modern Prometheus* (1818).

his inability to dissemble led to an overly frank exposé of Wollstonecraft's troubled life that ruined her reputation for generations to come.

From its title, Godwin clearly expected readers to be familiar with Wollstonecraft's key work. Yet in the first edition of *Memoirs of the Author of A Vindication of the Rights of Woman*, her work and intellect as a whole receive scant attention compared to the description of her life. True to his philosophical ideal that perfection could be achieved by reason alone, Godwin made no attempt to hide the less respectable events of Wollstonecraft's life. He shocked readers with details of how she had flung herself at a married Fuseli, had lived out of wedlock with Gilbert Imlay, by whom she had an illegitimate child, had twice attempted suicide, had become pregnant before her marriage to Godwin and, finally, had refused religious rites on her deathbed. In focusing on her personal life and distress, Godwin aimed to present his dead wife as a 'female Werther' – the doomed character in Goethe's influential novel *The Sorrows of Young Werther* (1774) – but his writing is more an exploration of his own feelings and the culture of sensibility than of the political philosophy of Wollstonecraft.[50]

By the mid-1790s Wollstonecraft was the most widely read political woman in Europe. While her death had been recorded by respectful obituaries, Godwin's *Memoirs* made a spectacle of her unconventional life. He described her as having 'sentiments as pure, as refined, and as delicate, as ever inhabited a human heart', but his principal mistake was to ask for sympathy for her plight and pose her as 'the fairest source of animation and encouragement to all who would follow'.[51] Godwin was of course deluded by grief, but he also misjudged the moral climate in presenting Wollstonecraft as a role model. Those periodicals that had applauded the *Rights of Woman* were almost unanimous in wishing Godwin had never written such a 'tribute' to his wife. Her posthumous reputation was also poorly served by his publication of her passionate, sometimes anguished, love letters and the unfinished *Maria,* which excuses adultery, argues for women to have control over their own property and is frank about female sexual appetites.

This was a boon to Wollstonecraft's opponents in the increasingly repressive climate that emerged in Britain following the Treason Trials of 1794, the naval mutinies of 1797 and the Irish Rebellion of 1798. Her life was turned into an emblem of Jacobin – that is, revolutionary – immorality in action. The government-sponsored *Anti-Jacobin Review* led an intense scurrilous attack to defame her and her beliefs. As if to sum up their position in the index for 1798, under the heading 'Prostitution', was printed 'see Mary Wollstonecraft'.[52] The *European Magazine* declared her a 'philosophical wanton', while Thomas James

Mathias (1753/4–1835) ironically condemned the woman who promoted rationality over sensibility as 'Fierce passion's slave [who] veer'd with every gust'.[53]

The Unsex'd Females

There was no literary model Godwin could use to depict Wollstonecraft as a subjective, intellectually assertive woman with desires without rendering her contemptible. Moreover, his catalogue of her sexual exploits and political beliefs provided a rod with which to beat all radical women writers. The grand inquisitor was the Reverend Richard Polwhele (1760–1838). His *The Unsex'd Females* (1798), a long verse-diatribe, is one of the most concerted critiques of late eighteenth-century feminist writers. Using the inflammatory category 'unsex'd', Polwhele identified and attacked women who had abandoned 'natural' modesty and deference, who supported the democratic politics of the French Revolution and who even went as far as to demand equality with men. Unsurprisingly, he considered Wollstonecraft the archetype 'unsex'd female':

> See Wollstonecraft, whom no decorum checks,
> Arise, the intrepid champion of her sex;
> O'er humbled man assert the sovereign claim,
> And Slight the timid blush of virgin fame.[54]

Besides Wollstonecraft, he named eight other 'unsex'd' women all of whom were published authors: Mary Hays, Helen Maria Williams, Catharine Macaulay, Anna Letitia Barbauld, Anne Jebb (1735–1812), Charlotte Smith (1749–1806), Mary Robinson (1756/58?–1800) and Ann Yearsley. Reinforcing the anti-Jacobin and misogynistic sentiment of the verse, Polwhele quoted from a similarly reactionary work, Mathias's *Pursuits of Literature*, to dismiss these women who 'now … confuse, us and themselves, in the labyrinth of politics, or turn us wild with Gallic frenzy'.[55] On closer inspection, what these 'unsex'd' women have in common is their literary independence, their support for progressive politics and their criticism of Britain's political, social and religious institutions.

While Polwhele confesses to prefer the 'crimsoning blush of modesty' to any 'spark of confident intelligence' in a woman, he was not entirely opposed to female learning.[56] He provides his reader with a list of exemplary 'seraphic' women writers – a sort of heavenly assemblage of virtuous, subordinate and God-fearing literary women.[57] Prominent among them are members of the bluestockings, including Elizabeth Montagu, Elizabeth Carter, Fanny Burney, Hannah More and Anna Seward. Polwhele's argument was that these earlier

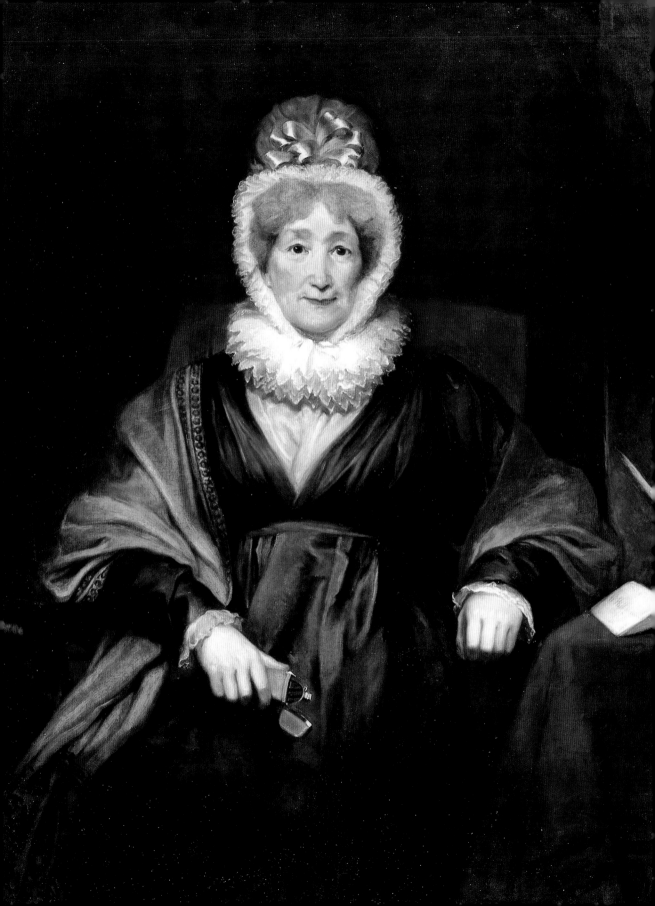

writers had cultivated female respectability and worked to build social ties between people rather than engender political faction. The battle between good and evil was perfectly clear in Polwhele's mind: 'Miss Hannah More may justly be esteemed, as a character, in all points, diametrically opposite to Miss Wollstonecraft.'[58] If Polwhele casts Wollstonecraft as the devil, then the God-fearing More, who promoted women's piety and philanthropy, was his saintly figure in the war against radical feminism.

Hannah More: A 'Bishop in Petticoats'?

In 1821, when Henry William Pickersgill (1782–1875) went to Devon to paint More's portrait, he met with an unwilling sitter. Even in her youth, when she had been an active figure in fashionable society, More had been troubled by the worldly vanity associated with portraiture and voiced her 'repugnance at having my picture taken'.[59] Her objection now, at the age of seventy-six and with an increasing sense of her own mortality, was 'in a moral point of view, that so much time out of my little fragment of life should be so spent'.[60] More's urgent sense of mission arose from her lifelong dedication to promulgating an agenda of conservative moral reform in almost every imaginable literary genre – from plays to paraphrases of Scripture. By the time she sat for Pickersgill she was saddened by the 'turbulent times', the resurgence of radical politics and civil unrest accompanying the campaigns for Catholic emancipation and parliamentary reform.[61] Still fiercely committed to her reforming goals, in 1823 she admitted to one correspondent that 'I should be better if I had less to do but I am willing to die in the harness.'[62]

No doubt in keeping with the sitter's preferences, Pickersgill's portrait does not flatter in the traditional sense. It makes no attempt to hide More's frailty and, despite her ageing complexion, presents her as an inspiring figure of 'Female Worth', as she was deemed by one admiring critic.[63] Pickersgill achieved this by drawing on a compositional vocabulary that includes the direct gaze and the imposing, throne-like chair and writing table – all familiar trappings in portraits of statesmen. For her advocates, Pickersgill's portrait could be taken as the honorific embodiment of the repeated comment that More was a 'Bishop in petticoats'.[64] Although this epithet was first employed as a satiric comment which might have raised questions about gender propriety, in the eyes of her supporters More was above reproach, having led a celibate and blameless life devoted to good works. Her public persona is reinforced by the letter on the table, which is addressed to William Wilberforce (1759–1833). This device alludes to More's evangelical conversion and identity as a zealous Christian reformer.

Hannah More, 1745–1833
Henry William Pickersgill, 1821
Oil on canvas, 1257 x 895mm (49½ x 35¼")
National Portrait Gallery, London (NPG 412)

The daughter of a devout Anglican headmaster and Tory, More had been raised an orthodox Christian and showed a lifelong attraction to powerful male mentors. In the 1780s she became increasingly disaffected with the immorality and irreligion of fashionable society. By the time she met Wilberforce in 1787 she had converted to evangelicalism – the Protestant movement that emphasized personal piety and the individual's struggle for redemption on the one hand and, on the other, public morality and responsibility for society's well-being. In the last decades of the century, evangelicalism had made great strides among the industrial middle classes, who were reacting to the deism of Enlightenment philosophy and the degeneracy of the aristocracy. Wilberforce, a leading Tory politician, had a clear sense of mission: 'God Almighty has set before me two great objects … The suppression of the slave trade and the reformation of manners.'[65] Under his aegis, More turned her pen to these causes.

In *Slavery: A Poem* (1788) she poignantly described a slave raid – 'the burning village, and the blazing town' – and sought to refute the prevalent theory of racial inferiority by showing that Africans had emotional needs and were, like Europeans, equally made in God's image.[66] Also in 1788 she published *Thoughts on the Importance of the Manners of the Great to General Society*, in which she stated: 'Reformation must begin with the GREAT, or it will never be effectual. Their example is the fountain … . To expect to reform the poor while the opulent are corrupt, is to throw odours into the stream while the springs are poisoned.'[67] Both works were based on the premise that Britain was suffering a crisis of moral and spiritual dissipation that would not be alleviated until the ruling classes attended to their paternalistic duties to those beneath them. The popular uprising in France served only to reinforce evangelical anxieties. Egalitarian only in her conviction that all strata of society were corrupt, in her next didactic treatise, *An Estimate of the Religion of the Fashionable World* (1791), More criticized the social order and called for a 'revolution in manners … a radical change in the moral behaviour of the nation'.[68]

A Revolution in Manners, or More on Wollstonecraft

During much of her life, More worked as a provincial schoolmistress and it was in this context that she developed her theories of female education. For her a proper education was one informed by Christian virtue that 'inculcates principles … regulates temper, cultivates reason, subdues the passions, directs the feelings … trains to self-denial, and … refers all actions, feelings, sentiments, tastes and passion to the love and fear of God'.[69] These ideals were the basis of More's several influential works, notably *Strictures on the Modern System of*

Female Education (1799) and *Hints towards Forming the Character of a Young Princess* (1805).

Although More had advocated a 'revolution in manners', as did Mary Wollstonecraft in *A Vindication of the Rights of Woman*, the views of these two women were in most ways utterly opposed. Horace Walpole had underlined this perception when describing More, memorably, as the reverse of that 'hyena in petticoats, Mrs Woolstencroft'.[70] Though both women shared the view that a proper education was necessary to make women more useful and productive members of society, More treated the premise of Wollstonecraft's *Vindication* with utter disdain. When asked by Walpole if she had read the book, More replied, 'there is something fantastic and absurd in the very title … I am sure I have as much liberty as I can make good use of … and there is perhaps no animal so much indebted to subordination for its good behaviour, as woman.'[71]

Unlike Wollstonecraft, who had suggested that the mind was without sex, More considered the idea of equality between men and women anathema. She argued that the sexes occupied separate spheres by nature as well as by custom. Men, she proposed, had 'superior strength of body', 'a firmer texture of mind … [and] a wider range of powers'.[72] Men were thus 'naturally formed for the more public exhibitions of the great theatre of human life'.[73] Women, in contrast, 'possess [a] high degree … of delicacy and quickness of perception and nice discernment'.[74] Women were best suited to seeing the world as if from 'a little elevation in her own garden'.[75] The language is indicative – due to biological predetermination, More's ideal woman was a gentler, domestic being. Female readers of *Strictures* were advised to accept their frailty and inferiority and were warned against an 'impious discontent with the post to which God has assigned them'.[76]

While More envisaged women's subordinate position to be both desirable and divinely ordained, she did not imagine it rendered women socially impotent. The combination of rational education, chaste morals and religious devotion that she encouraged was meant to help young middle-class women attract virtuous husbands and fulfil their duty towards relatives, improve their menfolk and raise God-fearing children. In consequence, such women held power indirectly through their moral sway over the family. With her female conduct literature – addressed firmly at the Christian middle classes – More explained how women might extend the influence of the home to society at large: 'It would be a noble employment, becoming the tenderness of their sex, if ladies were to consider the superintendence of the poor as their immediate office. They are peculiarly fitted

for it … they should be expected to have more sympathy; and they have obviously more leisure.'[77]

The Cheap Repository Tracts

With her conservative conviction that the paternalistic structure of society was God's will, More would have shared the view of the contemporary writer and economist Arthur Young (1741–1820) that the 'true Christian will never be a leveller'.[78] In the early 1790s, fears spread that the people were being poisoned by the proliferation of revolutionary pamphlets such as Paine's *The Rights of Man* (1790) and Wollstonecraft's *Vindication of the Rights of Men* (1790). More's horror at the events in France and the popular reaction in England is summarized in her own exasperated comment: 'From liberty, equality and the rights of man, good Lord deliver *us*.'[79] Understanding the importance of fighting print with print, she joined the pamphlet wars with *Village Politics* (1792), which was explicitly 'addressed to all the Mechanics, Journeymen and Labourers in Great Britain'. Written in the voice of 'Will Chip, a country carpenter', and set in a bucolic English village, this took the form of a dialogue between Jack Anvil, an honest blacksmith, and Tom Hod, a mason who had been radicalized on reading Paine's *Rights of Man* and now wants 'a new constitution'.[80] Voicing More's conservative sentiments in simple language and clear metaphors, Jack proceeds to ridicule Paine's work and explain that when 'this levelling comes about, there will be no infirmaries, no hospitals, no charity-schools … . For who is to pay for them? *Equality* can't afford it; and those that may be willing won't be able.'[81] The parable ends with Tom happily agreeing to mind his own business and return to his work.

More originally published *Village Politics* anonymously. The royal family and several of her friends greeted the work with enthusiasm. Fanny Burney quoted it with approval: 'Let every one mend one [self], as Will Chip says [and let] families be safely reformed – I hope you like "Village Politics". It makes much noise in London, & is suspected to be by some capital Author.'[82] When it became known that More was behind *Village Politics*, many assumed the pamphlet had been commissioned by William Pitt, the Tory Prime Minister. This was not so, but Pitt's appreciation of the loyalist propaganda is suggested by his generous contribution of a three-guinea subscription to More's next project 'to promote good morals among the Poor' – her Cheap Repository Tracts.[83]

The success of *Village Politics* persuaded More that she could write short, popular tracts that might advance the agenda of political and moral reform among the working class. Between 1795 and 1798, she, her sisters and several

BLACK GILES the Poacher;

With some Account of a

Family who had rather live by their Wits than their Work.

PART I.

Sold by J. MARSHALL,

(PRINTER to the CHEAP REPOSITORY for Moral and Religious Tracts) No. 17, Queen-Street, Cheapside, and No. 4, Aldermary Church-Yard, and R. WHITE, Piccadilly, London.
By S. HAZARD, at Bath: and by all Booksellers, Newsmen, and Hawkers in Town and Country.

Great Allowance will be made to Shopkeepers and Hawkers.

PRICE ONE PENNY.

Or 4s. 6d. per 100.—2s. 6d. for 50.—1s. 6d. for 25.

[*Entered at Stationers Hall.*]

other contributors wrote and published a large number of Cheap Repository Tracts. Taking the form of moral stories and improving ballads, these were designed to replace the existing, often licentious or superstitious, popular 'broadsides' and 'chapbooks' that hawkers carried from village to village and moralists like More considered unsuitable reading for the poor. The tracts were often short; many fitted on a single page with an illustrative woodcut and a title that summarized the moral of the story. This was the case with *Black Giles the Poacher* (1796), which was subtitled 'With some Account of a Family who had rather live by their Wits than their Work' (see p.119).

In their five years of production, over 100 titles were published, with More writing over fifty herself. They fall into two main categories, the first warning of the moral consequences of support for radical politics and civil disobedience. One such is *The History of Mr Fantom, the New Fashioned Philosopher, and his Man William* (*c*.1797), which tells the story of a rash footman, William, who has been led astray by his master's radical philosophy. He ends up hanged for crimes he commits, having lost any fear of divine retribution – 'The Lord have Mercy on his Soul'.[84] Other equivalent homilies include *The Riot, or Half a Loaf is Better than No Bread* (1795) and *The Loyal Sailor; or, No Mutineering* (1797), which, as wartime propaganda, reveal much about the realities of simmering insurrection that accompanied the economic hardships of the long war against France. The second, and more sizeable, category of tract was derived from the evangelical agenda for social reform that might lead to spiritual salvation. Using devout, upwardly mobile heroes, these promoted good behaviour and taught life skills in numerous tales that demonize gambling, drinking, idleness and theft or explain the pitfalls of loan sharks or false household economics. Thus in *Betty Brown, the St Giles Orange Girl* (1795), the heroine is freed from her wage slavery to evil Mrs Sponge the moneylender and ends up the owner of a modest sausage shop in Seven Dials. And *The Two Shoemakers* (1795) is a five-part tract that resurrects the Hogarthian tale of industry and idleness in the persons of the good and wicked apprentices. The collective message of the Cheap Repository Tracts was that redemption could be derived from passive obedience, industriousness and self-reliance, patriotism and the family. Moreover, the fostering of these virtues was intended to produce domestic harmony, political stability and economic prosperity: in short, to prevent a violent popular revolution in Britain.

Philanthropy: A New Form of Female Activism
Despite the success of More's other writings, it was the Cheap Repository Tracts that made her a household name. Selling for less than one penny, over two

million copies were printed between 1795 and 1796 alone. First and foremost, they were a huge hit with clergymen, employers and anxious landowners, who bought them in bulk to distribute among their constituents. For, like *Village Politics*, the Cheap Repository Tracts had their greatest success with the middle classes and a large proportion of them were circulated for free to assist the genteel in their philanthropic work. Along with religious tracts published by other reformist organizations, such as the Society for the Promotion of Christian Knowledge and the Religious Tract Society, the Cheap Repository Tracts were especially useful to the growing numbers of benevolent societies and free Sunday schools, which looked to supplement Bible reading with safe, apolitical and accessible texts that improved literacy and ultimately augmented the religious faith of the poor.

The belief that crime was linked to idleness, illiteracy and godlessness prompted numerous individuals to establish free Sunday schools in rural villages and the new industrial towns. Such charitable endeavours were welcomed as a systematic way of reforming the working classes and as an instrument of social change. They were also deemed an effective way for the middle and upper classes to carry out the Christian duty of care for the poor. Thus by 1789, when More established her first charity school in Cheddar, over 250,000 children were already enrolled in the numerous Sunday schools across Britain. More subsequently established a network of charity schools, as well as writing the didactic and sentimental literature which could be used in them. She also urged her readers to participate in the organization of voluntary societies, hospitals, orphanages and 'ragged' schools for the education and relief of the poor. Although their first duties were towards their homes and families, women, she argued, had a natural affinity for religious nurture and were empowered to lead the public reformation of manners. In More's novel *Coelebs in Search of a Wife* (1809) – a huge success and reprinted repeatedly in Victorian times – she called on women to use their influence for the national good, as 'charity is the calling of a lady; the care of the poor is her profession'.[85] Instead of advocating women's rights – as Macaulay and Wollstonecraft had done – More assigned women a central role as agents of the philanthropic action that would 'raise the depressed tone of public morals … awaken the drowsy spirit of religious principle, and … reanimate the dormant powers of active piety'.[87] In the early decades of the nineteenth century it was this model of middle-class female activism – and social formation – that enjoyed ascendancy in Britain.

Chapter Notes

1 Letter from Mary Wollstonecraft to Mary Hays, *c.*1797, cited in Barbara Taylor, *Mary Wollstonecraft and the Feminist Imagination* (Cambridge, 2003), p.246.

2 Catharine Macaulay, *The History of England from the Accession of James I to that of the Brunswick Line*, 8 vols. (London, 1763–83), Vol.I, p.v.

3 'The Political Platonic Lovers', *Town & Country Magazine*, Vol.VIII, 1776, pp.675–8.

4 Review of Catharine Macaulay's *History of England from the Accession of James I to that of the Brunswick Line* in *Monthly Review, or Literary Journal*, Vol.XXIX, 1763, pp.372–82, pp.411–20.

5 Ibid., p.372.

6 *European Magazine*, Vol.IV, November 1783, pp.330–34; *Gentleman's Magazine*, Vol.LIX, Part 2, September 1789, p.777.

7 John Adams, *Diary and Autobiography of John Adams* (Cambridge, Mass., 1961), p.360.

8 Letter from Edmund Burke to Richard Shackleton, n.d. (before 15 August 1770), in Lucy S. Sutherland, *The Correspondence of Edmund Burke*, 6 vols. (Cambridge, 1958–67), Vol.II, p.150.

9 Ephraim Chambers, *Cyclopaedia, or, An Universal Dictionary of Arts and Sciences*, 2 vols. (London, 1728), Vol.II, p.308.

10 Lord Lyttelton, quoted in George Otto Trevelyan, *The American Revolution* (Leipzig, 1899), cited in Kate Davies, *Catharine Macaulay and Mercy Otis Warren: The Revolutionary Atlantic and the Politics of Gender* (Oxford, 2005), p.61.

11 My account of the *Libertas* print is based on information provided in Davies, *Catharine Macaulay*, pp.61–3. Hollis's copy of Macaulay's *History* is at Harvard University Library.

12 Helmut von Erffa and Allen Staley, *The Paintings of Benjamin West* (New Haven and London, 1986), p.551.

13 Letter from Edmund Rack to Richard Polwhele, in Richard Polwhele, *Traditions and Reflections: Domestic, Clerical, and Literary*, 2 vols. (London, 1826), Vol.I, pp.122–3.

14 *European Magazine*, Vol.IV, November 1783, p.334, cited in Natalie Zemon Davis, 'History's Two Bodies', *American Historical Review*, Vol.LXXXXIII, No.1, February 1988, p.7.

15 Macaulay, *History*, Vol.V, p.382, cited in Bridget Hill, 'Catharine Macaulay', *Oxford Dictionary of National Biography* (Oxford, 2004–7).

16 Letter from David Hume to the Reverend Hugh Blair, in J.Y.T. Greig (ed.), *The Letters of David Hume*, 2 vols. (New York and London, 1932), Vol.II, p.321.

17 'The Political Platonic Lovers', *Town & Country Magazine*, pp.675–8.

18 Letter from Hannah More to one of her sisters, in William Roberts, *Memoirs of the Life and Correspondence of Mrs. Hannah More*, 4 vols. (London, 1834), Vol.I, p.51.

19 Letter from Elizabeth Carter to Elizabeth Montagu, 7 December 1778, in Montagu Pennington (ed.), *Letters from Mrs. Elizabeth Carter, to Mrs Montagu, Between the Years 1755 and 1800, Chiefly upon Literary and Moral Subjects*, 3 vols. (London, 1817), Vol.III, p.99.

20 *Six Odes, Presented to the Justly-celebrated Historian, Mrs Catharine Macaulay, on her Birth-day* (London, 1777), p.20.

21 Letter from Elizabeth Carter to Elizabeth Montagu, 7 December 1778, in Pennington (ed.), *Letters from Mrs. Elizabeth Carter*, pp.98–9.

22 Ibid., Alfred, 'Letter to the Editor', *Westminster Magazine*, Vol.VI, 1778, p.681.

23 'Review of *Six Odes*', *Monthly Review*, Vol.LVII, August 1777, p.146.

24 Letter from the Reverend Dr Baker to Augustus Toplady, cited in Bridget Hill, *The Republican Virago: The Life and Times of Catharine Macaulay, Historian* (Oxford, 1992), p.97.

25 Crito, 'Letter to the Editor', *Gentleman's Magazine*, Vol.XXXXVII, October 1777, p.470. 'On the Statue of Mrs. Macaulay erected in the Church of St. Stephen Walbrook, London, at the

Expence of Dr. Wilson, the Rector', *The Court Magazine and Monthly Critic and Lady's Magazine and Muse of the Belles Lettres*, Vol.VIII, October 1777, pp.509–10.

[26] A.Y.Z., 'Letter to the Editor', *Gentleman's Magazine*, Vol.LXI, Part 2, July 1791, p.618.

[27] 'An Admirer of Consistency', 'Letter to the Editor', *Town & Country Magazine*, Vol.X, December 1778, pp.623–4.

[28] *Letters from the Year 1774 to the Year 1796 of John Wilkes Esq., Addressed to his Daughter*, 4 vols. (London, 1804), Vol.II, p.115. Letter from Horace Walpole to Lady Ossory, 14 January 1779, W.S. Lewis (ed.), *Yale Edition of the Correspondence of Horace Walpole*, 48 vols. (New Haven and London, 1937–83), Vol.XXXIII, p.85.

[29] Elizabeth Montagu to Hester Thrale (1779), English manuscripts 551, John Rylands Library, University of Manchester, cited in Davies, *Catharine Macaulay*, p.174.

[30] Mary Hays, *Female Biography or Memoirs of Illustrious and Celebrated Women*, 6 vols. (London, 1803), Vol.V, p.292.

[31] Letter from Horace Walpole to Mary Berry, 20 December 1790, in Lewis (ed.), *Yale Edition of the Correspondence of Horace Walpole*, Vol.XI, p.169.

[32] Mary Wollstonecraft, *Mary, a Fiction* (London, 1788), 'Advertisement', n.p.

[33] 'Review of *Letters on Education, with Observations on Religious and Metaphysical Subjects*, by Catharine Macaulay Graham', *Analytical Review*, Vol.VIII, November 1790, reproduced in Janet Todd and Marilyn Butler (eds.), *The Works of Mary Wollstonecraft*, 7 vols. (London, 1989), Vol.VII, pp.309, pp.321–2.

[34] Catharine Macaulay, *Letters on Education, With Observations on Religious and Metaphysical Subjects* (London, 1790), p.48.

[35] Letter from Mary Wollstonecraft to Everina Wollstonecraft, 7 November 1787, in Janet Todd (ed.), *The Collected Letters of Mary Wollstonecraft* (London, 2003), p.139.

[36] Letter from Mary Wollstonecraft to Catharine Macaulay, 16 or 23 December 1790, manuscript MW 47, The Carl H. Pforzheimer Collection of Shelley and His Circle, The New York Public Library, Astor, Lenox and Tilden Foundations.

[37] Mary Wollstonecraft, *An Historical and Moral View of the Origin and Progress of the French Revolution; and the Effect it has Produced in Europe* (London, 1794), p.19.

[38] *Analytical Review*, Vol.VIII, 1790, p.416, cited in Bridget Hill, 'The Links between Mary Wollstonecraft and Catharine Macaulay: New Evidence', *Women's History Review*, Vol.IV, No.2, 1995, pp.177–92.

[39] I am grateful to William McCarthy for clarifying this for me and to Alison Stagg for additional research.

[40] Letter from Horace Walpole to Mary Berry, 20 December 1790, in Lewis (ed.), *Yale Edition of the Correspondence of Horace Walpole*, Vol.XI, pp.169–70.

[41] Edmund Burke, *Reflections on the Revolution in France, and on the Proceedings in Certain Societies in London Relative to that Event* (2nd edition, London, 1790), p.106.

[42] William Godwin, *Memoirs of the Author of A Vindication of the Rights of Woman* (London, 1798), p.76.

[43] John Knowles, *Life and Writings of Henry Fuseli*, 3 vols. (London, 1831), Vol.I, p.164.

[44] Letter from Mary Wollstonecraft to William Roscoe, 6 October 1791, in Todd (ed.), *The Collected Letters of Mary Wollstonecraft*, p.190.

[45] Mary Wollstonecraft, *A Vindication of the Rights of Woman* (London, 1792), pp.92–3.

[46] *Analytical Review*, Vol.XII, 1792, p.249, cited in R.M. Janes, 'On the Reception of Mary Wollstonecraft's *A Vindication of the Rights of Woman*', *Journal of the History of Ideas*, Vol.IXL, 1975, pp.293–302.

[47] Ibid.

[48] Cited in Janet Todd, *Mary Wollstonecraft, a Revolutionary Life* (London, 2000), pp.179–80.

49 Letter from William Godwin, cited in Barbara Taylor, 'Mary Wollstonecraft', *Oxford Dictionary of National Biography* (Oxford, 2004–7).

50 Godwin, *Memoirs*, p.112.

51 Ibid., pp.163–2.

52 *Anti-Jacobin Review and Magazine; or, Monthly Political and Literary Censor*, Vol.I, 1798, pp.94–102.

53 *European Magazine*, Vol.XXXIII, 1798, p.342; Thomas James Mathias, *The Shade of Alexander Pope on the Banks of the Thames. A Satirical Poem* (Dublin, 1799), p.47.

54 Richard Polwhele, *The Unsex'd Females. A Poem Addressed to the Author of the Pursuits of Literature* (London, 1798), p.13.

55 Thomas James Mathias, *The Pursuits of Literature. A Satirical Poem in Four Dialogues* (7th edition, revised, London, 1798), p.238, cited in Polwhele, *The Unsex'd Females*, title page.

56 Polwhele, *The Unsex'd Females*, p.16.

57 Ibid., p.28.

58 Ibid., pp.35–6.

59 Letter from Hannah More to Frances Boscawen, 1786, in William Roberts (ed.), *Memoirs of the Life and Correspondence of Mrs Hannah More*, 4 vols. (3rd edition, London, 1835), Vol.II, p.37.

60 Letter from Hannah More to Sir William Pepys, October 1821, ibid., Vol.IV, p.173.

61 Ibid., p.160.

62 Letter from Hannah More to William Wilberforce, 8 January 1823, cited in Anne Stott, *Hannah More: The First Victorian* (Oxford, 2003), p.307.

63 *Lady's Monthly Museum*, Vol.I, 1798, p.2.

64 More was first described as a female bishop in 1794. One notable use of the term was by William Cobbett, who called her this in the *Weekly Political Register*, 20 April 1822, p.188. See Stott, *Hannah More*, p.282.

65 Robert Isaac Wilberforce and Samuel Wilberforce, *The Life of William Wilberforce*, 4 vols. (London, 1838), Vol.I, p.84, cited in Roy Porter, *Enlightenment: Britain and the Creation of the Modern World* (London, 2001), p.469.

66 Hannah More, *Slavery: A Poem* (London, 1788), p.3.

67 Hannah More, *Thoughts on the Importance of the Manners of the Great to General Society*, (London, 1788), p.114.

68 Hannah More, *An Estimate of the Religion of the Fashionable World* (London, 1791), p.24.

69 Hannah More, *Coelebs in Search of a Wife*, p.13, cited in Anne K. Mellor, *Mothers of the Nation: Women's Political Writing in England, 1780–1830* (Bloomington and Indianapolis, 2000), p.26.

70 Letter from Horace Walpole to Hannah More, 24 January 1795, in Lewis (ed.), *Yale Edition of the Correspondence of Horace Walpole*, Vol.XXXI, p.397.

71 Letter from Hannah More to Horace Walpole, 18 August 1792, ibid., p.370.

72 Hannah More, *Strictures on the Modern System of Female Education*, 2 vols. (London, 1799), Vol.II, p.23.

73 Hannah More, *Essays on Various Subjects, Principally Designed for Young Ladies* (London, 1777), p.5.

74 More, *Strictures*, Vol.II, p.25.

75 Ibid., p.27.

76 Ibid., p.21.

77 Ibid. Vol.I, p.117.

78 Arthur Young, *An Enquiry into the State of the Public Mind Amongst the Lower Classes: and on the Means of Turning it to the Welfare of the State* (Dublin, 1798), p.25.

79 Letter from Hannah More to Horace Walpole, 7 January 1793, Roberts, *Memoirs*, Vol.II, p.357.

80 Hannah More, *Village Politics. Addressed to all the Mechanics, Journeymen, and Day Labourers, in Great Britain. By Will Chip, a Country Carpenter* (2nd edition, London, 1792), p.2.

81 Ibid., pp.16–17.

82 Fanny Burney, cited in Stott, *Hannah More*, p.145.

83 Letter from Hannah More to William Wilberforce, 1795, cited ibid., p.169.

84 Hannah More, *The History of Mr. Fantom, the New Fashioned Philosopher, and his Man William* (London, *c.*1797), p.23.

85 More, *Coelebs*, p.138, cited in Mellor, *Mothers of the Nation*, p.37.

86 More, *Strictures*, Vol.I, p.4.

87 Ibid.

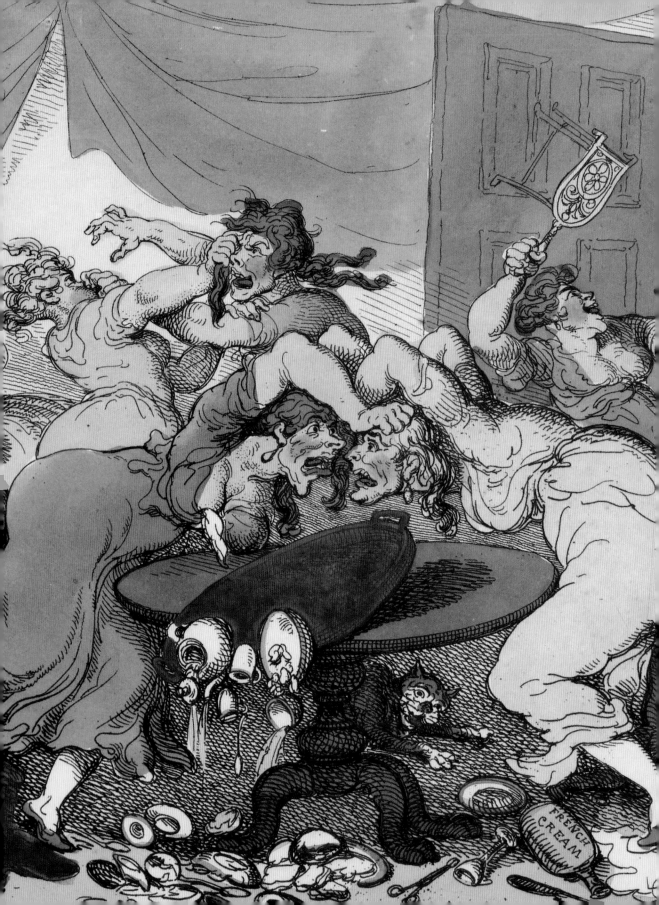

The Bluestocking Legacy

ELIZABETH EGER

This book has suggested that the eighteenth century was a time when literary and intellectual women were more present, and more powerful, than at other points in history. And yet the bluestockings' professional activity – its sheer range, ambition and diversity – is little known today. Important female writers in the nineteenth and twentieth centuries, from the poet Elizabeth Barrett Browning to the critic Germaine Greer, have complained of a lack of foremothers. Virginia Woolf's fictional heroine in *A Room of One's Own* (1929), 'Judith Shakespeare' – William's imaginary sister, who died young and never wrote a word – has become a misleading symbol of the woman writer's oppression and lack of agency. This perceived absence of female role models is often taken at face value, such has been the historical erasure of women's achievement. In order to understand why the original bluestockings slipped from view, we need to begin by tracing the backlash against the figure of the intellectual woman during the nineteenth century, when the term 'bluestocking' acquired its more familiar negative and misogynist connotations.

Breaking Up the Blue Stocking Club

Thomas Rowlandson's satire was published as a print in 1815 (see opposite and p.128), the year of Napoleon's final defeat at the Battle of Waterloo. This frenzied scene is very different in character from the classical harmony of Richard Samuel's Muses (see p.60), or the civilized tea and conversation promoted by the early Bluestocking Circle. A tea tray slides perilously to the floor as two central figures, locked in mortal combat, attempt to rip out each other's hair, while pairs of aggressive women brawl and bite, kick and shove. Over to the left, a bluestocking pours an urn of boiling water over the face of her opponent. To the far right, a desperate figure tries to escape from a young woman who is brandishing a brass kettle-stand, her breasts flying loose from her dress and her face flushed with exertion. Three huge cats look excited, or perhaps terrified, by the general uproar.

Rowlandson has chosen to emphasize the corporeality of his subjects rather than their mental accomplishments. These 'bluestockings' embrace a loss of control with ferocious appetite. The overturned chamber pot and 'French cream'

Breaking Up of the Blue Stocking Club (detail)
Thomas Rowlandson, 1815
Hand-coloured etching,
246 x 349mm (9⅗ x 13¾")
The British Museum, London

***Breaking Up of the Blue
Stocking Club***
Thomas Rowlandson, 1815
Hand-coloured etching,
246 x 349mm (9⅝ x 13¾")
The British Museum, London

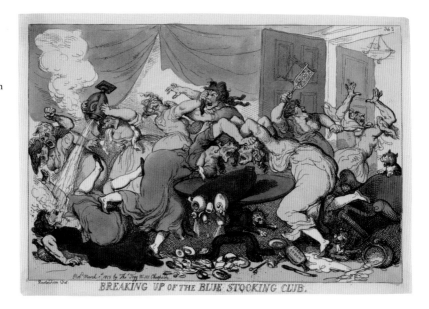

BREAKING UP OF THE BLUE STOCKING CLUB.

suggest a heady mixture of slovenliness, vanity and immorality (French cosmetics
were widely associated with female narcissism). The composition is circular,
picking up on the bluestockings' 'circles of conversation', but this circle is
a violent vortex. Can the print's visceral energy and shocking cruelty be taken
to signal the end of an era?

Rowlandson's title refers, on one level, to the specific 'breaking up' of
a bluestocking meeting, confirming a stereotypical view of what happens when
female gossips are left alone. But it also suggests a more general dissolution of
the bluestockings in the public imagination – or, rather, an aggressive reaction
against the very strength and visibility they had achieved by the end of the
eighteenth century. In the original Bluestocking Circle, learning and virtue were
upheld in a carefully controlled and elegant balance. The conscious efforts of
the original 'blues' ensured that, for a brief period, women's rich contribution to
the cultural and intellectual life of the nation was celebrated and proclaimed as
superior to that of any country in Europe. Women developed a strong public
presence in contemporary cultural life, establishing themselves through networks
of patronage, correspondence and publication. As Maria Edgeworth observed
in 1795, 'Women of literature are much more numerous of late than they were
a few years ago. They make a class in society, they fill the public eye, and have
acquired a degree of consequence and appropriate character.'[1]

Bluestocking women made their most significant impact as writers but were
also involved in the 'sister arts' of painting, drama and music. When Elizabeth

Montagu, 'Queen of the Blues', died in 1800 she was heralded in an obituary as 'an ornament to her sex and country', an icon of female intellect whose broader legacy could be discerned in the flourishing body of women working in a diverse range of cultural spheres.[2] In a short essay the same year, 'Present State of the Manners, Society, Etc. Etc. of the Metropolis of England', Mary Robinson, the actress, poet and journalist, combined her pride in British women writers with a celebration of the wider range of contemporary female cultural activity: 'We have also sculptors, modellers, paintresses, and female artists of every description.'[3]

The sheer number of women in contemporary cultural life was sometimes used as an argument for their potential equality with men. Reviewing Elizabeth Moody's *Poetic Trifles*, the *Monthly Review* declared:

> The polished period in which we live may be justly denominated the Age of ingenious and learned Ladies; … that we need not hesitate in concluding that the long agitated dispute between the sexes is at length determined; and that it is no longer a question, – whether woman *is* or is *not* inferior to man in natural ability, or less capable of excelling in mental accomplishments.[4]

Elizabeth Moody (1737–1814) is little known today, but she was celebrated in her time for her witty poetic dialogues, such as 'The Housewife; or, The Muse Learning to Ride the Great Horse Heroic', in which she satirized the masculine pride of poetic ambition. But even if, as the reviewer asserted, women's mental ability was accepted as equal to that of men, women were still denied the opportunity to exercise their intellect as full citizens with legal and property rights until the beginning of the twentieth century. Many liberal thinkers of the 1790s drew attention to the disparity between the limited legal position of women and the social reality in which some of them had achieved a great deal. However, it was only Mary Wollstonecraft (see p.109) who made an explicit and uncompromising claim for the rights of women to full citizenship.[5] Her experiments, in both her life and her writing, proved too radical for many of her contemporaries, who recoiled from her notorious personal scandals and her courageous politics.

By the beginning of the nineteenth century, the combined social and intellectual prominence of so many intelligent women was greeted with suspicion and disgust by many men. This hostility was exacerbated by the cultural anxiety caused by the French Revolution and its aftermath in Britain. 'Bluestocking' became a term of comedy and abuse, echoing earlier distrust

of learned women's 'slipshod' appearance and morality. Rowlandson's women seem akin to the 'fishwives', 'viragos' and 'furies of hell' that Walpole and Burke had condemned in their diatribes against radical women writers of the 1790s, or the 'unsex'd females' of the Reverend Richard Polwhele's notorious poem.[6] There may also be a suggestion of radical politics in the reference to 'French cream'.

So, by 1815 the reaction against female intellect was widespread and becoming more entrenched. The most vociferous and vitriolic attacks on bluestockings came from the leading male Romantic writers of the early nineteenth century, who wished to protect the masculine strongholds of literary institutions – poets and critics such as Samuel Taylor Coleridge (1772–1834), William Wordsworth (1770–1850) and Lord Byron (1788–1824). Coleridge wrote to his friend Charlotte Brent in 1813, praising her bad spelling and explaining, 'The longer I live, the more do I loathe in stomach, and deprecate in Judgement, all, *all* Bluestockingism.'[7] Byron's resentment of the blues appears in a number of literary satires but is perhaps most pronounced in his hugely successful comic epic *Don Juan* (1821), in which he used their example to complain about the meaninglessness of literary success:

> That taste is gone, that fame is but a lottery,
> Drawn by the blue-coat misses of a coterie.[8]

In the same year, the critic William Hazlitt (1778–1830) objected, 'I have an utter aversion to Bluestockings. I do not care a fig for any woman that knows even what *an author* means.'[9] In 1823 the *British Critic* ranted:

> We heartily abjure Blue Stockings. We make no compromise with any variation of the colour, from sky-blue to Prussian blue, blue stockings are an outrage to the eternal fitness of things … . Without being positively criminal, a Blue Stocking is the most odious character in society; … she sinks, wherever she is placed, like the yolk of an egg, to the bottom, and carries the filth … with her.[10]

Like Rowlandson's cartoon, the *British Critic's* anonymous author emphasizes the bodily excesses of the women he depicts. Such vituperative comments unwittingly record the bluestockings' achievement – but they also betray a profound misogyny, suggesting a very different cultural climate from that in which the early bluestockings first met.

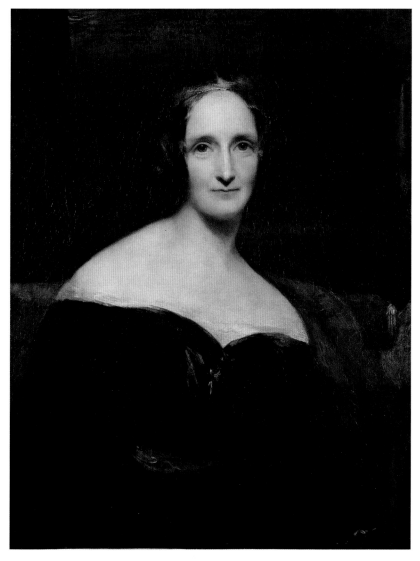

**Mary Wollstonecraft
Shelley**, 1797–1851
Richard Rothwell,
exhibited 1840
Oil on canvas, 737 x 610mm
(29 x 24")
National Portrait Gallery,
London (NPG 1235)

Daughter of Mary
Wollstonecraft and William
Godwin, Mary eloped with
the poet Percy Bysshe Shelley
(1792–1822) in 1814. Her
most famous novel
*Frankenstein, or the Modern
Prometheus* (1818) is a
masterpiece of the Gothic
genre that explores the
tension between aspiration
and rebellion. This portrait,
painted when she was forty-
three, shows her as a subdued
yet powerful presence.

By the time Queen Victoria acceded to the throne in 1837, the concerted
reaction against the original Bluestocking Circle had ensured that its achievements
were already forgotten. In July 1837 the influential poet and critic Leigh Hunt
(1784–1859) published his *Bluestocking Revels; or, The Feast of the Violets* in the
Monthly Repository, a literary periodical. This poem celebrated the female writers
of his day and their immediate predecessors, who had started to fade from public
view. Although a friend of Hazlitt, and part of the circle of Romantic writers
that had denigrated the bluestockings, Hunt adopted a different approach.

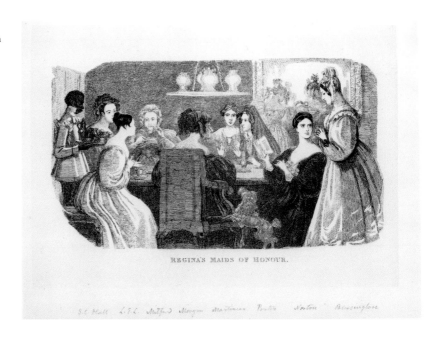

REGINA'S MAIDS OF HONOUR.

His satirical poem attempted to soften the bluestockings' reputation by praising those who maintained their feminine charms. These women, coyly christened 'violets', were advised to combine learning with all the standard accomplishments that men had always expected of them. If they stepped out of line, or grew 'formal, or fierce, or untrue', they would turn back to the dreaded shade of blue.[11]

The Irish painter Daniel Maclise's lithograph *Regina's Maids of Honour*, like Hunt's poem, domesticates intellectual women in order to make them more palatable, while at the same time belittling their achievement.[12] This seemingly celebratory image appeared in *Fraser's Magazine for Town and Country*, with an accompanying article by the editor, William Maginn (1794–1842), in January 1836, to 'welcome in the new year'. *Fraser's Magazine* was a general and literary periodical founded in 1830 and aimed at a middle-class audience. Maclise depicted eight fashionable women writers of his day seated round a table, some drinking tea and others chatting harmoniously, waited upon by an African servant. His subjects are, from left to right: Anna Maria Hall (1800–81), Irish novelist and children's writer; Letitia Elizabeth Landon (1802–38), known as L.E.L., the best-selling and innovative poet; Mary Russell Mitford (1787–1855), dramatist, letter-writer and poet; Lady Sydney Morgan (bap.1783, d.1859), novelist and Irish nationalist, author of the famous *Wild Irish Girl* (1806); Harriet Martineau (1802–76), essayist, popular educator and political economist; Jane Porter (bap.1776, d.1850), whose novel about Scottish

independence, *The Scottish Chiefs* (1804), was not only highly popular but also banned by Napoleon in its French translation (an honour she shared with Madame de Staël); Caroline Norton (1808–77), poet, novelist and pamphleteer; and, finally, the standing figure, Marguerite, Countess of Blessington (1789–1849), novelist, journalist and literary hostess.

If it weren't for the book that Caroline Norton is holding up, in discussion with the Countess of Blessington, there would be no way of knowing that these women were literary, let alone significant contributors to the cultural and political life of their time. Ironically, Harriet Martineau, depicted here as a submissive and silent figure, was soon to publish *Society in America* (1837), in which she attacked slavery and condemned the repressive effects of chivalry upon women's education. Her *Illustrations of Political Economy* (1832–4) had already brought her international fame. Maclise's innocuous image of bourgeois sociability belies the diversity and individual courage of his subjects and erases their more radical impulses. His over-arching concern is to reassure his audience of the femininity of his chosen writers. Unlike Samuel's *Living Muses*, who appear in an abstract and idealized exterior location, Maclise's eight learned 'ladies' are safely contained within a familiar, domestic interior.

The relationship between the civic and intimate spheres of life, the political and the domestic, the public and the private, remains a pressing topic, and has always been at the heart of any claims for sexual equality, as Wollstonecraft realized in her *Vindication of the Rights of Woman* in 1792. Historically, there has been a crude equation of the civic, political and public with men (or masculinity) and the intimate, domestic and private with women (or femininity). Despite the achievement of the original bluestockings in entering the cultural public sphere of their time, the nineteenth century witnessed a return of women to the home and a reassertion of their domestic vocation, famously praised by Coventry Patmore (1823–96) in his poem of 1854, *The Angel in the House*, in which he created a popular vision of his devoted wife as the symbol of ideal womanhood: passive and powerless, meek, charming, graceful, sympathetic, self-sacrificing, pious and, above all, pure.

Nineteenth-century Women and Literary Vocation: Writing and Rights

For women who wanted to be writers, such a relentlessly domestic image of womanhood was suffocating and repressive, destroying any sense of vocational or professional possibility – the very thing the bluestockings had fought so hard to establish. As Virginia Woolf wrote in her essay 'Professions for Women', 'killing the Angel in the House was part of the occupation of a woman writer'.[13] Woolf's

anger was direct and uncompromising. For her, and for her nineteenth-century predecessors, the novel, a genre traditionally associated with the feminine, provided an important intellectual outlet. Writing novels inevitably involved a complex, and sometimes subversive, analysis of woman's place within, and outside, the home. In searching for the intellectual legacy of the bluestockings, it is necessary to turn to fiction, a genre in which women's lives could be addressed with a seriousness, freedom and depth that combined passion and reason.

The novel is a genre in which women have historically excelled, more so perhaps than in any other field of the arts or literature. Ask anybody to identify eminent cultural women of the past and the names Jane Austen, Charlotte Brontë and George Eliot (pen name for Marian or Mary Anne Evans) will undoubtedly arise. What is less commonly known is that these individuals emerged from a mass of contemporary female novelists and were not lone examples of a woman's ability to compete with her male peers. As we have seen, they were also writing in the wake of the bluestockings' achievements in an impressive array of literary genres and different artistic and cultural fields. Historically, the novel has provided an important cultural space in which the place of woman in society can be explored, challenged and developed. It has also allowed women to investigate important questions of female cultural tradition and legacy that the bluestockings first established as integral to their identity as professional writers and artists.

By the end of the eighteenth century, both the female readers and female writers of novels were perceived as a threat. The idea of the isolated and socially irresponsible woman reader caused considerable concern. Hannah More, in her *Strictures on the System of Modern Female Education* (1799), connected female writers and readers in a frightening image of perverted biological reproduction:

> Who are those ever multiplying authors, that with unparalleled fecundity are overstocking the world with their quick-succeeding progeny? They are novel-writers; the easiness of whose productions is at once the cause of their own fruitfulness, and of the almost infinitely numerous race of imitators to whom they give birth. Such is the frightful facility of this species of composition, that every raw girl, while she reads, is tempted to fancy that she can also write.[14]

In her protest against the sheer number of female novel readers, More inadvertently touches upon the strength of the novel as potential educator and

Jane Austen, 1775–1817
Cassandra Austen, *c*.1810
Pencil and watercolour, 114 x
80mm (4½ x 3⅛")
National Portrait Gallery,
London (NPG 3630)

This frank portrait of Jane
Austen by her sister and
closest confidante, Cassandra,
is the only reasonably certain
image of the author taken
from life.

source of inspiration – women's experience of strong identification with the
heroines of novels occupies an important place in the history of their emerging
social and political freedoms.

 Jane Austen famously addressed the dangers of over-identification with
a novel's characters in her satire of the craze for the Gothic novel, in *Northanger
Abbey*, her earliest work, written in the late 1790s but published posthumously
in 1816. Yet within her playful satire she incorporated a famous defence of the
moral power of the novel and its distinguished female readers and authors.
At the end of Chapter 5, Austen describes the friendship between her heroine,

Catherine Morland, and Isabella Thorpe as built around their shared reading. Her own narrative voice emerges to argue that she is not ashamed to admit that her heroine is a novel reader:

> 'And what are you reading, Miss –?' 'Oh! It is only a novel!' replies the young lady, while she lays down her book with affected indifference, or momentary shame. 'It is only *Cecilia*, or *Camilla*, or *Belinda*'; or, in short, only some work in which the greatest powers of the mind are displayed, in which the most thorough knowledge of human nature, the happiest delineation of its varieties, the liveliest effusions of wit and humour, are conveyed to the world in the best-chosen language.[15]

Here Austen refers to her female contemporaries Fanny Burney (author of *Cecilia* and *Camilla*) and Maria Edgeworth (author of *Belinda*) in a defence of the novel as a moral genre that engages with human nature. She also makes clear her ambition as a novelist to address the 'world'. Austen has often been associated with a narrow vision of village life and belittled as an artist overly concerned with the domestic. It is interesting that the only surviving portrait of her can be used to confirm such a view (see p.135). This intimate portrait of Jane, sketched by her beloved sister Cassandra, inevitably has a poignancy and delicacy that suggest the author's domestic identity.

As with Austen, the most famous portrait of Charlotte Brontë (see opposite), in which she appears with her sisters Anne and Emily, was painted by her sibling, Branwell, and has acted to reinforce our sense of her as publicity-shy and sequestered from the wider world. However, her writing is concerned with a broad moral perspective, tackling social issues such as industrialization and the living conditions of factory workers (*Shirley*, 1849), or the 'buried life' of intelligent but impoverished women (*Villette*, 1853). *Jane Eyre*, first published in 1847, has proved her most popular and enduring work; it offers a complex exploration of a 'poor, obscure, plain and little' governess's sense of autonomy, and her struggle to square this with her fierce passion for her master, Mr Rochester. One of Jane's most deeply felt speeches takes place on the battlements of Thornfield Hall, Rochester's mansion, where she laments the narrow horizons available to her as a woman. She insists:

> It is vain to say human beings ought to be satisfied with tranquillity: they must have action; and they will make it if they cannot find it. Millions are condemned to a stiller doom than mine, and millions are in silent revolt

The Brontë Sisters
(Charlotte, 1816–55, Emily,
1818–48, and Anne Brontë,
1820–49)
Patrick Branwell Brontë,
*c.*1834
Oil on canvas, 902 x 746mm
(35 ½ x 29 ⅜")
National Portrait Gallery,
London (NPG 1725)

against their lot. Nobody knows how many rebellions ferment in the masses
of life which people earth. Women are supposed to be very calm generally:
but women feel just as men feel; they need exercise for their faculties, and
a field for their efforts as much as their brothers do … .[16]

Brontë depicts Jane as representative of innumerable lost and suppressed female
voices who suffer from a lack of education and thus cannot find a satisfactory
position in the world.

Jane's musings on independence are interrupted by the sound of mysterious
laughter which, she has been told, belongs to a disturbed servant, Grace Poole,

George Eliot (Mary Ann Cross), 1819–80
Caroline Bray, 1842
Watercolour, 178 x 146mm
(7 x 5¾")
National Portrait Gallery, London (NPG 1232)

George Eliot is depicted here as a young woman of twenty-three by her close friend Caroline Bray (1814–1905), wife of the philanthropist and reformer Charles Bray. The Brays' house near Coventry formed a haven for radical intellectuals, including Caroline's brother Charles Hennell, whose *Inquiry Concerning the Origins of Christianity* (1838) investigated the evidence of the truth of the gospels and formed an important influence on Eliot's thought.

but subsequently transpires to emanate from Mr Rochester's incarcerated and insane Creole wife, Bertha Mason. Bertha's unsettling presence not only haunts the novel but has also provided inspiration for several subsequent books. The feminist literary critics Sandra Gilbert and Susan Gubar called their influential study of nineteenth-century women's literature *The Madwoman in the Attic* (1979), arguing that Bertha's insanity was symbolic of suppressed female rage and anger. The twentieth-century novelist Jean Rhys wrote a mesmerizing 'prequel' to *Jane Eyre* entitled *Wide Sargasso Sea* (1966), in which she described the painful story of the first Mrs Rochester, connecting Brontë's treatment of

female oppression with an analysis of racial oppression in the nineteenth-century British Empire. More recently, the feminist theatre director Polly Teale created an immensely successful dramatic adaptation of Brontë's novel (*Jane Eyre*, 1997; revived in 2006). In Teale's imaginative production, Bertha Mason and Jane Eyre were constantly present on stage together, their actions physically linked in startling visual contortions that presented Bertha Mason as Jane's troubled alter ego. Brontë's novel has provoked an astonishing and consistent stream of female creative responses, in literature and the arts, each adding a new dimension to the original heroine's identity, as well as establishing a sense of historical dialogue between women who pursue a life of the mind.[17]

Heroines: Claiming a Cultural Heritage

When later nineteenth-century female writers looked back to their predecessors, it was often in search of heroines. For example, it was Wollstonecraft's courageous life that attracted the most admiration from her successors, rather than her literary works. When she was rediscovered by feminists, they were often disappointed to discover the moral tone of her work, having been drawn to her because of her unconventional and daring existence. The novelist George Eliot (see opposite) described Wollstonecraft as a ponderous intellectual and viewed *A Vindication* as 'eminently serious, severely moral, and withal rather heavy'.[18] George Eliot, like Wollstonecraft, lived openly with a man outside wedlock and braved contemporary prejudice in the pursuit of her intellectual beliefs. She had been encouraged to read Wollstonecraft by a friend, the painter and women's activist Barbara Leigh Smith Bodichon. A talented landscape artist who exhibited regularly in London and contributed to the Society of Female Artists, Bodichon was also a staunch defender of female education and became involved, with Emily Davies, in the foundation of Girton College, one of the early women's colleges at Cambridge University.[19] She enlisted Eliot's support in her political campaigns for the Married Women's Property Act (not passed until 1882), an important prerequisite for women's suffrage. Representation in Parliament was dependent upon two things: a property qualification and a gender qualification. If married women could not own property, they could not vote. Eliot immediately recognized that Bodichon's first campaign was merely 'one rung of a long ladder stretching far beyond our lives'.[20]

Eliot's most famous novel, *Middlemarch: A Study of Provincial Life* (1871), is set in 1832, the year of the Great Reform Act, which, while opening the vote to a slightly broader section of society, excluded women. Eliot's heroine, Dorothea, is symbolic of a certain type of woman who struggles between intellect and desire

Barbara Leigh Smith Bodichon, 1827–91
'Holmes of New York', 1850s
Ambrotype, 83 x 64mm
(3¼ x 2½")
National Portrait Gallery, London (NPG P137)

in her search for a meaningful vocation. Dorothea's individual story is set in the context of a long history of idealized visions of womanhood (such as St Theresa, who forms the subject of *Middlemarch*'s Prelude) in which sacrifice is necessary for the good of others. The final sentence of the novel acknowledges the important contribution made to society by women who are unknown to history:

> But the effect of her [Dorothea's] being on those around her was incalculably diffusive: for the growing good of the world is partly dependent on unhistoric acts; and that things are not so ill with you and me as they might have been, is half owing to the number who lived faithfully a hidden life, and rest in unvisited tombs.[21]

Like many other important feminist writers, including Wollstonecraft and Virginia Woolf, Eliot suggests that it is not only heroines we should remember in thinking about those who have come before us. As Wollstonecraft famously wrote, 'I wish to see women neither heroines or brutes, but reasonable creatures.'[22]

The sense of being exceptional, isolated or treated as 'honorary men' has often urged female intellectuals to seek out literary or artistic foremothers in order to create historical, as well as contemporary, female networks of significance. Women poets of the early nineteenth century, for example, sought to catalogue women's achievements for posterity. Lucy Aikin (1781–1864), Anna Barbauld's niece, published her *Epistles on Women, exemplifying their character and condition in various ages and nations* in 1810. The work paid tribute to her foremothers in a poem that traced the history of civilization from a female perspective. Felicia Hemans, the best-selling poet of domestic life, similarly published her *Records of Women* (1828), in which she chose a series of feminine icons of courage and religious faith. In these tributes to women of the past it is possible to detect an emerging focus on the domestic and an interest in women as icons of morality, reforming private life for the benefit of the public sphere. However, for some women, particularly those who wished to pursue a professional vocation in competition with men, such domestic virtues were precisely the things that needed to be forgotten.

The poet Elizabeth Barrett Browning (see opposite) complained, 'England has had many learned women … and yet where are the poetesses? … I look everywhere for grandmothers, and see none.'[23] Barrett Browning had sought significant inspiration in Madame de Staël's figure of the '*improvisatrice*' poet Corinne (see p.86) in writing her own epic of female creativity, *Aurora Leigh* (1857).[24] But while in thrall to this fictional model, she was frustrated by the

apparent lack of real precursors she could draw upon for inspiration. Germaine Greer has written of 'the phenomenon of the transience of female literary fame', describing the recurrent historical pattern whereby 'a small group of women have enjoyed dazzling literary prestige during their own lifetimes, only to vanish without a trace from the records of posterity'.[25] It is in the face of this phenomenon that women writers and artists have struggled to forge a sense of continuity, to assert a consciousness of their sex in cultural and historical terms.

Equal or Different? Women, History and Collective Identity

In an early essay, Susan Sontag (1933–2004), the New York film director, intellectual and essayist, wrote:

> Every generation produces a few women of genius (or at least of irrepressible eccentricity) who win special status for themselves. But the historical visibility of … that small band is understood to follow precisely from their possessing qualities that women do not normally have. Such women are credited with 'masculine' energy, intelligence, wilfulness and courage.[26]

Intellectual women have often faced a sense of being 'special cases', as many of the early bluestockings' lives and letters show. In 1777 Hannah More argued that women were not suited for literary genius but should focus on more feminine duties: 'The lofty Epic, the pointed Satire, and the more daring and successful flights of the Tragic Muse, seem reserved for the bold adventurers of the other sex.'[27] The question of whether or not successful women writers must become 'honorary men', or can celebrate their difference as women, is still one that plagues women authors, whether they like it or not.

While many writers of the Bluestocking Circle worked in accepted feminine genres, such as letters and conduct manuals, Elizabeth Carter and Elizabeth Montagu had shown that it was possible for women to succeed in areas that were traditionally the preserve of male authors. Carter's *All the Works of Epictetus* (1758) made available a classical text that was vital to the understanding of political history – she intervened boldly in public and literary life. Similarly Montagu's *An Essay on the Writings and Genius of Shakespeare* (1769) ensured her reputation as a popular defender of national literary genius. On the one hand, she cleverly made use of her feminine privilege as speaker of the 'mother tongue' to argue that she was particularly equipped to understand Shakespeare's natural and 'unlearned' genius. On the other hand, she dared to set herself in competition with Samuel Johnson. She was celebrated as a critical Amazon who, alone among

Virginia Woolf, 1882–1941
Vanessa Bell, 1912
Oil on board, 400 x 340mm
(15¾ x 13⅜")
National Portrait Gallery,
London (NPG 5933)

This gently abstracted
portrait of Virginia Woolf,
who is concentrating upon
her crochet work, was painted
by her sister Vanessa Bell
(1879–1961) around the
time that Woolf was working
on her first novel,
Melymbrosia, to be published
as *The Voyage Out* in 1915.

her contemporaries, challenged Voltaire's notorious criticisms of Shakespeare.
When Montagu's essay first appeared anonymously, she and Carter joked about
the fact that some readers assumed it had been written by a man. Montagu
and Carter became icons of national progress whose fame set them apart from
other women but was nevertheless sanctioned by the fact that they preserved
traditional notions of feminine virtue. While breaking certain cultural
boundaries, they did not challenge the social customs and legal norms of their
time. Where Catharine Macaulay and Mary Wollstonecraft departed from
bluestocking identity most significantly was in their disregard for conventional
feminine behaviour in their sexual lives. It was one thing to adopt a masculine
prose style, but quite another to adopt masculine sexual behaviour.

Women writers and artists have constantly had the tiresome experience of 'having their sex always taken into account', as Hannah More wrote, observing that her 'highest exertions will probably be received with the qualified approbation, that it is really extraordinary for a woman'.[28] More's incisive description of the prejudice against women who aspire to literary success conveys the ongoing dilemma faced by female intellectuals. Her view that women were not suited for literary genius but should focus on more feminine duties and leave the more ambitious ranges of intellectual production to men appears conservative and unsympathetic to modern ears. However, it is still the case that 'higher' genres of literary and intellectual writing are dominated by male authors. Women playwrights, composers, poets and philosophers are thin on the ground in comparison with their male counterparts. Even in the realm of the novel, a genre traditionally associated with women, it is still felt to be necessary, by some, to have a prize reserved for women's writing. The Orange Broadband Prize for Fiction, awarded annually to a woman novelist by an all-female panel of judges, was established in 1995 to redress a perceived neglect of women novelists by the major literary award committees.

Virginia Woolf famously addressed the topic of women and fiction in her essay *A Room of One's Own*, probably one of the most influential feminist essays of the twentieth century. In a portrait of her painted in 1912 by her sister, the artist Vanessa Bell, she is shown seated in an armchair, working some pink crochet – a surprisingly domestic image of someone who was famous for valuing her professional vocation (see p.143). Both sisters knew from an early age that they wanted to paint and write, and they later became central members of the circle of intellectuals known as the Bloomsbury Group. Bell designed several book jackets for the Hogarth Press, the publishers founded by Leonard and Virginia Woolf in 1917, including the bold image of a clock on a mantelpiece for Woolf's *A Room of One's Own*. First published in 1929, it was based upon a series of lectures Woolf gave to the students of the all-female Cambridge colleges, Newnham and Girton. Her elegant satire on the all-male colleges of 'Oxbridge' emphasized the economic deprivation and ridicule suffered by women who dared to admit to any literary ambition or professional vocation. She viewed economic independence as absolutely essential to women's freedom, praising the eighteenth-century bluestockings for showing that it was possible to live by the pen:

The extreme activity of mind which showed itself in the later eighteenth century among women – the talking, and the meeting, the writing of essays on Shakespeare, the translating of the classics – was founded on the solid

fact that women could make money by writing. Money dignifies what is frivolous if unpaid for. It might still be well to sneer at 'blue stockings with an itch for scribbling', but it could not be denied that they could put money in their purses. Thus, towards the end of the eighteenth century a change came about which, if I were rewriting history, I should describe more fully and think of greater importance than the Crusades or the Wars of the Roses.[29]

Woolf drew attention to the fact that history reflects the values of those who write it. Her essay traced a female literary tradition and asserted the importance of a female collective consciousness: 'For masterpieces are not single and solitary births; they are the outcome of many years of thinking in common, of thinking by the body of the people.'[30] In her stirring conclusion, she reflected upon the sense in which women's experience as a class had been submerged historically and politically but had to be written about and expressed in order to give birth to future female genius. Woolf created the imaginary Judith Shakespeare, who symbolized the suppression of women's consciousness by history.[31] Woolf (like Wollstonecraft) believed that individual potential would never be realized until the status of women was transformed.

Ironically, given Woolf's awareness of her bluestocking forebears, Judith Shakespeare came to symbolize a history of women's writing defined by oppression and absence rather than by professional presence.[32] *A Room of One's Own* has often been read as a history of the woman writer's lack of agency, arguably contributing to the frustrating state of affairs in which women are forever in the process of rediscovering their foremothers.

Modern-day Bluestockings
Germaine Greer is, like Woolf, a prominent intellectual who has altered our sense of women's history. Her first, and most famous, book, *The Female Eunuch* (1970), was immediately an international best-seller. Arguing that domestic, suburban middle-class life had disempowered women and cut them off from their desires and capacity for action, she urged women to take control of their own sexual and professional destinies. Greer has always been interested in the connection between an artist's libido and his or her creativity. Her second book, *The Obstacle Race: The Fortunes of Women Painters and Their Work* (1979), argued that the reason why women painters had not succeeded at the heights of their profession was because their egos had been damaged and their wills suppressed by an overwhelmingly oppressive patriarchal society.

Greer's portrait (see opposite), painted by the artist Paula Rego, is a powerful example of contemporary portraiture: vigorous, straightforward, but monumental as well. In a recent essay on Rego's work, Greer praised her as 'a painter of astonishing power, and that power is undeniably, obviously, triumphantly female. Her work is the first evidence I have seen that something fundamental in our culture has changed: the carapace has cracked and something living, hot and heavy, is welling through.'[33] Greer's own power as a writer is evident in her extended and luminescent description of Rego's works, in which the reader senses the electricity of recognition between two formidable figures.

Recent group portraits of intellectual and culturally active women address the question of their professional identity in ways that highlight women's vexed relationship with their history – and with the masculine institutions that have excluded them. John Goto's picture of the nine female vice-presidents of the British Academy (see p.148) was commissioned in 2001 as part of the celebrations to mark the centenary of the British Academy in 2002. The artist has united the living with the dead, creating a sense of dialogue between past and present generations, grouping them together in the Reading Room at the British Museum. Goto's eminent women of the past, depicted in black and white on the left-hand side of the image, are, from left to right: the literary scholar Dame Helen Gardner (1908–86), whose many distinctions included being the first Oxford Merton Professor of English and also a trustee of the National Portrait Gallery; the archaeologist Dame Kathleen Kenyon (1906–78); the historian and head of Lady Margaret Hall, Oxford, Dame Lucy Sutherland (1903–80); and Renaissance literary scholar Professor Kathleen Tillotson (1906–2001). His living subjects, depicted in colour, are, from left to right: Professor Margaret Boden, a cognitive and computer scientist; Dame Gillian Beer, a scholar of English literature; Professor Janet Nelson, a medieval historian at King's College London; Professor Karen Spärck Jones, a computer scientist; and Professor Margaret McGowan, a literary scholar. It seems fortuitous that at the time of the British Academy's centenary there had been nine vice-presidents who could act as a symbolic group of nine 'Muses'. Goto has included two anonymous and shadowy female figures, librarians carrying books, to suggest the unsung heroines of women's scholarship. While the image is in many ways celebratory, it reminds us that these women are vice-presidents rather than presidents (a portrait of the six, male presidents of the academy by the painter Stuart Pearson Wright was made in the same year). It was not until 2005 that the academy elected its first female president, the philosopher Baroness Onora O'Neill, formerly president of Newnham College, Cambridge.

Germaine Greer, b.1939
Paula Rego, 1995
Pastel on paper laid on
aluminium, 1200 x 1111mm
(47¼ x 43¾")
National Portrait Gallery,
London (NPG 6351)

**Nine Female Vice-Presidents
of the British Academy**
John Goto, 2002
Photographic montage,
2290 x 2035mm
(90⅛ x 80⅛")
British Academy Collection

While the position of women today is immeasurably different from that
of the original bluestockings, the tale is not one of simple progress. For every
'rediscovery' of women's cultural and intellectual achievement there has been a
loss. Questions of equality, recognition and power remain important for women
working as writers, artists and intellectuals in today's 'post-feminist' climate. When
Derry Moore was commissioned in 1996 by *Country Life* to revisit Samuel's
Nine Living Muses, the magazine combined an attempt to modernize the image
with an almost nostalgic reference to eighteenth-century ideals of femininity:
'The areas in which their [the Muses'] excellence is expressed have evolved,
but their qualities of social poise and accomplishment remain the same … .

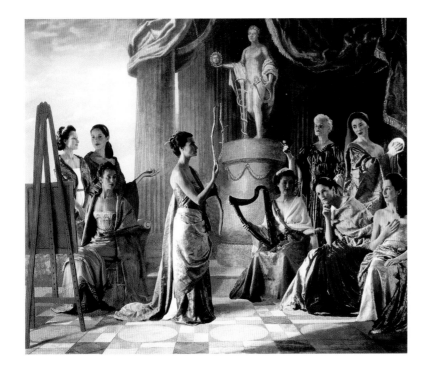

Modern Muses of Great Britain
Derry Moore, 12th Earl of Drogheda, 1996
Digital C-type colour print, 405 x 470mm (16 x 18½")
National Portrait Gallery, London (NPG x126319)

They are gracious in their determination to succeed; their independence of spirit is an example to others.'[34] *Country Life*'s *Modern Muses of Great Britain* were the educationalist Tessa Blackstone; the dancer Darcey Bussell; the percussionist Evelyn Glennie; the interior decorator and 'chatelaine' Sarah Hervey-Bathurst; the horsewoman Mary Elizabeth King; the soprano Emma Kirkby; the painter Emma Sergeant; the fashion designer Vivienne Westwood; and the actress and environmental campaigner Tracy Louise (Ward), Marchioness of Worcester. Moore's photo-montage was spotted by the *Independent* and 'Muses for a Modern Britain unveiled' appeared on the front page of the national broadsheet. According to the *Independent*'s gloss, Moore's image illustrated that 'Britain excels at modern art, auctioneering, exploring and theatre – London's West End has twice the number of theatres of Broadway; the armed forces and inventions – Britain has won sixty-one Nobel prizes compared to Japan's four; gardens, the City, broadcasting, field sports and public education.'[35]

The patriotic impulse to celebrate women as icons of national pride might remain, but in other respects this updated image of Samuel's Muses could not be more different, particularly in the relative absence of intellectuals – and the absence of a single professional writer. Perhaps it was easier to be a bluestocking in the eighteenth century than it is in our own age.

Chapter Notes

[1] Maria Edgeworth, *Letters for Literary Ladies*, ed. Claire Connolly (London, 1993), p.7; originally published in 1795.

[2] Quoted in Rebecca Warner (ed.), *Original Letters with Biographical Illustrations* (London, 1817), p.231.

[3] *Monthly Magazine*, Vol.X, 1800, pp.138–9.

[4] *Monthly Review*, Vol.XXVII, December 1798, p.422.

[5] Mary Wollstonecraft, *A Vindication of the Rights of Woman* (London, 1792). See Adriana Craciun, *British Women Writers and the French Revolution: Citizens of the World* (Basingstoke, 2005).

[6] See Ch.3 for a more detailed discussion of Richard Polwhele's poem *The Unsex'd Females* (London, 1798), a diatribe against radical women writers of the 1790s.

[7] Samuel Taylor Coleridge, *The Collected Letters*, ed. E.L. Griggs, 6 vols. (Oxford, 1956–71), Vol.III, p.459.

[8] George Gordon Noel, Lord Byron, *Don Juan* (London, 1819–24), Part IV, Stanza cix.

[9] William Hazlitt, 'Of Great and Little Things' (1821), in *The Complete Works*, ed. P.P. Howe, 21 vols. (London, 1931–4), Vol.VIII, p.236.

[10] *British Critic*, Vol.XX, July 1823, pp.50–55.

[11] Leigh Hunt, *Bluestocking Revels; or, The Feast of the Violets,* in *The Poetical Works of Leigh Hunt*, ed. S. Adams Lee, 2 vols. (Boston, 1857), Vol.I, p.282.

[12] I would like to thank Anne Mellor for alerting me to this image, and to Leigh Hunt's *Bluestocking Revels*, which she discusses in her unpublished paper 'Romantic Bluestockings: from Muses to Matrons', delivered at Yale University, January 2003.

[13] Virginia Woolf, 'Professions for Women', in *The Death of the Moth and Other Essays* (London, 1942), pp.150–51.

[14] Hannah More, *Strictures on the Modern System of Female Education*, 2 vols. (London, 1799), Vol.I, p.184.

[15] Jane Austen, *Northanger Abbey*, introduced by Claudia Johnson (Oxford, 2003), p.24.

[16] Charlotte Brontë, *Jane Eyre*, ed. Michael Mason (London, 1996), pp.125–6.

[17] See also Paula Rego's illustrations to Brontë's novel: Paula Rego, *Jane Eyre*, introduced by Marina Warner (London, 2003).

[18] George Eliot, 'Margaret Fuller and Mary Wollstonecraft' (1855), in *Essays of George Eliot*, ed. Thomas Pinney (New York, 1963), p.201.

[19] The movement to found Girton College began in 1866 and the college was officially founded as an independent association in 1872. Newnham College, the only other female college during the nineteenth century, was founded in the early 1870s.

[20] G.S. Haight (ed.), *The George Eliot Letters*, 9 vols. (1954–78), Vol.II, p.227.

[21] George Eliot, *Middlemarch*, ed. W.J. Harvey (London, 1965), p.896.

[22] Mary Wollstonecraft, *A Vindication of the Rights of Men and A Vindication of the Rights of Woman*, ed. Sylvana Tomaselli (Cambridge, 1995), p.155.

[23] See *The Letters of Elizabeth Barrett Browning*, ed. Frederick G. Kenyon, 2 vols. (New York, 1899), Vol.I, pp.230–32.

[24] See Cora Kaplan's introduction to her edition of Barrett Browning's work in *Aurora Leigh and Other Poems*, ed. Cora Kaplan (London, 1978).

[25] Germaine Greer, 'Flying Pigs and Double Standards', *Times Literary Supplement*, 26 July 1974, p.784.

[26] Susan Sontag, 'The Third World of Women,' *Partisan Review*, Vol.XL, 1973, p.181.

[27] Hannah More, *Essays on Various Subjects, Principally Designed for Young Ladies* (London, 1777), pp.6–7.

[28] Hannah More, *Strictures*, Vol.II, 'The practical use of Female Knowledge', p.13.

[29] Virginia Woolf, *A Room of One's Own* and *Three Guineas*, ed. Hermione Lee (London, 2001), p.55.

[30] Ibid., p.56

[31] Ibid., p.98. For an interesting discussion of the tradition of creating feminist icons, see Barbara Taylor's review of Elaine Showalter's *Inventing Herself: Claiming a Feminist Intellectual Heritage* (London, 2001), in *London Review of Books*, Vol.XXIV, No.1, 3 January 2002, pp.3–4.

[32] Margaret Ezell, *Writing Women's Literary History* (Baltimore and London, 1993). See Ch.2, 'The Myth of Judith Shakespeare: Creating the Canon of Women's Literary History in the Twentieth Century', pp.39–66.

[33] www.saatchi-gallery.co.uk/artists/paula_rego_articles_untamed_by_age.htm. Consulted June 2007.

[34] Rupert Uloth and Isambard Wilkins, 'Nine Modern Muses', *Country Life*, 24 October 1996, p.41.

[35] *Independent*, 25 October 1996.

Select Bibliography and Further Reading

Paula Backscheider, *Eighteenth-Century Women Poets and Their Poetry: Inventing Agency, Inventing Genre* (Baltimore, 2005)

G.J. Barker-Benfield, *The Culture of Sensibility: Sex and Society in Eighteenth-Century Britain* (Chicago and London, 1992)

Joan Bellamy, Anne Laurence and Gill Perry (eds.), *Women, Scholarship and Criticism: Gender and Knowledge, c.1790–1900* (Manchester, 2000)

John Brewer, *The Pleasures of the Imagination: English Culture in the Eighteenth Century* (London, 1997)

Kerry Bristol, '22 Portman Square: Mrs Montagu and her "Palais de la Vieillesse"', *British Art Journal*, Vol.II, No.3, 2001, pp.72–85

Alice Browne, *The Eighteenth-Century Feminist Mind* (Brighton, 1987)

Kate Chisholm, *Fanny Burney: Her Life, 1752–1840* (London, 1998)

Norma Clarke, *Dr Johnson's Women* (London and New York, 2000)

—, *The Rise and Fall of the Woman of Letters* (London, 2004)

E.J. Clery, *The Feminization Debate in Eighteenth-Century England: Literature, Commerce and Luxury* (Basingstoke, 2004)

Linda Colley, *Britons: Forging the Nation 1707–1837* (London, 1992)

Kate Davies, *Catharine Macaulay and Mercy Otis Warren: The Revolutionary Atlantic and the Politics of Gender* (Oxford, 2005)

Elizabeth Eger, 'Representing Culture: "The Nine Living Muses of Great Britain (1779)"', in *Women, Writing and the Public Sphere, 1700–1830*, eds. Elizabeth Eger, Charlotte Grant, Clíona Ó'Gallchoir and Penny Warburton (Cambridge, 2001), pp.104–132

—, 'Luxury, Industry and Charity: Bluestocking Culture Displayed', in *Luxury in the Eighteenth Century: Debates, Desires and Delectable Goods*, eds. Maxine Berg and Elizabeth Eger (Basingstoke, 2003), pp.190–206

Maria Fairweather, *Madame De Staël* (London, 2005)

Charlotte Grant, 'The Choice of Hercules: the Polite Arts and "Female Excellence" in Eighteenth-Century London', in *Women, Writing and the Public Sphere, 1700–1830*, eds. Elizabeth Eger, Charlotte Grant, Clíona Ó'Gallchoir and Penny Warburton (Cambridge, 2001), pp.75–103

Harriet Guest, *Small Change: Women, Learning and Patriotism, 1750–1810* (Chicago, 2000)

John Ingamells, *Mid-Georgian Portraits 1760–1790* (London, 2004)

Anne Janowitz, *Women Romantic Poets: Anna Barbauld and Mary Robinson* (London, 2005)

Vivien Jones (ed.), *Women in the Eighteenth Century: Constructions of Femininity* (London, 1990)

—, *Women and Literature in Britain, 1700–1800* (Cambridge, 2000)

Gary Kelly (ed.), *Bluestocking Feminism: Writings of the Buestocking Circle, 1738–1785*, 6 vols. (London, 1999)

Sarah Knott and Barbara Taylor (eds.), *Women, Gender and Enlightenment* (Basingstoke, 2004)

W.S. Lewis (ed.), *The Yale Edition of Horace Walpole's Correspondence*, 48 vols. (New Haven and London, 1937–83)

Devoney Looser, *British Women Writers and the Writing of History 1670–1820* (Baltimore and London, 2000)

Anne K. Mellor, *Mothers of the Nation: Women's Political Writing in England, 1780–1830* (Bloomington and Indianapolis, 2000)

Sylvia Harcstark Myers, *The Bluestocking Circle: Women, Friendship and the Life of the Mind in Eighteenth-Century England* (Oxford, 1990)

Gill Perry, 'Women Artists, "Masculine Art" and the Royal Academy of Art', in *Gender and Art*, ed. G. Perry (New Haven and London, 1999), pp.90–105

Nicole Pohl and Betty A. Schellenberg (eds.), *Reconsidering the Bluestockings* (San Marino, CA, 2003)

Marcia Pointon, *Hanging the Head: Portraiture and Social Formation in Eighteenth-Century England* (New Haven and London, 1993)

—, *Strategies for Showing: Women, Possession and Representation in English Visual Culture, 1665–1800* (Cambridge, 1997)

Roy Porter, *Enlightenment: Britain and the Creation of the Modern World* (London, 2000)

Sir Joshua Reynolds, *Discourses on Art*, ed. Robert R. Wark (New Haven and London, 1975)

Angela Rosenthal, *Angelica Kauffman, Art and Sensibility* (New Haven and London, 2006)

Betty A. Schellenberg, *The Professionalization of Women Writers in Eighteenth-Century Britain* (Cambridge, 2005)

Mary D. Sheriff, *The Exceptional Woman: Elisabeth Vigée-Lebrun and the Cultural Politics of Art* (Chicago, 1996)

David H. Solkin, 'Great Pictures or Great Men? Reynolds, Male Portraiture, and the Power of Art', *Oxford Art Journal*, Vol.IX, No.2, 1986, pp.42–9

Susan Staves, *A Literary History of Women's Writing in Britain, 1660–1789* (Cambridge, 2006)

Anne Stott, *Hannah More: The First Victorian* (Oxford, 2003)

Barbara Taylor, *Mary Wollstonecraft and the Feminist Imagination* (Cambridge, 2003)

Janet Todd, *Mary Wollstonecraft, a Revolutionary Life* (London, 2000)

Stella Tillyard, *Aristocrats: Caroline, Emily, Louisa and Sarah Lennox, 1740–1832* (London, 1994)

Cheryl Turner, *Living by the Pen: Women Writers in the Eighteenth Century* (London and New York, 1992)

Amanda Vickery, *The Gentleman's Daughter: Women's Lives in Georgian England* (New Haven and London, 1998)

Marina Warner, *Monuments and Maidens: the Allegory of the Female Form* (London, 1985)

Anthologies

Andrew Ashfield (ed.), *Romantic Women Poets, 1770–1838* (Manchester, 1995)

—, *Romantic Women Poets, 1788–1848*, Vol.II (Manchester, 1998)

George Colman and Bonnell Thornton (eds.), *Poems by Eminent Ladies*, 2 vols. (3 editions, London, 1755, 1757, 1773; revised in 1780)

Alexander Dyce (ed.), *Specimens of British Poetesses: Selected and Chronologically Arranged* (London, 1825)

Paula Feldman (ed.), *British Women Poets of the Romantic Era. An Anthology* (Baltimore, 1997)

The Folger Collective on Early Women Critics (ed.), *Women Critics 1660–1820* (Bloomington and Indianapolis, 1995)

Roger Lonsdale (ed.), *Eighteenth-Century Women Poets* (Oxford, 1989)

Eric. S. Robertson, *English Poetesses: A Series of Critical Biographies, with Illustrative Extracts* (London, 1883)

Frederic Rowton (ed.), *The Female Poets of Great Britain: Chronologically Arranged* (London, 1853)

Janet Todd (ed.), *A Wollstonecraft Anthology* (Cambridge, 1989)

Picture Credits

Locations and lenders are given in the captions, and further acknowledgements are given below.

Index

Figures in *italics* refer to illustrations